THE PHOTOGRAPHER'S
STUDIO
MANUAL

THE PHOTOGRAPHER'S
STUDIO
MANUAL
MICHAEL FREEMAN

AMPHOTO
An Imprint of Watson-Guptill Publications/New York.

Copyright © 1984 Nicholas
Enterprises Limited

First published in 1991 in the United
States by Amphoto, an imprint
of Watson-Guptill Publications, a
division of BPI Communications, Inc.,
1515 Broadway, New York,
New York, 10036

Library of Congress Cataloging-in-Publication Data

Freeman, Michael, 1945—
 The photographer's studio manual/Michael Freeman.—Rev. ed.
 p. cm.
 Includes bibliographical references and index.
 ISBN 0-8174-5463-2 (hc.)—ISBN 0-8174-5464-0 (pbk.)
 1. Photography, Indoor. 2. Still-life photography. I. Title.
TR550.F74 1991

778.7′2—dc20 91—11431
 CIP

Editorial Director Claire Howell
Designer Lawrence Bradbury
Illustrators Rick Blakely
 Phil Holmes

Phototypeset by Dorchester
Typesetting Group Limited,
Dorchester
Illustrations originated by East
Anglian Engraving Limited, Norwich

Printed in Italy
by Eurograph Spa · Milan

CONTENTS

Introduction

It is virtually an axiom of photography that the studio is the site of the controlled planned picture. Studio photography stands in contrast to all the work in which the camera principally observes – photo-journalism and all kinds of documentary photography, where the important skills are in the area of capturing something of an event or a situation. In the studio, the camera is not a passive witness; it is part of the deliberate creation of an image that begins in the mind of the photographer. Consequently, all that happens within the setting of the studio is purely for the purpose of making a photograph.

As a result, studio photography is not only performed in quite different ways from other kinds, it is judged on quite different criteria. The technical resources that are now commercially available are impressive – if at times costly – and studio photographers have the means to put onto film almost any deliberate vision they care to have. What can be imagined can generally be photographed, from the refined simplicity of a still-life in the classic tradition to a complex tableau with models or a technically sophisticated piece of surrealism.

With this technical and creative freedom, however, comes a certain amount of responsibility. The results are the photographer's alone, for better or worse. The street photographer displays his ability to cope with an uncontrollable situation and to snatch from it something elusive, but the studio photographer is responsible for everything that appears in the picture. If there is anything lacking, in acuteness of observation, or in content, there are no excuses. This fundamental fact creates a different attitude among studio photographers. They tend to be careful, to plan, and to concern themselves with the quality of the image – the production values of photography. Serendipity plays less part in the studio than in the street, and although some photographers create for themselves situations in which chance can play a part – in portraiture, especially – even these conditions must be set up deliberately. This element of control is so important in studio photography that it can count for more than the physical location. Not every studio needs to be of the type commonly imagined – a large, open interior space with batteries of lighting and background fixtures. A set temporarily built on location is, for the day, every bit as much a studio. If sufficient technical control is exercised, even outdoors, then similar problems and methods also apply. Defining a studio by its appearance is as imperfect as describing a cuisine by the state of its kitchens. It is the style of the results that is the framework of this book.

Studio photography also spreads beyond its physical setting in an internal way. A large amount of modern studio work relies on certain darkroom and post-production techniques. Particularly with special effects pictures, the shooting is often planned to take advantage of retouching and image combination, and there is no point at which it can be said that the studio photography has finished and the post-production starts. These, too, are a part of the necessary repertoire of skills.

Michael Freeman

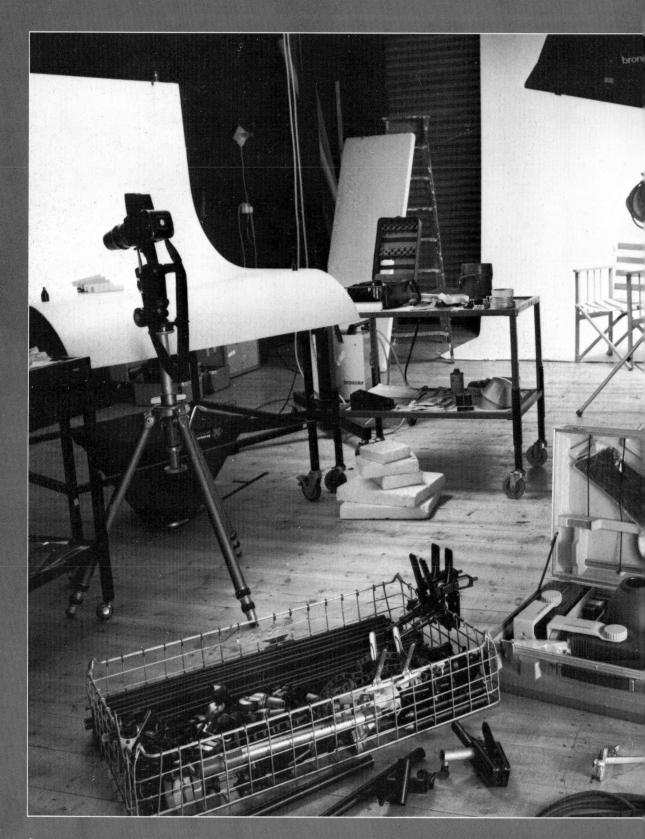

THE STUDIO

Organizing the physical space for studio photography can be a major undertaking, and the basic facilities of floor area, ceiling height and light-proofing determine the scale and type of photography that can be tackled. Because the rental and conversion of a studio are often costly, the ideal conditions may be out of reach, or at least difficult to justify on economic grounds. As a result, some of the more physically demanding subjects, such as room sets and vehicles, remain extremely specialized fields for practical rather than creative reasons; for the general run of studio subjects, mainly portraits and still-life sets, the requirements are easier to meet.

The nature of studio photography, with its emphasis on precision and deliberation, encourages the search of perfection in its images.

The same standards, however, are not always necessary in the construction of the studio itself. Certainly, the better fitted, better equipped and neater the studio is, the easier and more enjoyable it is to work in, but if this principle is followed to excess many photographers would be discouraged from ever starting. Making do with the space and material at hand is a valuable ability, and can, as all the techniques in this section show, make it possible to work even in temporary surroundings.

The basic studio

In as much as there is such a thing as a basic studio, there are a number of standard features common to most. The cutaway illustration is slightly idealized, but typical in its way.

In practice, studio photography tends to fall into subject categories. Two of these – still-life and people – are so much more common than any other that they have strongly influenced studio design. A general purpose studio is one that can handle these two types of subject, and the size of those shown here reflects this.

The main function of a studio is to provide control, and the way of doing this is by isolating the subject. This calls for an empty area considerably larger than the set in front of the camera, and the means to vary the background and the lighting. In very few photographs does the actual studio ever appear, and most are essentially an anonymous framework in which sets are constructed for single shots and specific lighting erected. In a way, the more anonymous and adaptable, the more useful a studio is.

Because of this, most of the fittings and supporting equipment are collapsible or can be moved easily. Sets rarely stay up for much longer than a day and need to be put up and down quickly. System supports, which can be assembled in a number of different configurations are common. Heavy equipment, including power packs and camera stands, is often fitted with wheels or castors, and a smooth, tough flooring is essential.

However, the major control that any studio offers is overlighting. On the one hand, it excludes extraneous light and on the other provides the means for building up a fresh design from scratch. Daylight is usually blocked out by painting or boarding over windows, or by installing shutters or special light-proof blinds of the type made for darkrooms. In addition, neutral surroundings are important to avoid the unintentional reflections from studio lighting that can ruin a still-life shot; walls and ceiling are usually painted black, white, or a neutral grey. Black is the most efficient because it adds nothing to the lighting, but can be claustrophobic to work in regularly; white helps to fill in shadows whether this is wanted or not.

The effect of all these preparations is to create a kind of blank sheet for the lighting. The extremely varied types available for a studio light then allow, in theory at least, any conceivable lighting effect to be created. The range of lighting equipment is detailed on pages 60-79.

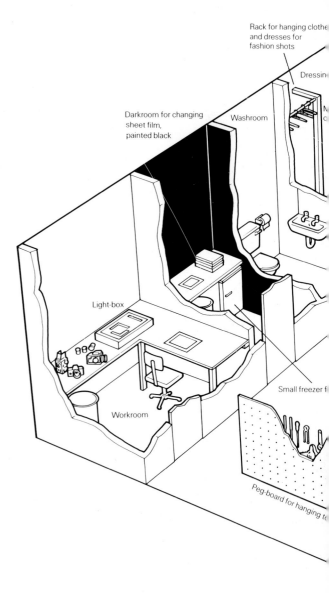

Rack for hanging clothe and dresses for fashion shots

Dressin

Darkroom for changing sheet film, painted black

Washroom

Light-box

Small freezer f

Workroom

Peg-board for hanging t

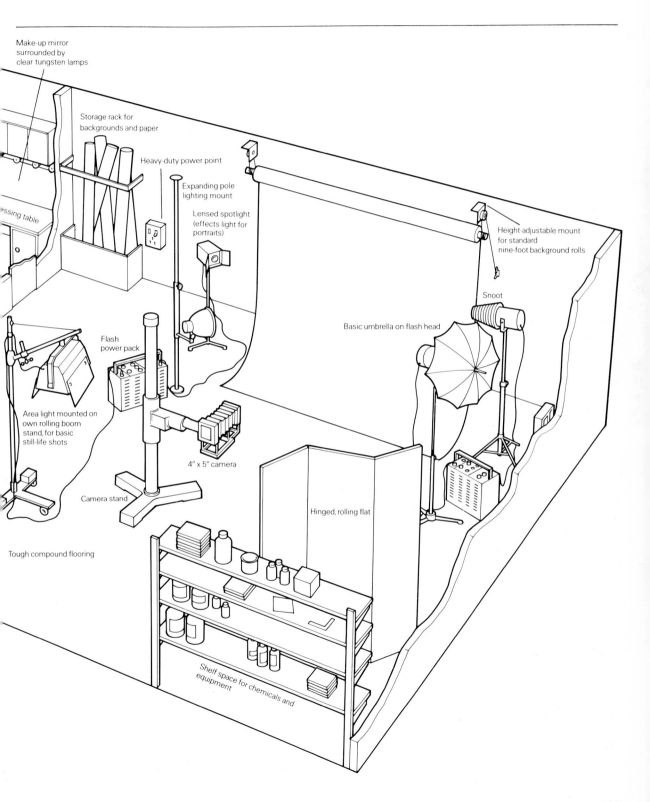

Make-up mirror surrounded by clear tungsten lamps

Storage rack for backgrounds and paper

Heavy-duty power point

Expanding pole lighting mount

Lensed spotlight (effects light for portraits)

ssing table

Flash power pack

Area light mounted on own rolling boom stand, for basic still-life shots

4" x 5" camera

Camera stand

Tough compound flooring

Height-adjustable mount for standard nine-foot background rolls

Snoot

Basic umbrella on flash head

Hinged, rolling flat

Shelf space for chemicals and equipment

The daylight studio

A large area light is one of the most attractive, and efficient, styles of illumination, and many photographers go to considerable effort and expense to build one. However, the largest of all area lights, the sky, may be a much cheaper, and even more attractive alternative. It has severe limitations, certainly, but for some methods of working it may be better than artificial lighting, and some notable photographers of people – Snowdon, for instance – use it by choice.

Only a room with a skylight is worth considering for a permanent daylight studio. In many ways, an angled skylight, of the type found in lofts, is ideal, giving some direction to the top-light effect. For some specific shots, such as full-length portraits, full floor-to-ceiling windows give good, broad, side lighting, but this has rather limited uses.

The great difficulty with daylight as a studio light source is control. In one way – direction and position – it cannot be altered, while in another – intensity and colour – it varies too much.

The time of day and weather both control intensity and quality of the light. If the skylight is so angled that the sun strikes it for part of the day, then there will be a massive variation from time to time – with some unwelcome shadows included for good measure. Many rooms with skylights, however, were built as artists' studios and face north to avoid this problem; the lighting quality is often more consistent – in everything except colour. The standard for colour temperature is 5500K Mean Noon Sunlight, and all other weather conditions are variable. The worst case is bright blue sky through a north facing skylight needing considerable colour correction with filters. There are two types of control possible. One is a system of blinds and diffusing material that can be hauled in front of or below windows in different combinations. Depending on the window area, black cloth blinds can alter the direction and brightness of the light, while thin white cloth can soften direct sunlight and increase consistency (fading, or the nature of the material, may alter the colour). The other control is to filter, an essential precaution with colour film (transparencies especially). A colour temperature meter and a full set of light-balancing filters are necessary equipment, except for black and white photography.

The great advantage, for which some photographers are prepared to put up with these inconveniences, is simple and general illumination at a reasonable cost. As the light source is, in effect, set in the ceiling, a daylight studio does not actually have to be as high as other types. Large hinged reflectors are useful for modifying shadows.

Adjustable window area with a strong overhead component is the basic requirement for a daylight studio. In the diagram opposite, a series of adjustable blinds give control over the lighting quality, while an ample selection of reflectors control shadows.

If the windows unavoidably face south, a second, underlying set of translucent blinds will be necessary in order to diffuse direct sunlight.

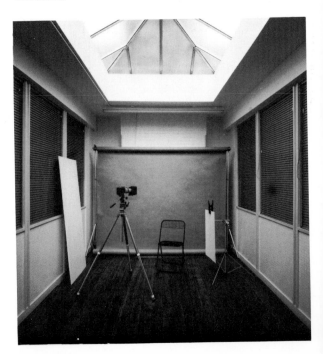

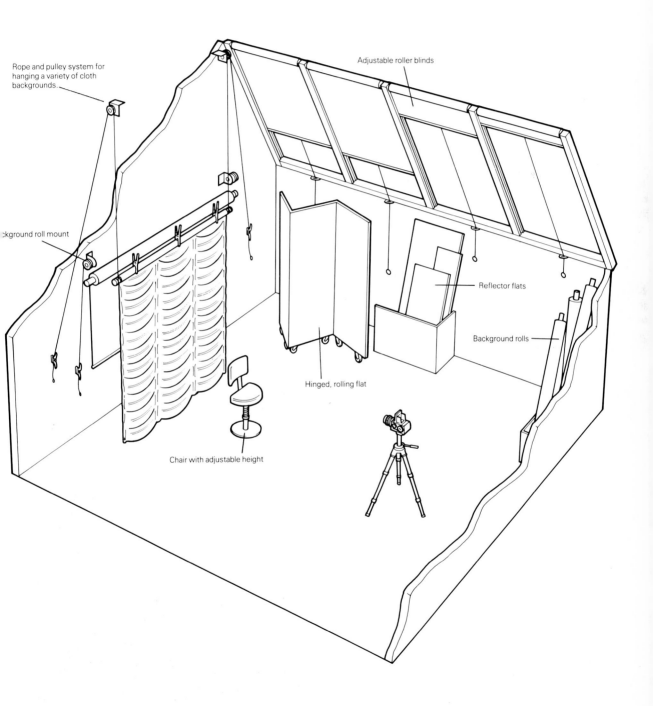

Rope and pulley system for
hanging a variety of cloth
backgrounds.

Adjustable roller blinds

ckground roll mount

Reflector flats

Background rolls

Hinged, rolling flat

Chair with adjustable height

The portable studio

The singular attractiveness of shaded natural light has tempted many photographers to make their portraits outdoors, even while trying to exercise as much control as possible in the manner of regular studio photography. If the environment is to be made an integral and working part of the shot, the matter is straightforward, but this intrusion of the surrounding world does not suit every photographer's style. Irving Penn's answer was to adopt a method used by some Victorian photographers who had no choice but to use daylight – he took with him what was essentially a consistent background. In construction it was rather more sophisticated, with floor and walls, and with a tent-like arrangement of poles.

The addition of a roof of diffusing material, and adjustable flaps give such a portable studio some versatility in adjusting the lighting and compensating for variations in weather, time of day, and the site. It is also possible to use artificial lighting, although this tends to defeat the original purpose.

Background material is largely a matter of personal preference, provided that it will fold for carrying. Canvas or tenting material is a convenient choice if it is also acceptable visually – it is fairly neutral in tone and texture, which tends to suit a variety of subjects, giving some continuity. It also does not suffer from being folded, as the natural creases create their own special textures. Jointed aluminium poles are the most convenient type of support, and the whole structure can either be adapted from an existing model of tent, or built up from parts supplied by a camping manufacturer.

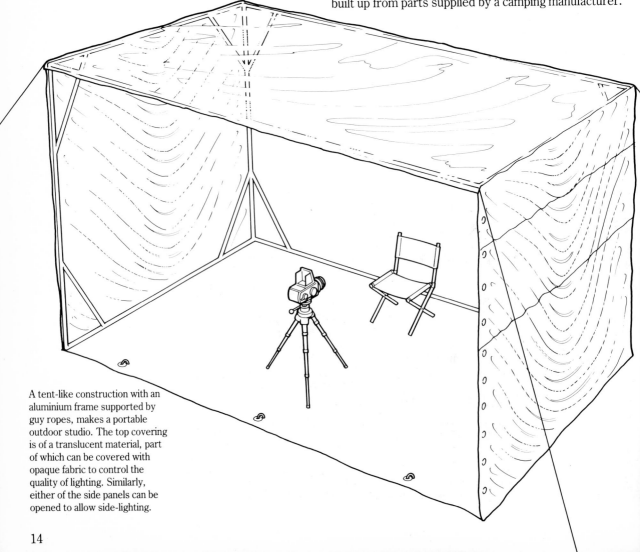

A tent-like construction with an aluminium frame supported by guy ropes, makes a portable outdoor studio. The top covering is of a translucent material, part of which can be covered with opaque fabric to control the quality of lighting. Similarly, either of the side panels can be opened to allow side-lighting.

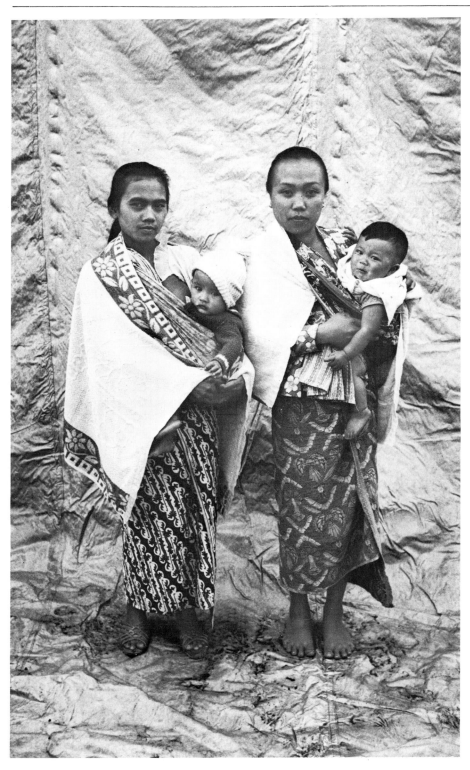

Against a portable backdrop of plastic sheeting on scaffolding, these Javanese women were photographed on location, in their own village, in studio-like conditions. This portable daylight studio provided a means of focusing attention on the people (without distracting local backgrounds) and of giving continuity to a series of such portraits.

Specialized studio layouts

In a sense, all studios are specialized to a degree, reflecting the interests and methods of the people who use them. Nevertheless, most subjects tend to be of a limited type, more by common practice than anything else, and the studio designs described earlier will serve fairly well. Still-life and portraits have grown to be the principal concerns of studio photography, and it is hardly surprising that most studios and most studio equipment are geared to these ends.

Certain subjects, however, have extraordinary needs, both administratively and photographically, and if they are the major concern of a studio, the facilities need to reflect these. Even still-lifes and portraits, if of a very specific type, may need specialized arrangements.

Food photography As a variation of still-life photography, food needs special logistics – of access and preparation. Apart from shots of cold dishes and raw materials, cooking facilities are mandatory, and these involve power supply for the cooker, plumbing, and safety provisions. The fumes, heat, and liquid in most cooking do not go well with photographic equipment, and it is nearly always best to have a separate kitchen. As the normal deliberations of most still-life photography apply equally to food, it is normal to need duplicate dishes, so that two cookers are better than one. For shots of actual cooking, a separate on-site cooker is an advantage, and for speed of control, calor gas tanks are usually better than electricity. All this carries a fire hazard and must conform to local fire regulations.

Food
In this layout for a food studio, the photographic area is kept separate from the kitchen, to protect equipment. The connecting door slides, to avoid accidents when moving food · through.
As much professional food photography involves an extended session preparing several dishes, there is provision for two set-ups, so that as shooting takes place on one an assistant can be arranging the next. A portable gas cooker is available in the studio area for cooking shots.

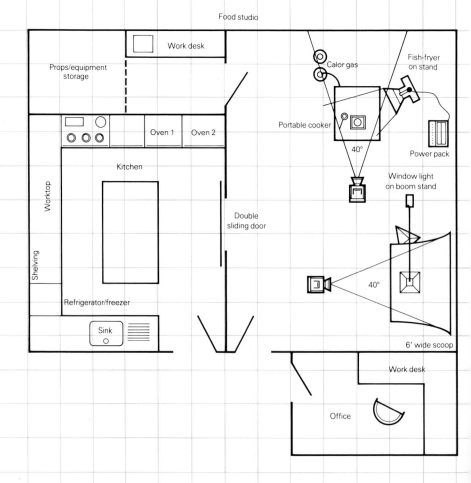

Food studio

◄ 2ft ►

Fashion and nude photography The lighting requirements depend on the style of the photographer, but are generally similar to those for portraits (they may need to accommmodate full length shots – see pages 154-155). Special requirements are a dressing room with mirror and adequate lighting for make-up. Moving shots and elaborate sets will need a larger working space. A fan is a useful accessory to give movement to hair and clothes in static shots.

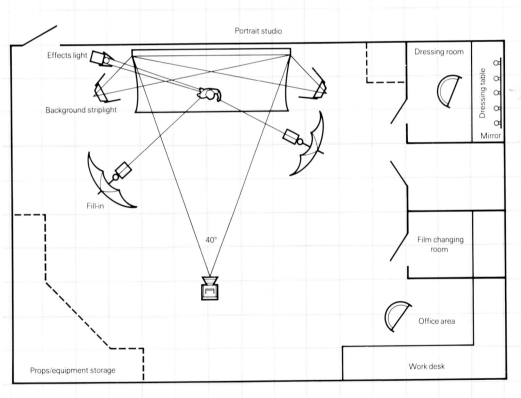

Portrait studio

Effects light

Background striplight

Fill-in

40°

Props/equipment storage

Dressing room

Dressing table

Mirror

Film changing room

Office area

Work desk

Fashion

A fashion and portrait studio needs, first and foremost, a large area for moving around – the model may need to walk, run, or perform some other action, and broad lighting is likely to be needed.

In addition, there is a well-equipped changing and dressing room, with a make-up mirror and table, and cupboards to hang dresses. There is extra space for ironing and altering clothes, and storage area for large background rolls.

Specialized studio layouts

Cars

A car studio is, of necessity, the size of a large garage, and needs, in addition, a high ceiling in order to provide broad overhead lighting. The curved cyclorama scoop, also known as a cove, is an expensive construction, but important in order to provide both a smooth background and a lighting reflector. It is generally painted freshly for each shot.

Overhead lighting can be provided by bouncing light off a painted ceiling or, as shown here, by a false translucent ceiling with lights suspended above it.

A rolling gantry is for painting and for adjusting lights. If the wheels are locked, it can also double as a high camera platform.

◄ 5ft ►

Car studio

Ramp

12' double sliding doors

Cyclorama

Overhead lighting gantry

Props/ equipment storage

Trace frames

Office Office

Lighting gantry

Retractable lights

Suspended frame for seamless paper

Cyclorama

Movable scaffolding

Car photography As detailed on pages 228-229, the reflective paintwork and size of most vehicles calls for a lighting system that relies on a high output, and a smooth enveloping surface. The construction, capital and space costs involved make car studios at the top of the league of specialization, as the illustration shows, and few are owned by individual photographers.

A very large power supply is needed, capable of producing at least 50,000 watts of lighting. As vehicle shots are usually static yet need powerful illumination, tungsten lamps and a time exposure are usually more convenient and cheaper than the equivalent in flash equipment. Access is important; vehicles need to be driven in, and a ground floor location is the most convenient.

Room set photography It is often more convenient to build the framework of a specially designed room than to find the same on location. Apart from being able to meet details of an art director's layout exactly, a set built within a larger studio has the advantage of camera and lighting access. One or two walls can be left off to give a wider field of view for the camera, and the ceiling can be left off for overhead lighting.

The basic requirement is size, which is why old warehouses and churches are often converted. Also needed is constructional space for building the sets, and a large amount of lighting (for the same reasons as in car photography, tungsten is more usual than flash), and large access doors and parking space outside.

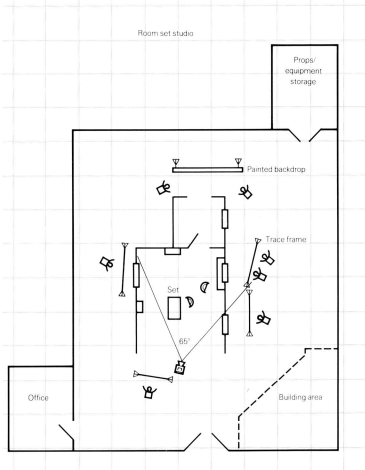

Room set studio

Props/ equipment storage

Painted backdrop

Trace frame

Set

65°

Office

Building area

Room sets
This room set studio is much larger than the typical interiors that are to be built inside it. Not only must there be sufficient space for construction and scene shifting, but also for lighting aimed into the set from beyond its walls. As with a car studio, a high ceiling is necessary for overhead lighting.

Designing a studio/basic requirements

Any studio layout is something of a compromise between what would be best for a particular style of photography and the physical constraints of the space available. It may even be a three-way compromise, being additionally between the ideal choice of fixtures, fittings and equipment, and what is affordable. Careful planning is important, and the earlier it is applied, the better.

Knowing that some compromise will be likely, it makes sense to approach the design from opposite directions, listing on the one hand the requirements, and on the other the possibilities for conversion offered by the space. Ideally, a studio should meet just the needs of the type of work that the photographer expects to be doing, and this calls for some anticipation. During the life of the studio, a photographer may change approaches and methods, not only adding new equipment that might call for new space (for instance, longer lenses that will need a greater working distance), but also developing new interests. While unused space is something of a luxury, it is also a waste of effort and money to design a studio to specifications that are too limited. The basic provisions are:

Sufficient working space This depends on the size of the subject (portrait or still-life, for example), the space needed behind the subject for the background, working space in front of the camera (depending on the focal length of the lenses), and space outside the picture area for lighting and other equipment that must stay out of shot (such as a wind machine and various supports).

Light-proofing If artificial lighting is to be used for shooting, all other light must be excluded. This can be done permanently by boarding up windows or painting them over (in black, or with a black undercoat), or else by fitting light-tight shutters or special darkroom blinds that run in grooves.

Adequate lighting The choice of lighting is enormous, as the section on pages 60-79 shows. A daylight studio clearly needs a fairly specific design, as the layout on page 13 illustrates. If the lighting is to be artificial, various power packs and lamp heads will have to be mounted somewhere – on the studio floor, walls or ceiling. Overhead lighting often calls for more ceiling height than many rooms have. Controlling the lighting means, in particular, being able to exclude extraneous light, colours and reflections.

Light-sealing the room makes it possible to construct a lighting pattern from scratch, although it will make insulation necessary. Avoid colour in the walls and ceiling: the standard alternatives are black, white, or a neutral grey.

Sufficient power The electrical circuitry is crucial, and must be capable of taking the load of all the lighting and other appliances at the same time. There should also be enough outlets, properly fused.

Heavy duty flooring The floor should be smooth (for rolling and sliding equipment around), strong (camera stands and large area lights can be heavy), and stable (to prevent camera shake). Have a careful structural inspection made, and consider re-surfacing. Unit flooring such as rubber compound tiles or parquet tiles are probably the best choice.

Access Existing doors may be too small or open insufficiently to move equipment and props in or out. Especially large or bulky subjects, such as vehicles, need special access.

Storage There should be sufficient room away from the working space for camera, lighting, background, props and tools.

Ventilation, air-conditioning, heating Particularly if the studio is light-sealed, the working conditions must be comfortable – in both summer and winter.

Darkroom facilities If sheet film is used (that is, a view camera), a small light-tight darkroom is much better for changing film than a changing bag.

This moderately large professional studio, has both the space and a flexible arrangement of equipment and fittings to allow different set-ups at the same time. Then, for instance, the still-life set at left can be left untouched after shooting until the processed film has been examined and the client has approved it, while the next project, a portrait, can be prepared in another part of the studio.

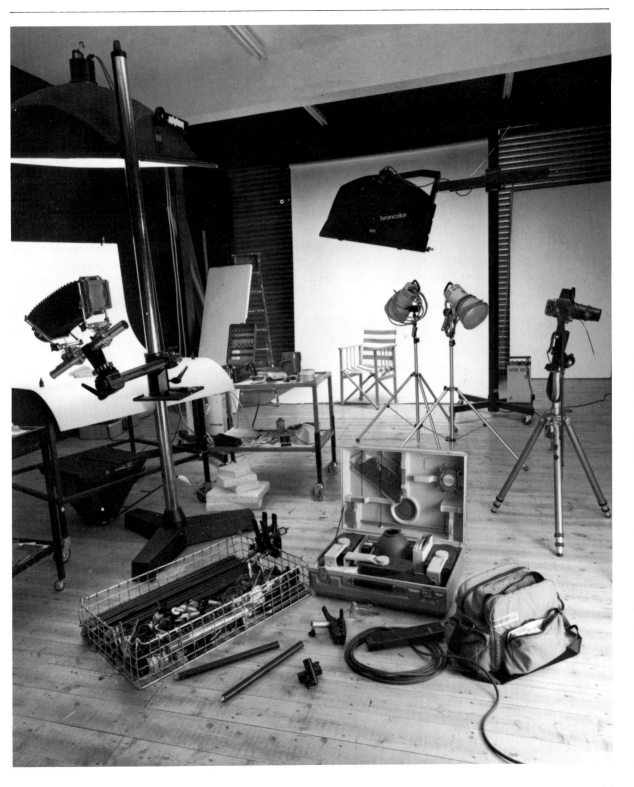

Designing a studio/the layout

With the basic needs in mind, the first practical step is to make a flat plan of the floor space, either measured out or direct from the architect. Graph paper makes it easier to work to scale. After some rough sketches, one idea is to make a scale model out of card. Alternatively, if you use a computer, a simple CAD program will simplify the designing. Working from either or both of these methods, the following stages make a logical progression:

1 Calculate the maximum working space. Measure the actual area of a picture, allowing for the largest subject likely to be brought into the studio. Next, taking the longest and the shortest focal length of lens that will be used, use a protractor to draw the angles of view of each, and draw them back from the picture area just measured. Then, extend these angles beyond the subject as far as a typical background. Allow a few feet behind the camera for ease of working, and the result is a kind of cone that is the centre of the studio design. The longest focal length of lens decides the length, the shortest focal length decides the width.

2 Experiment with the layout to see what choices there are for the position of the working space. If it is too ambitious for the floor plan, shorter focal length lenses may have to be used.

3 Measure the size of the basic lights and the cones

of light they emit (see pages 62-69). The specimen studio layouts on pages 16-19 give some idea of typical lighting requirements for average subjects; see if these fit. Ceiling height is likely to be a problem and may call for some design modifications. Ceiling mounts can save a few inches over boom arms, and lamp heads that are separate from the power pack take up less space than single-unit studio flash units. Custom-made reflectors can save even more space. Generally, umbrellas need more room than any other kind of lamp, but kickers and snoots often need a longer throw.

4 Check if any space is needed behind the background – for the supports, for instance, or if any lighting or back-projection needs to be installed.

5 Check that doors and corridors are wide enough to carry in and out the type of equipment and props likely to be needed. Permanently fixed equipment, such as lighting, can be brought in unassembled.

6 Plan storage areas. The more that can be attached to the walls, the more usable area there will be for working. See pages 58-59 for ideas.

7 Allow an area for general paperwork, and a work area for construction and assembly of props.

8 Check with the specific sections later in this book to see what the particular needs will be for specialized shooting – for instance, cooker and plumbing for food photography, dressing table for fashion photography.

In this example of studio planning the photographer has constructed a card model from the sketched plan, as an aid to visualizing the way that the space will work:

1. Sketching the flat plan, using a protractor (this one is specially made for such layouts) and a table of lens angles or view.
2. With a cut-out angle of view for one lens, checking the working space.

3. Measuring the height of an umbrella-fitted light.
4. Calculating back-projection space behind a translucent screen.

5

6

5. Checking door width.
6. Allocating storage space.

7

8

7. Desk area for paperwork and viewing transparencies.
8. A dressing-room for this studio, in anticipation of fashion work.

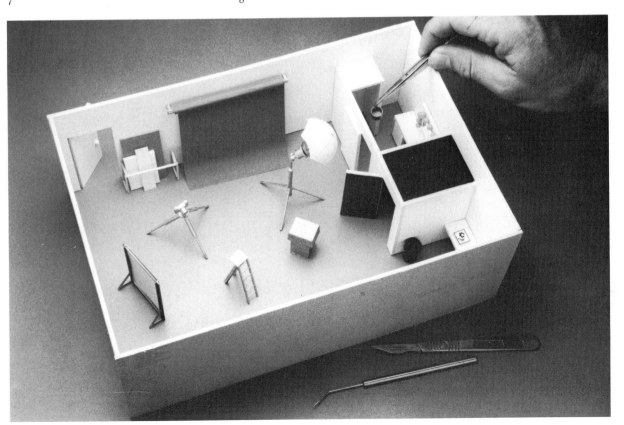

Designing a studio/management

Studios are never as large as most photographers would like them to be, but a basic principle of studio management is to make organized use of what is available. This in turn requires two things: a certain amount of discipline in working, and using space-saving design, particularly in storage. Ideally, all this should make it possible to break down a simple set and switch to another in less than a hour.

One method is to keep as much as possible off the floor. The upper walls and ceilings are nearly always unused in shooting, and so are perfect places for storage and fittings. As most main lighting tends to be higher than the mid-point of a subject, an efficient point for a light mount is on or close to a ceiling. A jointed, swivelling wall frame is one possibility; another is direct attachment to the ceiling, using a heavy plate or hook screwed into a main beam. For more directional versatility, lights can be attached to sliding mounts that run from one end to the other. A pantograph, or a simpler rope and pulley, gives even more scope for positioning, and also make it practical to store lights up against the ceiling when not in use. Pantographs and ceiling tracks can be motorised, although expensively, or else can be operated by cranking rods. See pages 60-79 for more details of light fittings. Shelves and cupboards are standard fittings; in addition to upper walls, most corners are unused, and so good places for storage. A sliding door increases the available working space, and can also carry any secure fitting, such as small box-like cupboards, or hooks and pegs. Work surfaces do not necessarily have to be permanent and can be hinged against the wall (fit a swivelling bracket underneath for firm support when in use).

A pegboard system is one of the most useful for tools and other small, regularly-used items, such as tape and cables. As an aid to tidiness, one tip is to draw an outline against each hanging item with a marker to make it obvious when it is missing.

Some wall space needs to be left free for the inevitable large flat objects that cannot be folded or rolled – sheets of Formica, Perspex (diffused plastic), wood, glass and so on. A stack of these tends to creep out onto the floor with use, but this wasted space can be saved by building a simple rack.

Another approach to saving space is to make fittings movable or collapsible. Castors under stand, tripods, power packs, flats and other large objects make it easy to shunt everything around (on a smooth floor). Trestles make simple, collapsible bases.

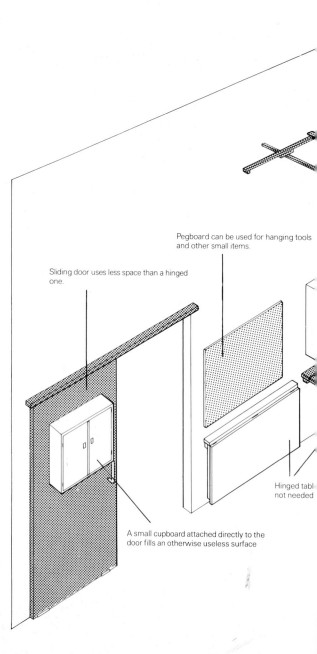

Pegboard can be used for hanging tools and other small items.

Sliding door uses less space than a hinged one.

Hinged table not needed

A small cupboard attached directly to the door fills an otherwise useless surface

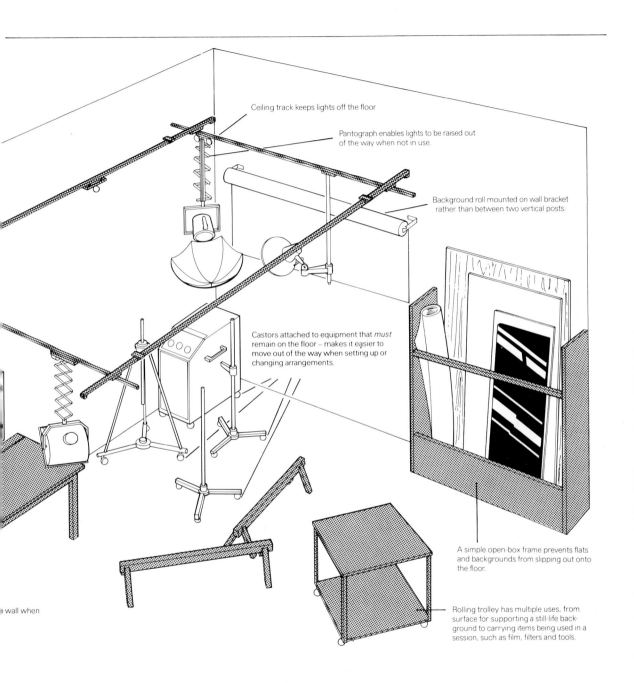

Ceiling track keeps lights off the floor

Pantograph enables lights to be raised out of the way when not in use.

Background roll mounted on wall bracket rather than between two vertical posts.

Castors attached to equipment that *must* remain on the floor – makes it easier to move out of the way when setting up or changing arrangements.

A simple open-box frame prevents flats and backgrounds from slipping out onto the floor.

Rolling trolley has multiple uses, from surface for supporting a still-life background to carrying items being used in a session, such as film, filters and tools.

wall when

A temporary studio

Elaborate permanent studios are certainly desirable, but by no means always necessary, and not always affordable. If commercial photography pays the rent, then a custom-designed, fully equipped studio is a sound-proposition, but for occasional, or amateur use, it is a luxury. A feasible alternative is to devise a system whereby one room of a house can be converted temporarily, when the need arises. Doing this efficiently involves more than just moving furniture to one side. The more uncomfortable and untidy the working conditions, the more likely the photography is to suffer. The biggest problem with using other spaces, such as living rooms, and studios, is that it takes more effort to concentrate on the picture, and most studio photography calls for deliberation.

The aim in constructing a temporary studio such as this is to make the least disturbance to furniture and fittings using equipment that can be used conveniently and erected easily, collapsible stands, background and lighting are important. The choice of which room to use is often limited from the start, and it is this that usually dictates the layout and equipment.

Working space

The first step is to calculate the exact shape of space that will be needed; a comprehensive method is the one recommended for designing a permanent studio on page 22. The best position in the room is the one that needs the least movement of the furniture, and if this can also be away from the window, there will be less need to block the daylight. The floor surface may be a problem: a carpet can be damaged by stands, tripods, and things spilled, and is not as stable as a solid tile, parquet or a stone floor. If it cannot be rolled up, it will need some protection in the form of a covering, and to avoid the tripod wobbling, a base, such as a piece of wood, will need to be laid on top.

Light-proofing This problem can be tackled from two directions – blocking out light from the windows, and making it less necessary. Fitted shutters, as shown on page 21 will black out a room effectively, but a sheet of thick black cloth cut and sewn to size will store more easily. Using flash rather than tungsten makes complete light-proofing unnecessary – all that is needed is enough darkness to be able to judge the lighting effects from the low-wattage modelling lamp. Positioning the set away from the window, and even working after dark, also cuts down the need for light-proofing.

Lighting Virtually any standard studio lights are suitable, with these special precautions: power demands from a heavy-duty flash unit (particularly if it has

First choose the room for temporary conversion and decide which part of it will be the easiest to alter. Measure the space, paying particular attention to the ceiling height – it must be high enough for the lighting. Some items of furniture are more easily shifted than others.

a booster) or several 1-kilowatt tungsten lamps may be too much for a domestic circuit, and an electrician's advice is a precaution; most domestic rooms have low ceilings, making it difficult to fit lights over a tall subject, but a simple answer is to paint the ceiling white and aim lamps upwards.

Maintenance Wear and tear is difficult to avoid when equipment is being erected and dismantled constantly. Painted plaster walls can be filled and retouched more easily than wallpaper, but in either case, redecoration is likely to be more frequent than normal.

Some form of light-proofing is nearly always needed, as most domestic rooms have ample window space with only partial facilities for blocking out light (such as curtains or blinds). A simple method is a large sheet of heavy black cloth, which can be clamped in place like this.

For diffuse over-head lighting, when photographing large objects in a small, low-ceilinged room, one solution is to bounce light from the ceiling.

Making a temporary studio

Although the adjustment must vary from room to room, the steps below are reasonably typical of a convenient arrangement in a living room. The basic simplicity of this room's design is an obvious advantage, but practically, its second function as a studio makes few demands on its normal use. Floor-to-ceiling windows along the whole of one wall might seem to be a major problem for a studio that needs precisely controlled light, but electronic flash can be used easily with ambient light, and the room's regular blinds dim it sufficiently for most purposes; a large sheet of black cloth excludes daylight completely for critical shooting.

1. Clear the working space of furniture and fittings that are likely to be in the way of the equipment or the view.

2. Roll up the carpet, if possible, so as to have a smooth floor that is solid enough to prevent unwanted movements of the camera or stand. If this is not possible, put down a protective covering (such as heavy duty plastic mats from an office furniture supplier) and a solid board as a base for the tripod.

3. For a typical still-life set, use a board that can rest either directly on an existing table, or on folding trestles.

4. For a scoop background save space by working right up against a wall – a sheet of Formica will fall into a natural curve against it.

1

2

3

4

5

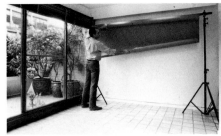

6

7

8

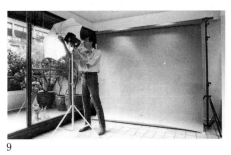

9

10

11

12

13

14

5. A very stable overhead mount for still-life lighting is the same cross-bar arrangement used for background rolls. As both are unlikely to be used together, the same stand can perform double service.

6. Suspend standard 9ft background rolls (or any other portrait background material) from a cross-bar fixed between two tripods. This wastes some space, as the background is away from the wall, but the alternative – permanent wall fittings – is likely to be unacceptable in a living room, unless they can be disguised. A smooth, white wall alone may be a sufficient background.

7. Use pelmets or door frames, if possible, for mounting lights, to save the space that would be taken up by a stand. Pad the grips of the clamps with felt to prevent damage to the paintwork, or else cover the pelmet with a small cloth.

8. The top of a door can serve as another space saving lighting mount.

9. Alternative light fittings are regular stands with umbrellas or spots, and a counter-balance boom for a still-life area light.

10. A white ceiling makes it possible to save height in a small room; lamps can be aimed upwards, to reflect. This can give very diffuse light for large subjects.

11. With powerful lamps, spread the load on a domestic circuit. Use extension cables for distant power outlets and tie off or tape down all loose cables.

12. Set up the camera and tripod.

13. If flash is used, closing blinds or curtains may be sufficient. Flash exposures are unaffected by ambient light.

14. For a complete blackout, cover the windows with a heavy black cloth (attach with clamps rather than tacks, to avoid damage, or even jam the cloth into the top of the window); or fit shutters.

Studio location work

Any planned, lit photography on location is virtually the same as setting up a studio – whether to photograph a single object in a museum, or a complete room in a house. The two essential qualities for the travelling kit are that it should be portable and versatile – portable because moving and erecting heavy equipment is arduous and takes up time, and versatile because conditions away from home base are rarely predictable, and often contain surprises.

Transport costs, particularly on aircraft, are another consideration, and anything that can keep weight down is worth investigating.

Preparation and anticipation can help; knowing the scale of the subjects and the settings in advance, the maximum lighting power can be worked out, so that just enough can be taken. The obvious advantage is hiring as much equipment as possible on site, but unless the hire sources (such as local camera shops) have been contacted and checked out beforehand, there is a risk of a crucial item not being available. Stands, clamps and cables are generally the safest bets for hiring, but unfamiliar lights are a risk.

Location Kits

Travelling kits for location work tend to be idiosyncratic – some photographers prefer to travel with the minimum and improvise on the spot, others feel safer with equipment to cover all eventualities. The kits shown here are middle-of-the-road versions, and are additional to camera, lenses, tripod and film.

Choosing between tungsten and flash is partly a matter of personal preference, partly a matter of the expected shooting conditions. The practical pros and cons on location are:

Tungsten
Light in weight
Uncomplicated
Effect can be seen
For static shots, like interiors, longer exposures solve all light output problems
Hot, preventing use with enclosed reflectors
Not always easy to balance daylight
Action blurs

Flash
Balanced for daylight
Stops action
Cool, so can be used with area lights
Fixed limit to light output, only partly soluble with
 multiple flashes
Electronics can be damaged by manhandling
With ambient lighting, needs a Polaroid to show results

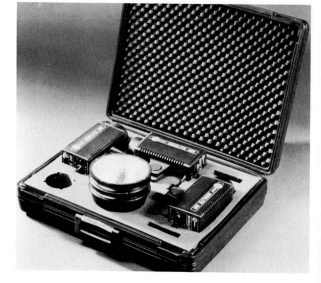

A pre-packed lighting set in its own case is a convenience when travelling. This kit comprises three single-unit flash lights of 200 joules (watt/seconds) each.

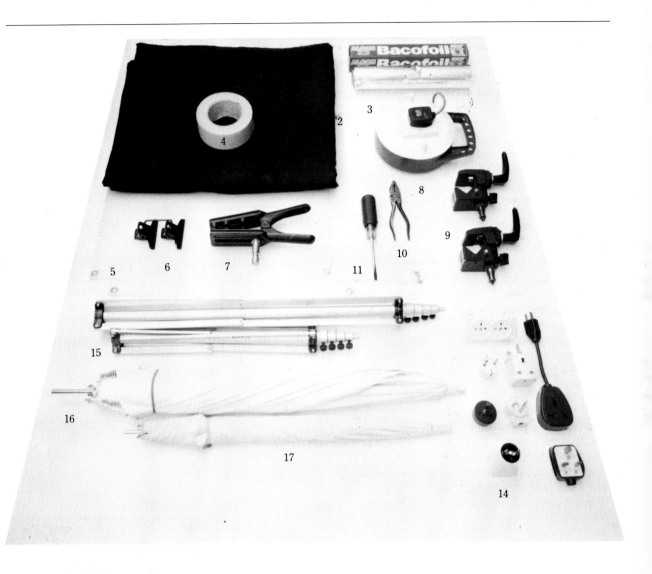

Basic location kit

This kit can be used with either flash or tungsten. In addition to the items shown here, large backdrops can be packed to choice – for instance, canvas or sailcloth measuring at least 9ft for full-length portraits.

1. Flexible, washable white plastic for simple still-life shots
2. Black cloth or black velvet, for blocking out backgrounds
3. Aluminium cooking foil for reflector (a reflective survival blanket is an alternative)
4. Gaffer tape
5. Corrugated translucent plastic for diffusing light
6. Two-way clips
7. Gaffer grips
8. Extension cable
9. Screw clamps
10. Pliers
11. Insulated screwdriver
12. Spare fuses for plugs
13. Choice of plugs and adaptors for different countries
14. Convertible plug
15. Light-weight collapsible stands
16. Reversible white/silver umbrella
17. Translucent umbrella

Studio location work

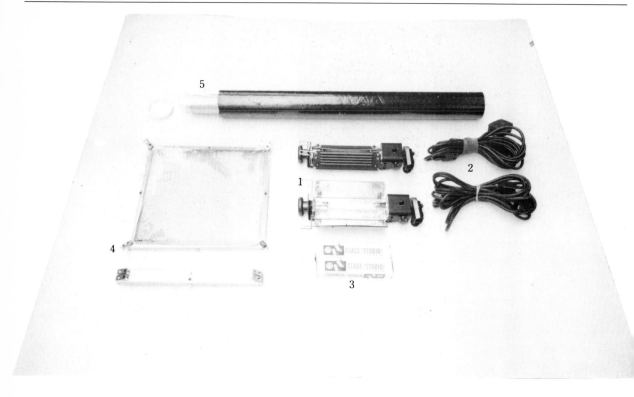

Additional kit for tungsten lighting

1. These portable lights accept tungsten-halogen lamps rated at 800 or 1000 watts and for 110/120 or 220/240 volts.
2. Cables and switches for lights.
3. Spare lamps. Changing voltages is as simple a matter as carrying a second set of appropriately rated lamps.
4. Outrig frames fit in front of the lights, and accept diffusing scrims and material, or blue gels to balance the tungsten lighting to daylight.
5. Blue gel roll.

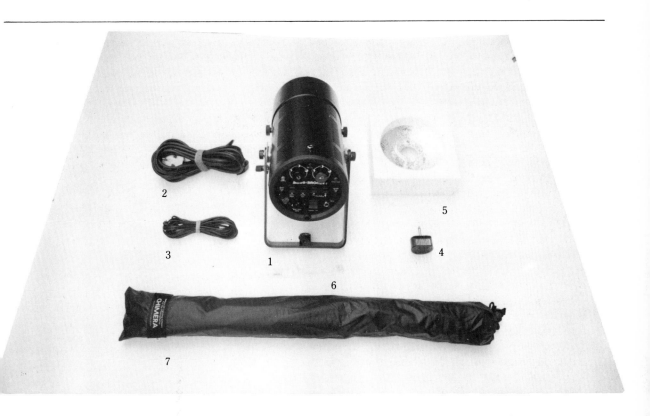

Additional kit for flash lighting
If working in a country with a different voltage mains
supply, a transformer may be necessary.

1. A single-unit flash is versatile and handy
2. Power cable for flash
3. Sync lead
4. Photocell slave trigger
5. Spare flash tube
6. Spare fuse
7. Collapsible softbox made from sailcloth and
 fibreglass rods gives an area light (unusable with
 tungsten because of the heat).

Outdoor location lighting

Although outdoor location work may strive to appear natural, its logistics may be more difficult than other kinds of location shooting. Weather and time of day may control events completely, and at least call for protection and some lighting provisions. The two special considerations are the scale of most scenes shot outdoors, and the lack of a local power supply; both influence the lighting.

Location lighting outdoors can be used to imitate natural light, but this is practical only over short distances and on limited sets. More often, it is used to modify the existing light in some way: this can be done realistically, to fill in shadows and lower contrast on sunny days, and to lift a shot taken on an overcast day, or it can be patently artificial for effect. In either case, there is only a certain amount that can be done passively (using reflectors and diffusers with sunlight), and most major sets call for lighting to be provided.

Running an extension cable from the nearest house is the easiest solution to the power problem, and more load can be carried by taking power from the point where it supplies the building rather than from domestic outlets. If in doubt, find an electrician. When using large drum cables, unwind them fully to avoid inductance heating and use the shortest extension cables to do the job, as the longer they are, the more the voltage will drop, and this will lower the colour temperature of tungsten lamps.

When there is no local power supply, the choice is between a gasoline-fuelled generator and a portable, battery-powered lighting system. There are several available portable systems, both tungsten and flash. Portable tungsten has been around for a long time, designed principally for the movie industry; the battery packs, however, are heavy, even those made to strap around the waist in the form of a belt. Battery portable flash is more recent, but has been developed to the point at which the output from a single head, even when well-diffused, is enough to work at small apertures with a 35mm camera. Units such as the Norman 400 produce 400 joules (watt/seconds) from dry battery packs.

Battery packs are rechargeable (this, of course, needs a mains supply), and you should make sure that you have a sufficient number of batteries to last through a location setting. Most systems allow rapid recharging of battery packs (usually in less than an hour), but for this the batteries must be in good condition. Otherwise, overnight trickle charging is needed.

When calculating electrical loads on electrical and power supplies:

$$\text{amps} = \frac{\text{watts}}{\text{volts}} \text{ and watts} = \text{amps} \times \text{volts.}$$

Outdoor lighting kit

For modifying sunlight, a collapsible trace frame can be covered with muslin; polystyrene panels can be used either as white reflectors, or more strongly if covered with crumpled cooking foil or mylar; black cloth can block sunlight out completely; tall collapsible tripods, jointed aluminium cross-bars and clamps can be used to suspend muslin or scrim directly over a scene. Heavy-duty battery portable flash, battery-powered sun guns designed for video or movie work, or even flash bulbs can provide portable light to cover small, local areas. More serious lighting calls for either long extension cables if there is a mains supply nearby, or a gasoline generator.

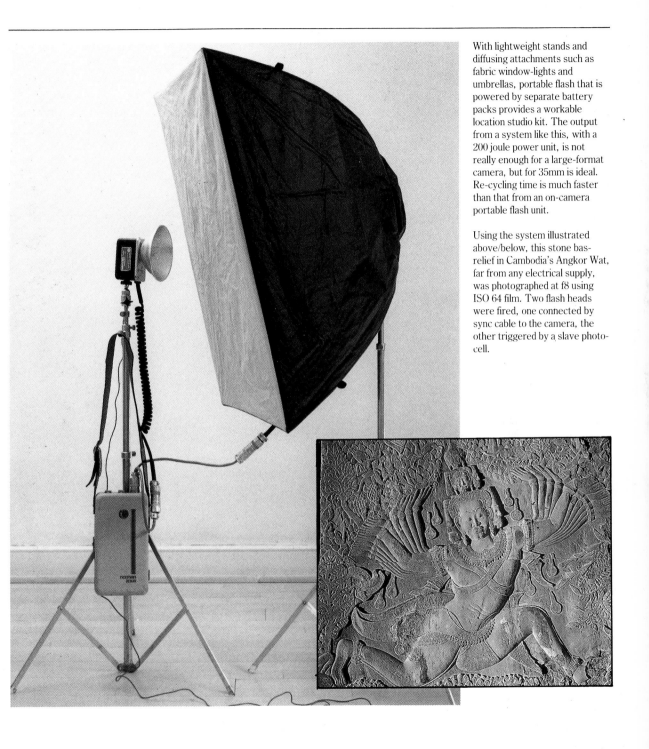

With lightweight stands and diffusing attachments such as fabric window-lights and umbrellas, portable flash that is powered by separate battery packs provides a workable location studio kit. The output from a system like this, with a 200 joule power unit, is not really enough for a large-format camera, but for 35mm is ideal. Re-cycling time is much faster than that from an on-camera portable flash unit.

Using the system illustrated above/below, this stone bas-relief in Cambodia's Angkor Wat, far from any electrical supply, was photographed at f8 using ISO 64 film. Two flash heads were fired, one connected by sync cable to the camera, the other triggered by a slave photo-cell.

CAMERAS FOR THE STUDIO

In location photography, the usual unpredictability of events and conditions favours cameras that are easy to handle, and the fact that most of it is performed on the move, so to speak, has made portability important. Not surprisingly, 35mm cameras dominate the fields where the photographer is *not* in control – the equipment has to compensate by being able to respond to fast reactions.

Off-the-cuff shooting is not characteristic of studios, however, and slower large-format cameras can here perform at their best. A deliberate way of working is no disadvantage in conditions where the photographer can choose exactly how to set about shooting, and the benefits of a large film size are obvious. In addition, the movements on a view camera offer a special kind of control over the distribution of sharpness, and the geometry of an image.

None of this, however, disqualifies 35mm cameras or any other format from studio use, and a small format can even bring some advantages in certain types of work, such as photomacrography, and when great depth of field is important. Studios create no special problems at all for equipment; indeed most of the work involved in setting up a photograph concerns everything *but* the camera, and many sets are capable of being shot on any format.

35mm cameras

Although 35mm cameras have always been designed with an eye on rapid location work, and are essentially a product of miniaturization, they are also generally the most precise instruments in photography. Although the image is small, there is sophisticated technology in abundance, and 35mm SLR's are as well suited to a studio as to any other area of use.

35mm cameras are less than ideal in just two respects, and there are ways of compensating for both, at least in part. The small format, 24 × 36mm, always needs great magnification later, however it is used. This inevitably works against image quality, because errors and blemishes, which might seem trivial, or even pass unnoticed when shooting, are magnified every bit as much as the picture; moreover, a small image just cannot contain the detail possible in a large sheet of film – an 8 × 10 inch original transparency or negative is more than 60 times larger than a frame of 35mm film. Another disadvantage, but one that only becomes apparent by comparison, is the lack of the camera movements so important in large-format photography. These movements control the shape of pictures, and the parts of the image that stay sharp; in particular,

they overcome the need for good depth of field.

Basic precautions, then, when using a small-format camera, are extreme care in all details that will be magnified when the picture is enlarged (such as accuracy of focus), a fine-grained film, and the use of small apertures to maintain front-to-back sharpness. Fortunately, good 35mm cameras are built to fine tolerances, and can be used accurately, and the most finely-grained of all transparency films, Kodachrome, is *only* available in 35mm format. Kodachrome 25 is virtually in a class of its own, while for fine black-and-white image quality, Kodak Technical Pan developed with Technidol LC developer approaches the standards of 4 × 5 inch regular sheet film. Some adaptations are useful when working with 35mm cameras in a studio. An even ground-glass viewing screen gives a less distracting image than the normal design with prisms, and a finely-etched grid helps vertical and horizontal alignment. If the viewing head can be removed, replacements that allow waist-level use may be better; certainly a direct view of the screen is more two dimensional than the usual method, and so can help in judging composition. A perspective-control lens offers

While a 35mm camera is as usable in a studio as on location, certain accessories help to overcome the limitations of a small format. A waist level finder aids composition as does a viewing screen etched with grid lines. A shift lens gives some control over convergence while fine-grained films are usually essential.

Fine grain film

Kodak technical pan film 2415
ESTAR-AH Base

some of the advantages of view-camera movements (see page 48), while efficient lens hoods are essential when lights are used close to the subject.

For checking the details of a shot before using film, Polaroid tests are commonly used with large-format cameras; this is more difficult with 35mm, but still possible with a special Polaroid back that fits in place of the regular camera back, or by using the 12-frame cassettes of 35mm Polachrome (see page 128).

Given these precautions and adaptations, 35mm cameras are simple to use for studio photography, and even outshine larger cameras in some respects. Because the format is smaller, equivalent lens focal lengths are shorter, which means that not only a shorter working space is satisfactory, but that depth of field is greater at the same f stops. Moreover, film is less expensive and so allows for more experiment and bracketing of exposure and filtration.

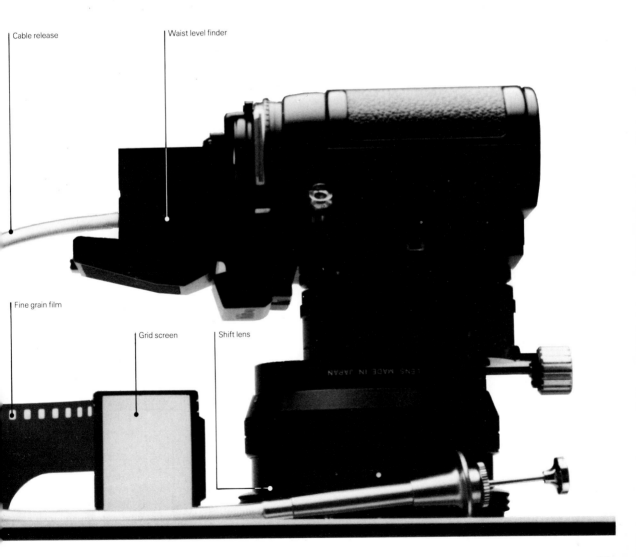

Cable release

Waist level finder

Fine grain film

Grid screen

Shift lens

Rollfilm cameras

Rollfilm cameras, of which there are several types and formats, occupy the middle ground between 35mm and sheet film equipment. As such, they have some of the benefits and drawbacks of each, but the practical result is that they have specific uses for certain fields of studio photography.

The chief advantage of 35mm cameras is the larger picture area which, in theory, allows higher image quality. Set against view cameras and sheet film, they are handlable, and so can be set up in different positions quickly and can be used quickly. Sheet film must be used shot by shot, with no simultaneous reflex viewing; a rollfilm camera fitted with a cranked film transport handle or a motor drive can take a rapid sequence of pictures. The disadvantages are not very obvious, and are mainly seen against larger formats: the image quality is proportionally less, and the same degree of camera movements are not available.

In practice, rollfilm cameras are useful in situations where rapid, simple use is more important than extreme detail in the picture. Portraiture and fashion

are both prime uses for medium-format cameras. In both, there is always some movement, and poses, gestures, and facial expressions are usually important. Capturing fleeting moments calls for equipment that is immediately ready for the next shot.

This one-film type has sponsored a greater variety of camera design than any other. Formats range from 4.5×6cm to frames so wide that they can hardly be used for normal photography – the 6×17cm Linhof Technorama, for instance. The most common formats for studio use however are still 6×6cm and 6×7cm.

There is little standardization of design – each major make is virtually in its own category. SLR's are the most convenient, but also necessarily complex and expensive. The Mamiya and the Hassleblad both have the extremely valuable feature of interchangeable film backs, for which an extra capping shutter is needed in the body. The same shot can be made on different film stocks with no trouble; this, for instance, allows a test roll to be shot of a number of consecutive sets, alongside the regular photography, and also allows Polaroid testing (see pages 126-129) which is as straightforward as with view cameras. A range of instant films for this format is available.

Twin-lens reflex cameras are an older, less expensive and less adaptable alternative. Parallax, which is a persistent problem at close working distances, is indicated in the viewer, and can be compensated for.

View cameras

The view camera, and in particular its modular version, the monorail, is the one design actually intended for studios. These are heavy, unwieldly and unprotected instruments, but because no concessions have been made by their manufacturers towards quick location use, they can make the most of the special facilities of a controlled situation. A modern studio monorail system is the standard by which all other studio cameras can be judged.

There are two basic constructions of view camera. Flat-bed models are built on a fixed base, which can be extended for focusing, generally by means of a rack and pinion. A bellows is built into the camera, which is usually designed nowadays to fold for packing and carrying. Traditionally-built makes, of mahogany, or some other hard wood with brass or chrome fittings, are called field cameras (being quite light and portable, they can be used on location), while the more precisely engineered all-metal makes are known as technical cameras. Technical cameras have a supplementary viewing system, so that they can be used by hand.

A completely different principle of construction is the modular one, used in monorail cameras. Here the framework has as its 'base' a single rail, rather like an optical bench, on to which slide and lock the different units of the camera. As the different configurations on pages 44-45 show, modular construction allows what

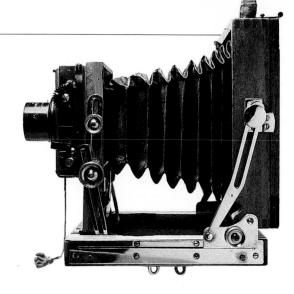

The traditional flat-bed field camera (this is an early example from the nineteenth century) has a lightweight folding design, making it portable and suitable for location work.

amounts to several different cameras to be assembled from the same equipment. For studio photography, which generally features individually constructed sets and unique problems, tailor-made configurations like this are ideal. A monorail system is less a single camera than a means of putting together the appropriate picture-taking equipment for each specific job.

The adaptability of monorail systems calls for more technical expertise and photographic knowledge than other kinds of camera. The choice of lens, for example, requires familiarity with optics, as different designs are available of similar focal length; some lenses are intentionally convertible, and the area of film covered is an important consideration if camera movements are to be used. The same lens may be usable with different formats, and indeed, many studio photographers regularly use one monorail system in two or more sizes.

The most common film sizes are 4 × 5 inches (10.2 × 12.7cm) (in parts of Europe, especially Germany,

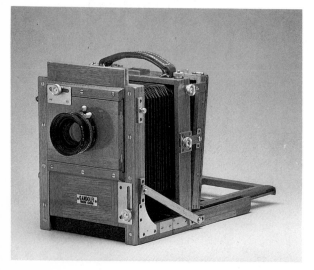

Another design of flat-bed camera has a fixed front in contrast to the more normal fixed back. Focus and limited tilts are made from the back; the lens panel has slides to allow rise and fall.

A modern monorail camera is essentially a system of interchangeable components, attaching to a strong rail instead of to a flat base. Formats can be changed simply by attaching a different film back and appropriately tapered bellows.

the slightly smaller 9 × 12cms is used) and 8 × 10 inches (20.3 × 25.4cm). In addition, certain film in sheets is available in sizes ranging from 3¼ × 4¼ inches (the larger sizes are intended for use in the darkroom rather than the camera).

Many old cameras, still usable today, have more unusual formats but provided the film holders exist, trimming down a larger stock size is straightforward.

Selecting a view-camera lens

Choosing a lens for large-format photography involves extra decisions to those for smaller, fixed-body cameras. The angle of view depends partly on the picture size, and a focal length that would be standard for an 8 × 10 inch (20.3 × 25.4cm) format – say 300mm or 360mm – would be a long-focus lens if used with 4 × 5 inch (10.2 × 12.7cm) film. The picture area actually covered also varies, and while it is possible to use a lens that simply covers the image circle, all the possible camera movements cannot be made; *they* depend on a generous image area, as pages 48-49 explain. The circle of coverage for 4 × 5 inch (10.2 × 12.7cm) film is 160mm in diameter and for 8 × 10 inch (20.3 × 25.4cm), 32cms in diameter (the diagonal measurement, in other words), but to make good use of camera movements, add on as a guide, 75 per cent. For example, when using 4 × 5 inch format, any of the lenses that are used should have a diameter of 280mm.

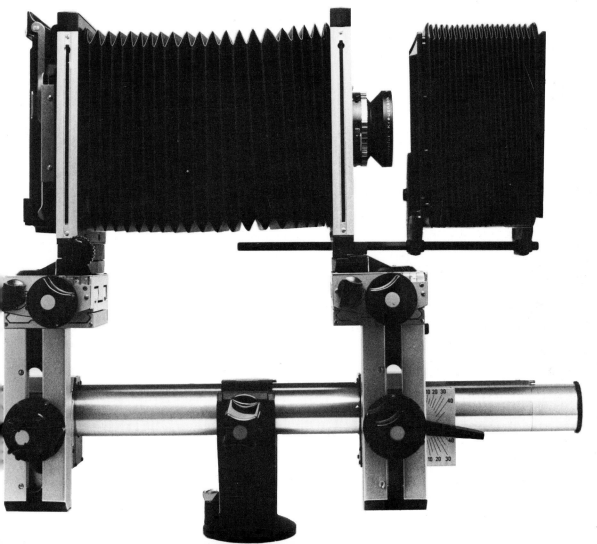

View cameras

Monorail view cameras are intended to be modular systems, adaptable and convertible to the special needs of any conceivable studio picture. Exactly how adaptable is evident from this selection of the most precisely engineered and comprehensive of all monorail systems, the Sinar.

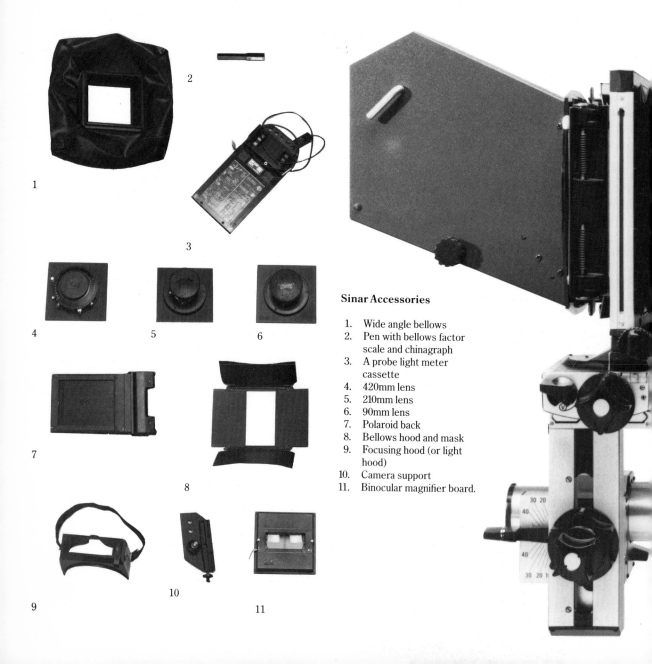

Sinar Accessories

1. Wide angle bellows
2. Pen with bellows factor scale and chinagraph
3. A probe light meter cassette
4. 420mm lens
5. 210mm lens
6. 90mm lens
7. Polaroid back
8. Bellows hood and mask
9. Focusing hood (or light hood)
10. Camera support
11. Binocular magnifier board.

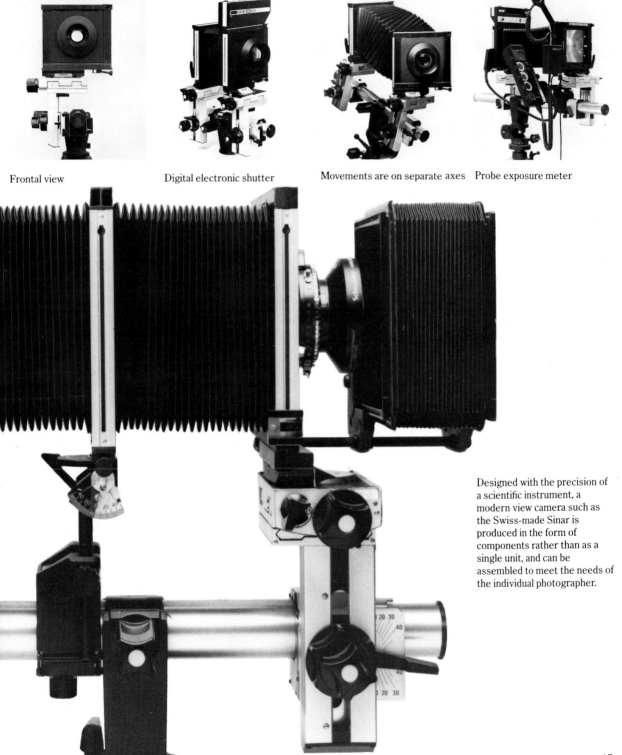

Frontal view Digital electronic shutter Movements are on separate axes Probe exposure meter

Designed with the precision of a scientific instrument, a modern view camera such as the Swiss-made Sinar is produced in the form of components rather than as a single unit, and can be assembled to meet the needs of the individual photographer.

Using a view camera/image size

The prime benefit of the view camera is the extremely simple one of the large image. The bigger the picture, the more detailed information it can contain, and it needs less magnification when reproduced as a photographic print or as a half-tone in a book or magazine. Not only can it carry more details of the scene in front of the camera than a smaller format, but the textural qualities of the image – the subtleties of tone and colour

– are preserved. The graininess of the film remains virtually hidden in all but gigantic enlargements, and does not interfere with the picture.

There are also more practical advantages. Large film, which remains flat throughout its use, has a thick durable base, and is much less susceptible to damage than smaller films: also, if it is scratched or damaged in any way, repairs are easier. Indeed, all kinds of

One of the penalties of a large film size is the dim viewing image. This is because the light must travel further from lens to film, and because very small apertures are often used. Checking the depth of field with a dark subject is difficult. One aid is to hold something bright at different positions near the subject as a focusing target.

An alternative, and brighter, image on which to focus is a small flashlight. Even at f45 or f64, its image is bright enough to be easily visible in the viewing screen.

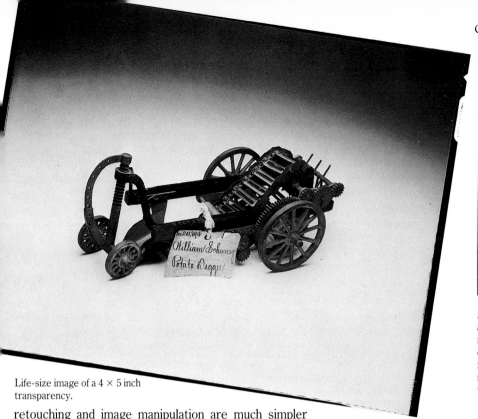

Life-size image of a 4 × 5 inch transparency.

Although the film size is large, and so forgiving of some mistakes (it needs less enlargement than small formats), it is still important to make critical checks of focus, with a loupe.

retouching and image manipulation are much simpler because of the size of the working area, and some techniques, such as direct transparency retouching, only become feasible on sheet film. Within the camera, tolerances are broader; if the film buckles slightly, or if the focus has not been set exactly, it may not be crucial. While a 35mm frame always needs to be

checked for technical accuracy with a loupe, an 8 × 10 inch sheet can usually be inspected by eye alone.

In practice, some precautions need to be taken, as some of the consequences of a large film size create technical problems. Lens focal lengths and distance between the lens and the film are proportionately greater than in small cameras. As a result, a great deal of light is lost within the bellows (light intensity falls off according to the inverse square law: twice as far gives *four* times less light, and so on), so that more light is needed on the set – or longer exposures. This is the reason for the large power packs and arrays of high-intensity lamps shown in the lighting section on pages 62-79. In addition, viewing itself is more difficult, as the view appears dimmer, particularly towards the edges of the frame. Adding a Fresnel screen helps to even out the view, but makes fine focusing less easy.

Depth of field is relatively shallow, because of the longer focal length of lenses, and care is needed in calculating it. For great depth of field, apertures as small as f64 are usual, but at this setting the view is all but invisible. To overcome these viewing problems, one method is to use a cloth hood to shield light from the back of the screen. Another is to view the scene from different angles. Depth of field can be checked on a still-life set by using a torch, or by placing a white or reflective small object at different distances.

Rollfilm adaptors are available, fitting simply onto the view camera back. Possible formats range from 6 × 6cm to 6 × 12cm.

When using a rollfilm back, either fit a specially marked ground-glass screen attachment, or cut a mask from black plastic or card.

Using a view camera/shift movements

Camera movements are a concept virtually unknown in small-format photography, but when used appropriately with a view camera provide an important and varied control over the appearance of the picture. The simplest type of movement, however, *is* represented in some 35mm and rollfilm SLR systems by a perspective-control lens, used mainly for architectural photography. It consists of nothing more complicated than the mechanics for sliding the lens up, down, or to either side, but the effect is to bring into view parts of the scene in front of the camera that would normally be off the edge of the picture.

The two ends of a typical view camera are known as standards: the front standard carried the lens panel, the rear standard carries the ground-glass viewing screen and spring-loaded back for the film holder. On most view cameras, shift movements, as they are known, are accomplished by moving the entire standard, vertically or horizontally. Shifting the front or the rear

standard generally amounts to the same thing, except that in close-range studio work, there is some parallax effect when the lens panel is moved (shifting the rear standard has no effect on the geometry of the image).

Shift movements rely on having a lens that covers a wider area than the picture format. As the diagram below left shows, the *potential* picture is a fairly large circle, and within this the *actual* picture can be positioned at will. One of the most valuable uses is to correct convergence by keeping parallel lines in the scene also parallel in the picture. Aiming the camera slightly down to photograph a straight-sided object causes convergence, as the example shows, and the only way to correct this is to keep the film plane parallel to the sides of the object. One simple way of doing this is to aim the camera horizontally, and then slide the image into view by shifting one or both of the standards. Note, however, that the same effect, to an extreme, can be achieved by using swings or tilts

All the shift permutations of a view camera are illustrated. All rely on having a picture area larger than the film format, as the diagram below illustrates.

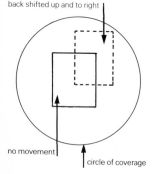

back shifted up and to right

no movement

circle of coverage

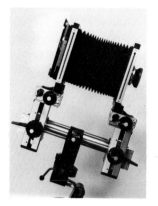

Normal position (side view).

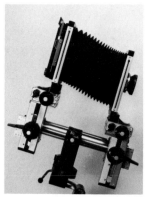

Falling front

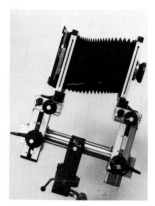

Rising front

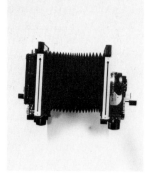

Normal position (top view)

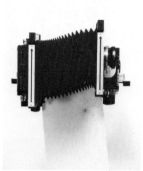

Front shift left

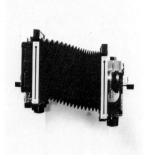

Front shift right

described on the following pages – the mechanics are different, but the principle is the same.

Shifts are also useful if the camera cannot be positioned ideally. If the only practical view is off-centre, perhaps because of an obstruction, a shift can appear to centre the view. A special case of this is in photographing a mirror face-on while concealing the camera's reflection; the camera is deliberately off-centred, and then the rear standard, (not the lens panel) shifted until the image of the mirror is brought into the middle of the picture. There is always a risk with this technique of creating unintentionally odd perspectives, with seemingly head-on views that strangely show one side of an object.

Using shift movements fully inevitably means taking the image from the edges of the lens, and the quality may suffer. Aberrations are greater away from the centre, and the precautions mentioned on pages 52-53 are important.

The two photographs of a mirror show one use mentioned in the text. By off-centering the camera and then shifting the image of the mirror back into frame (by moving the rear standard) the camera's own reflection in the mirror is removed.

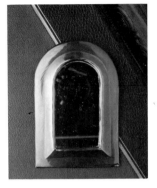
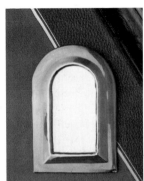

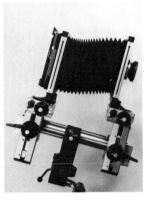

Falling back

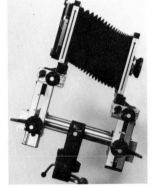

Rising back

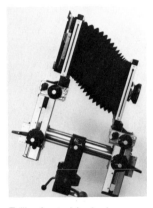

Falling front, rising back

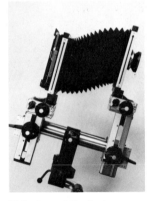

Rising front, falling back

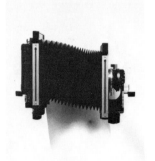

Back shift left

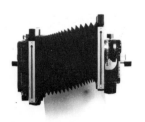

Back shift right

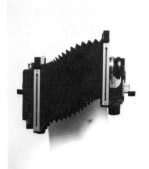

Front shift left, back shift right

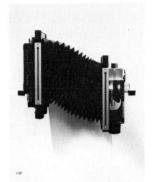

Front shift right, back shift left

Using a view camera/controlling sharpness

Users of 35mm cameras are familiar with the idea that sharpness of focus extends towards and away from the lens. There is a *plane* of sharp focus and, with a rigid body camera, the only variable is whether this plane is near or far, depending upon how close the lens is to the film – in all other respects it behaves like an invisible, upright sheet of glass.

This, however, is only a special condition, and with a thoroughly flexible view camera this plane of sharp focus can be angled in virtually any position. Tilting the lens panel forward a little has the effect of tilting the plane of sharp focus a great deal: tilting it backwards, or from side to side, has similar results. The rule that governs this behaviour is known as the Scheimpflug principle, and is easier to understand by visual example,

as in the diagram opposite, than by formulas or description. The precise position of the plane of sharp focus can be worked out by making the imaginary planes of the film back and the lens panel intersect with a line drawn from the focused object. Although apparently complicated in theory, the tilts and swings that alter the distribution of sharpness are straightforward enough to use, and most view camera photographers work out the angles by eye, checking the focus on the viewing screen.

Tilts revolve the lens on a side-to-side axis while swings revolve it on an upright axis. These same movements can also be made, at least on a monorail, to the rear standard, and have the same kind of effect on sharpness; however, they also affect the *shape* of the

Sharpness can be re-distributed over the image by rotating either the front or rear standard. However, as rear standard movements also change the shape of the image, they are dealt with on the following pages. For simplicity of description, front standard movements only are shown here.

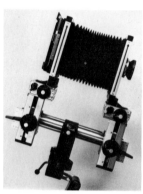

Normal position (side view).

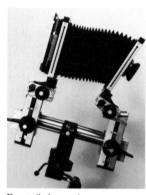

Front tilt forward

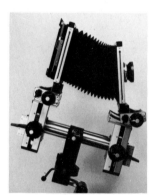

Front tilt backward

Normal position (top view)

Front swing left

Front swing right

In this steeply angled photograph, overall sharpness was achieved by tilting the front and rear standards together, *not* by increasing depth of field. Some cameras incorporate systems for altering the plane of sharpness that can be worked out through the viewing screen but standing to one side and estimating the necessary convergence, as in the diagram below, is a straightforward alternative.

picture, and to avoid complicating the issue, rear standard movements are left until the next two pages. In practice, all movements can be combined in a shot, and while individually they are fairly simple in effect, together they can stretch the ability to imagine the result.

The importance of sharpness-controlling movements is that the very best use can be made of depth of field. Large-format cameras have limited depth of field, and using it to sharpen all areas of a picture is not very efficient (it needs more light or longer exposures to allow a small aperture, and the lens does not perform at its best when stopped right down). Most scenes, except notably flat objects face-on to the camera, and spheres, are three dimensionally lop-sided – that is to say, there is an imaginary plane at some angle that takes in the scene's longest axis. Tilting or swinging to align the plane of sharp focus with this achieves the maximum sharpness. This is *not* the same thing as increasing the depth of field.

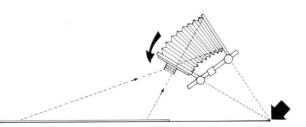

The useful Scheimpflug principle shows how the plane of sharp focus can be altered and calculated. Imaginary lines drawn from the plane of sharpness, the front standard and rear standard all meet at a point (arrowed above). In the situation shown, this can be estimated from the subject and rear standard planes; the front standard can then be tilted forwards to coincide.

Using a view camera/controlling shape

As the shift movements on pages 50-51 demonstrated, the relative positions of the film and the subject – disregarding the lens – affect the graphics of the picture. If the film is at an angle to one surface of an object, the result is convergence – the perfectly normal effect of perspective. In practice, there always is some perspective effect of this kind, unless the subject is flat, like a painting, and copied face-on.

So, by positioning the rear standard (which carries the film) at an angle, the shape of the image is changed. It affects the distribution of sharpness as well, and this is a complicating factor, but by moving both rear and front standards, one can compensate for, or even exaggerate, the effects of the other. In other words, if the best place for the plane of sharp focus in one picture is upright and square-on to the camera just as it would be with a 35mm SLR, then all the photographer needs to do is to make the operation in two stages: first changing the shape by moving the rear standard, and

then moving the lens panel in the same direction to restore the original distribution of sharpness.

The reasons for actually wanting to alter the shape of a picture depend on individual circumstances and are mainly creative decisions. Stretching the lower part of a still-life picture, for example, exaggerates the importance of the foreground objects (this is accomplished by tipping the rear standard backwards). Alternatively, swinging or tilting the rear standard *against* the principal plane of the subject can normalize shapes already distorted by the angle of view (although this can only be done up to a point, or the plane of sharp focus cannot be made to match).

Because rear standard movements change both shape and sharpness, working out the best procedure is not always simple. As a general rule, before moving anything, consider the ideal distribution of sharpness (tempered with the possible depth of field which might be used instead) and the ideal alteration of shape

Rear standard tilt or swing movements always change the shape of the image. Often, front standard movements must then be used to adjust the plane of sharpness.

All movements – shift, swing and tilt – may cause image cut-off if extreme. Check that the stopped-down lens aperture is still circular when seen from the corners of the viewing screen.

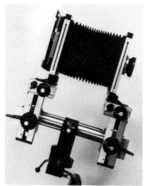
Normal position
(side view)

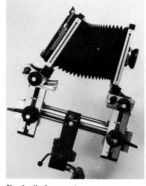
Back tilt forward

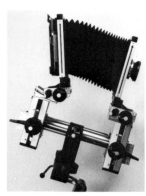
Back tilt backward

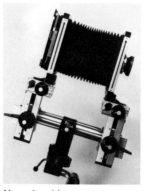
Normal position
(top view)

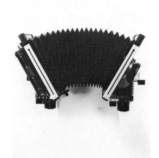
Back swing left,
front swing right

Back swing right,
front swing left

(including the correction of convergence). In some cases, such as a still-life of parallel upright objects that is higher at the back than at the front, the best movements will help each other, but in others the movements will work against each other and some compromise will be needed.

Essential lens precautions

One of the dangers of working close to the *edge* of an image projected by a lens is that the aberrations are worse than in the middle. To an extent this can be helped by stopping the lens down so that its centre forms the picture, but it may be better simply to use a more moderate movement. If extreme movements are important, a lens with extra wide coverage for the format is essential.

Another danger is that part of the picture may be cut off, particularly at one or two of the corners. This can happen because the image projected on a view camera's ground-glass screen is not at all easy to see, particularly towards the corners. Using movements demands a careful check and a good aid, standard to many models, is a screen with cut corners. To use this, the back of the lens is viewed directly from the corner; if the aperture does not appear to be circular, there is some cut-off.

A final precaution is to allow extra exposure with extreme movements – even up to an extra f stop in some cases with wide-angle lenses. The reasons are that lenses, particularly those with short focal lengths, pass less light from their edges than from the centre, and that severe swings or tilts will extend the draw of the bellows, with an effect similar to close-up magnification. The best methods of re-checking the exposure are by taking light readings directly off the film plane (available on some cameras) and by running a Polaroid test.

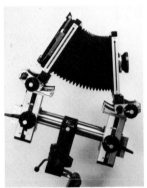

Back tilt forward, front tilt backward.

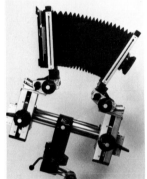

Back tilt backward, front tilt forward.

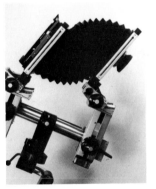

Back tilt forward, front tilt forward

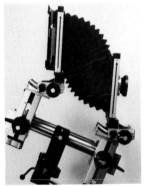

Back tilt backward, front tilt backward

The practical effect of an extreme rear standard swing is seen in these two photographs of an old stereo camera. In the top photograph no movements have been used.

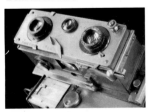

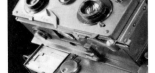

In the lower, the rear standard has been swung left and tilted a little back. The nearer parts of the image appear stretched.

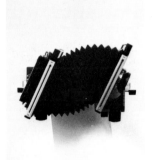

Back swing left front swing left

Back swing right, front swing right

Tripods and stands

Regular tripods are as usable in the studio as on location, and for most general uses are perfectly adequate. Nevertheless, there is specific equipment that is only practical in the protected conditions of a studio, but which covers the two special needs of extra stability and unusual camera angles.

With small-format cameras – 35mm and rollfilm – a standard portable tripod is sufficiently sturdy, but the larger view cameras used in most professional studios need a more solid platform. Although there are no environmental hazards, such as gusts of wind, there is the danger of cameras being moved inadvertently, or over-balancing. Also, probably because of the opportunities of creating imaginative sets in the studio, a wide variety of camera angles is typically used – more so than in most location photography. Suspending and extending heavy cameras requires extra support equipment.

Portability is not an issue in a studio, and supports that are designed mainly for this use are usually heavy and bulky. The strongest of all camera supports, and ideal in spite of its expense, is a camera stand – a thick vertical column on a heavy-wheeled stand that will hold the largest view camera steady. Heavy tripods are almost as stable, and can be made more so by devices such as spreaders and crow's feet, and by weighting and tying them down. As changing the camera angle is common, mounting a tripod on wheels is useful, and a dolly, as this attachment is called, also helps to make the tripod more stable, in the same way as a spreader. Unusually high and low camera positions are often needed, especially for still-life shots; two fairly common camera angles are a plan view – vertically downwards – and a low view angled upwards to enhance the perspective of a small object. Plan views, which are convenient for most kinds of copying, are reasonably straightforward on a small scale and on a small camera; a large camera, however, may overbalance a normal tripod, and a high camera position runs the risk of including some of the support (tripod legs, for instance) in the shot. One solution is to extend the tripod head horizontally, and several proprietary adaptors are available for this. Alternatively, the legs on some large tripods can be opened to a greater angle, so improving stability and remaining out of view even with a fairly wide-angle lens (but special care must be taken with the siting to prevent shadows cast by the lights from falling across the subject). Another method is to clamp the camera to any overhanging surface, such as a table, or

Vise
Particularly useful for location use and for placing the camera in small, difficult-to-reach positions.

Screw-locking clamp
The padded grips of this adaptable clamp will lock securely onto any standard bar or pole.

G-clamp
An adapted G-clamp serves the same purpose as the vise above.

Table-top tripod
For small-format cameras, a miniature tripod is useful for low positions or on top of any firm, level surface.

Side-arm for shooting vertically downwards, a side-arm extends the camera out beyond a position where the tripod legs would appear in the frame.

Copystand

For copyshots (see pages 240-244), a purpose-built, pre-aligned stand is the easiest support to use. It gives an absolutely vertical camera axis onto a level baseboard.

The most stable and adjustable studio camera support (but also the heaviest and most expensive) is a stand. The castor base can be locked, and the massive central column is rigid enough to hold the largest view camera. By the same token, it is hardly necessary for small-format cameras.

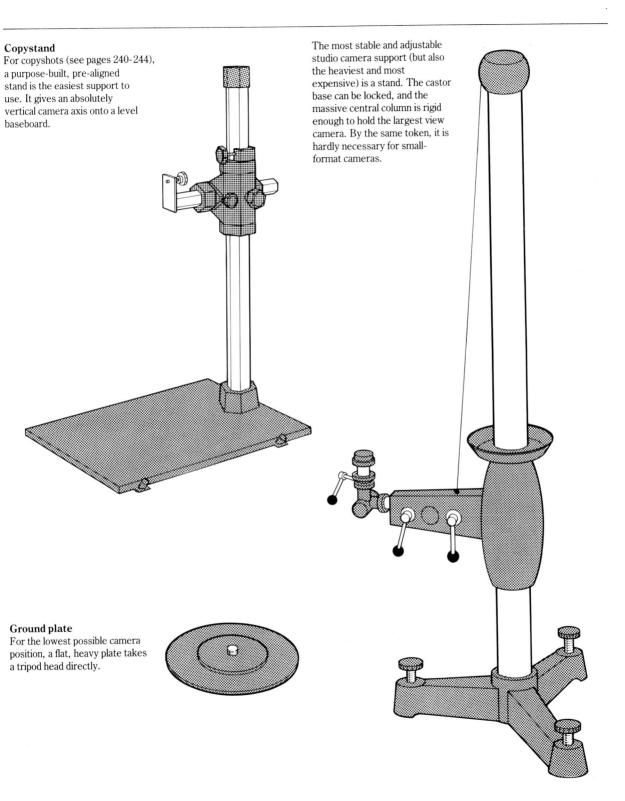

Ground plate

For the lowest possible camera position, a flat, heavy plate takes a tripod head directly.

Tripods and stands

to use a copy stand for small subjects. View cameras have the disadvantage in vertical shooting that they need a longer working distance than smaller cameras, and so need to be higher. However, their advantage is that shift movements can be used to move the view away from the legs or column of the support.

For low camera positions, some tripod legs can be spread widely, or the centre column can be turned upside down, or a horizontal extender can be used from a low position; alternatively, the tripod head can be mounted directly on to a ground plate. View cameras, because of their size, cannot be positioned as low as smaller cameras.

Tripod heads employ either a ball-joint, which gives universal positioning with one locking knob, or a pan-and-tilt system, in which the movements are divided into separate axes. Ball-joints are easy for gross changes in position, but pan-and-tilt heads allow more control.

Reversible centre column
Some models have provision for the centre column to be removed, reversed, and inserted from beneath, so that the camera can be mounted close to the floor.

High rise tripod
A high camera position calls for a tripod that has additional supporting arms. Some high rise tripods can be extended up to eight feet.

Studio tripods and stands need principally to be sturdy rather than easily portable. Rubber feet are the most generally useful, but some models have interchangeable feet, as shown at right (the spiked foot is for location work on soft ground). Spreaders of various designs lock the legs into position and increase stability.
The solidity and adjustability of the head is every bit as important as the design of the tripod itself.

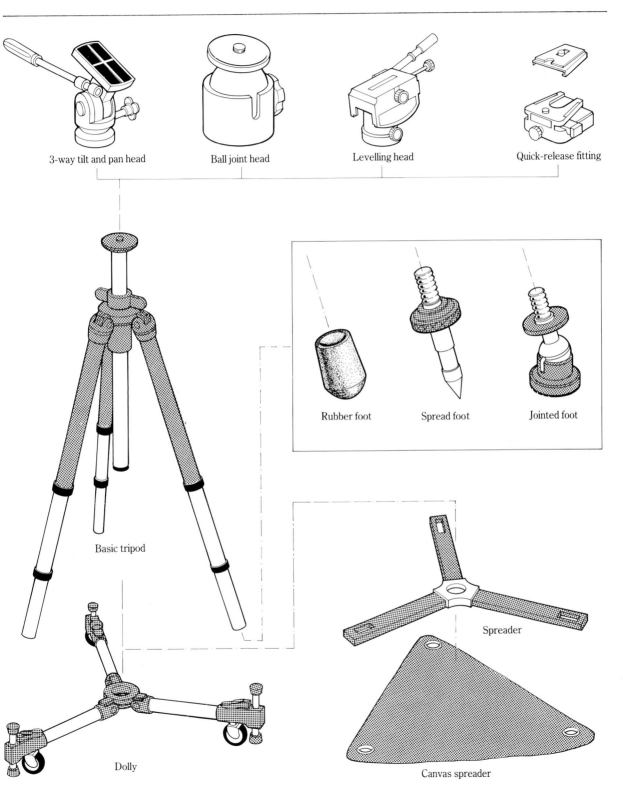

3-way tilt and pan head

Ball joint head

Levelling head

Quick-release fitting

Basic tripod

Rubber foot

Spread foot

Jointed foot

Spreader

Dolly

Canvas spreader

Storage and care of equipment

Although there are no environmental factors to affect camera equipment, regular maintenance is as important in the studio as on location. Equipment intended for studio use is often not as compact, and can be more fragile, so that in general handling and in storage, rather more care is needed.

It is usually more important that cameras and accessories are readily to hand than that they are securely packed, and there is a good case for laying everything out in one special storage area, rather than packing each separate item in its own case. In a large studio, a walk-in cupboard with adjustable shelving would be ideal; the door provides security and keeps out dust. In a one-room studio, ordinary shelving can be used, but movement and the occasional use of sprays can create deposits of dirt and dust on the exposed equipment, and either cupboards or wall-mounted boxes offer better protection. In all cases, dusting and vacuum-cleaning should be performed regularly.

A studio photographer's complement of camera equipment is likely to include more specialized items than location outfits – accessories, special-format cameras, a variety of lenses in different shutters for view cameras, and so on – and a number of these may see infrequent use. Single-piece items such as clamps and spare bellows generally need no special attention, but those with complex moving parts, particularly under tension and those containing batteries, do require some precautions if they are stored out of use for more than a few weeks. If tensioned parts remained taut, the springs will eventually weaken, so that for long storage it is better to leave the movement of a shutter and the aperture diaphragm on lenses uncocked and open. Springs can stick or become unreliable with disuse; if the item is not often used, it should be worked periodically to keep the movements free.

Remove batteries and store separately.

Release tension in sprung parts.

Seal equipment first in kitchen cling-wrap.

For extra protection also wrap in foil.

Batteries eventually leak, and in so doing can cause severe damage through corrosion. In regular use, they simply lose their charge, but long storage inside the equipment should be avoided. An additional danger is when equipment that contains batteries is tightly wrapped – if there is a leak, the release of gases may cause an explosion.

Given these precautions, there may be some value in sealing equipment that is very rarely used; for example, seal first with the clinging transparent wrap used in kitchens, including a sachet of desiccant, and then wrap inside plastic or baking foil. If the humidity inside the studio is fairly high, a perforated tin of desiccant (silica gel) in the equipment cupboard will lessen the risk of corrosion.

Place silica gel crystals in perforated tin.

A set of storage trays makes access easier.

LIGHTING EQUIPMENT

As lighting is the major photographic ingredient that studio conditions offer, the choice of lamps, fittings and accessories, is, not surprisingly, greater than in any other category of equipment. Indeed, in another area of studio hardware, such as backgrounds, settings or camera mounts, the enormous array of attachments that are available might look like pure gadgetry. The many different constructions, shape and materials on the following pages might at first glance suggest that what is on offer is duplication more than choice. In fact, the lighting quality from all this equipment is distinct, even if subtly so. The differences are in the degree of diffusion or concentration, the shape of the light as it falls, the sharpness of the shadow edges, the evenness of the lighting pattern, and other, similarly delicate qualities. Moreover, this subtle degree of choice is absolutely necessary. In outdoor location shooting, there is a rich variety of lighting conditions and, as viewers of photographs, we are used to seeing such complexity of effect. In building a lighting pattern from scratch in the studio, however, there is some risk of being unsubtle simply through having to work with light sources that can only be adapted to a limited degree. A full selection of lighting equipment expands the range of studio subjects that can be handled, and their individual treatment.

Light sources/daylight

Although the source is permanent and basically invariable, when it reaches a studio set, daylight is not constant and cannot always be predicted. Its intensity varies with the time of day and the season of the year, and also with the weather. Its colour varies with the same factors, from orange to blue. Its softness depends on how much cloud, or mist, covers the sun. For studio photography, these local variables always need watching, and can be inconvenient where a shot has to be planned in advance or is likely to take more than an hour to do.

In any particular instance, the size and position of the window is important; because it accepts light from only a small area of the sky, it modifies the variables. The colour of the light, for example, may be strongly affected on a clear, sunny day if the studio skylight faces only blue sky.

Intensity

To be efficient, a studio window should not face direct sunlight at any time of the day; this is because it is difficult to control direct sunlight when it has been filtered through a frame. For most typical daylight studio skylights, the brightest lighting conditions are at midday in summer, with a thin cloud cover (this spreads the sunlight). This is not likely to allow exposure settings better than about 1/60 of a second at f2.8 with ISO 100 films. White walls and ceiling may improve this setting by about a half to a full f stop.

Diffusion

More than anything, the window shape controls the diffusion of the light, particularly if there is no direct sun. The diffusion can be increased by covering the window with white translucent material, particularly if this is hung or mounted a little in front of the window frame, or the lighting can be made more directional by covering up part of the window to reduce its area.

Colour

For the purposes of calculating filtration, the colour of daylight, as of tungsten lighting, is measured as colour temperature. This is the temperature at which some notional material would glow if it were heated, from red-hot (around 2000K) to white-hot (about 5500K) to blue (more than 6000K). Daylight film is balanced to 5500K, and for any colour temperature lower or higher than this, colour-balancing filters can compensate, so that the light reaching the film is 'white'. The chart opposite shows how this is calculated, but a colour-temperature meter is the only precise way of judging it. Diffusing material over the window may affect it.

If the windows of a daylight studio are in such a position that direct sunlight falls for part of the day, fit either translucent blinds over them, or for closely-framed shots suspend a diffusing sheet over the subject. This pair of photographs show the tonal differences that diffusion can give.

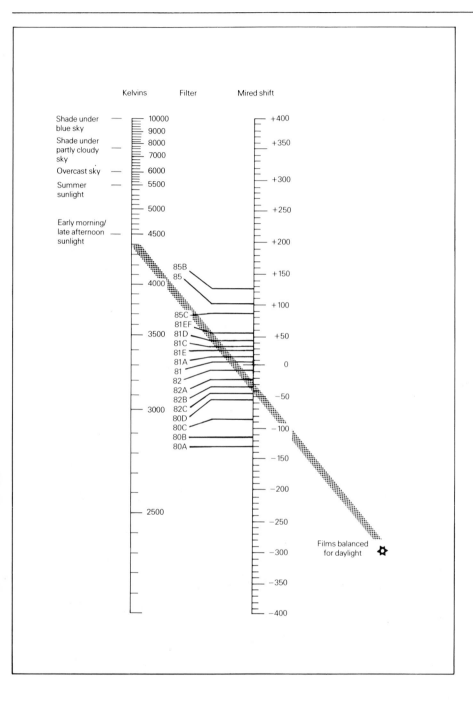

Kelvins | Filter | Mired shift

Shade under blue sky —
Shade under partly cloudy sky —
Overcast sky —
Summer sunlight —
Early morning/late afternoon sunlight —

This table of the range of daylight colour temperatures is arranged in such a way that you can read off the filter needed to balance the light. Simply draw a line from the asterisk on the right-hand side to the colour temperature of the light. The point at which it crosses the right-hand column will show the Wratten filter required.

Films balanced for daylight ✿

Light sources/flash

In most studios, electronic flash is the standard source of lighting, and has generally replaced tungsten lamps for all but specialized areas (mainly large, static sets). The principal advantages of electronic flash are that it is fast and cool, contrasting favourably with an equivalent tungsten array, which would need slow shutter speeds and produce considerable heat. Even though high-output flash produces relatively slow discharges, these rarely last longer then $\frac{1}{1000}$ or $\frac{1}{500}$ of a second, making it possible to handle most regular action, such as the limb movements of a fashion model or a splashing liquid. The low output of heat is an important advantage not simply because it makes for more pleasant working conditions in a small studio, but because it allows lamp heads to be fitted inside enclosed area lights. This type of diffusion is heavily used in still-life photography, and would be impossible with tungsten lamps. Moreover, many still-life sets are lit from a very close distance to achieve maximum diffusion from an area light, and many subjects – food for instance – would suffer damage from heat.

All of these advantages, however, depend on having a sufficient power output, and this depends on both the type of photography and the camera format. With continuous lighting, such as daylight or tungsten, exposure can be controlled by adjusting the aperture, shutter speed or the light (altering its intensity or proximity). As the aperture and lighting position also affect the appearance of the image (through the depth of field and the quality of illumination), this means in practice that changing the shutter speed is the most useful method – as long as the subject is static, it makes no difference to the style of the shot.

A flash discharge, however, is more or less instantaneous, and so should be capable of allowing the ideal aperture for a typical shot. The factors involved are: the minimum lens (less on a large view camera – f64 is normal for 8 × 10 inch format), working distance for the lights (more for a large subject such as a group of people, less for a small-scale still-life), and lighting attachments (the more diffusion or reflection, the more power needed). In all of this, film speed is not normally an area of choice, as fine-grained images are standard in most studio work.

Studio flash is rated, not by guide number (misleading and imprecise, given all the ways of modifying lighting with diffusers and reflectors), but by the electrical input. The measurements used are joules, or watt-seconds, and the most common size of power-

Whereas tungsten can record movement as a streak, flash is needed to freeze action in the studio. This close view of an old soda bottle required a stream of bubbles, provided by an air hose and filter. A single 750-joule flash discharge at an aperture of f32 isolated each individual bubble.

pack is rated at about 1000 joules. Typically, such power-packs can be linked in series to deliver a much higher total output, while single large power-packs are available up to 5000 joules. At the lower end of the scale, units of about 200 joules and 400 joules are useful for small-format cameras.

Separate power-packs offer considerable flexibility, as there is usually provision for feeding a number of flash heads from one console, and the ratio can be altered. In other words, 1000 joules could be split in several ways between a few heads: 750 joules and 250 joules, or 500 joules, 250 joules and 250 joules, or four heads, each with 250 joules. An alternative system is the type of flash unit that combines power-pack and head in one; in some ways these are neater and have fewer trailing cables, although they are bulky.

The power output needed can only be worked out by experiment, knowing the typical conditions. For example, heavily-diffused close range still-life sets would need minimum aperture settings (f22 or f32 on a 35mm camera, f45 on a 4 × 5 inch camera, f64 on 8 × 10 inch), and if an area light was typically used from two or three feet, the power needed would be in the region of 500 joules for 35mm, 1000 joules for 4 × 5 inch, and 2000 joules for 8 × 10 inch (much depends on the thickness of the diffuser and on the magnification). For a head-and-shoulders portrait lit with an umbrella, the power requirements would be in the order of 1,000 joules with a medium-speed film. Much depends on the depth of field needed and maximum aperture of the lens but this rating will be generally satisfactory for small and medium-format cameras.

If the subject is static, cumulative flash can be used – triggering the flash several times to build up the light output. Two flashes allow one extra f stop, four flashes two extra f stops, and so on, but the practical limit is soon reached because of the danger of over-heating the tube. Cumulative flash can be triggered in a darkened studio with an open shutter, or, with some risk of camera movement, by cocking the shutter each time.

Power pack and booster
Free-standing power packs are the basic workhorse of studio flash photography – they can supply several heads, and the power can usually be split in several different combinations. A booster speeds up recycling.

Strobe flash
A stroboscopic unit can deliver a rapid sequence of flashes for multiple exposures of action. The light output is relatively weak.

Slave Unit
The simplest remote trigger for several flash units is a photo-cell slave. It eliminates the need for trailing leads, and is particularly useful for integral flash units.

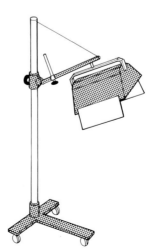

Large area lights, also known variously as windows, softlights, boxlights and 'fish-fryers', are *sometimes* manufactured as complete flash units on counter-balancing stands. The flash tubes inside are often linear.

Light sources/flash

Flash head for use with separate power pack. Low capacity heads generally have a ring-shaped flash tube; high capacity heads such as this, have coiled tubes that carry discharges of up to 5000 joules (watt/secs) in some cases.

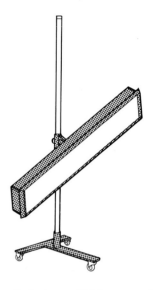

For background lighting, a trough-shaped strip light has a linear flash tube.

The alternative to a power pack and separate heads is an integral flash unit, combining capacitor, controls, flash tube and reflector.

Except at close-up scales, the power output of most ringflashes limits their use to small format cameras.

Also for small-format cameras, portable flash units are an inexpensive alternative to mains-powered units, although by no means as versatile.

Area lights are one of the greatest benefits of electronic flash. Enclosed heads such as these, fronted with translucent perspex (plexiglas), would overheat rapidly if used with tungsten lamps. Even so, cooling fans are sometimes built in to these fittings, and fluorescent lamps make cooler modelling lights than tungsten.

Light sources/tungsten

Although the practical advantages in most regular photography definitely lie with flash, tungsten has some distinct uses. What it provides is continuous light, in contrast to the instant pulse of flash, and there are two types of photography where this may be better: one is where the aim is to show the movement of something as a blur, the other is where the camera needs a very great deal of light. In both cases, the relatively long exposures dictated by tungsten lighting are used deliberately to advantage.

Recording movement as a blur, or streak photography as it is also known, is a popular convention for creating the visual impression of speed and action. Often, the blur is combined with a sharp image of the object, either by coordinating the movement with the shutter release (the object remains still for part of the exposure, then moves), or by combining flash and tungsten.

Building up the quantity of light is tungsten's more important use. In close-ups, a small aperture setting needed for maximum depth of field and a bellows extension needed for the magnification both call for more light. The practical maximum in the power output of a lamp is about 5000 joules for flash and about 2000 watts for tungsten, which frequently leaves two alternatives: several flashes fired consecutively or a long exposure with tungsten. If the equivalent flash method needs more than about four or eight pulses, tungsten is usually more convenient. On a large scale, such as the lighting of a big room or a car set, where many individual lamps are needed, simple economics favour tungsten. In all these cases, however, the subject must be motionless.

Most tungsten lighting is balanced for 3200K, as in type B film, although some are rated at 3400K – slightly bluer – for use with the less common type A film. Colour balance is, however, not a major issue with tungsten lighting, as it can be altered very simply by using light-balancing filters over the lens (80, 81, 82 and 85 series) or larger gels over lamps. Indeed the fine tuning of filters is standard practice.

Tungsten lamps are available both separately, for fitting into standard screw and bayonet sockets, and built into special holders. The light output is determined mainly by the wattage of the lamp, generally 275 watts and 500 watts in the case of photofloods, 850 watts and

For large sets requiring a great deal of illumination, tungsten lamps have a distinct advantage over flash. Because they are continuous light sources, exposure can easily be increased simply by extending the exposure time, flash illumination, by contrast, can only be added incrementally, with multiple flashes. 6,000 watts were used for this old engineering workshop.

1000 watts in the case of the smaller, more intense halogen lamps used in most professional lighting systems. The latter are filled with halogen gas, to prevent blackened deposits from the tungsten element from forming on the envelope, which is made of a heat-resistant quartz-like material. Their advantage is that they are brighter and do not lower their colour temperature with age, as photofloods do. They are, inevitably, expensive to replace and can be dangerously hot for some light fittings. Grease or dirt, even from handling them without gloves, shortens their life. Although photographic tungsten lamps are normally used in studios, any other form of incandescent lighting, including domestic and office lighting, has similar characteristics and can be used. The only main variable is colour temperature, which can be measured with a meter and compensated for with filters.

Softlight
A curved bowl, painted white, gives a broad light that is softened further by a bar covering direct light from the bare lamp.

Mini-spot
A small lensed spotlight useful in medium-sized studios. Basically, a miniature version of a luminaire.

Redspot
A relatively small, fitting that has general-purpose uses, it can be used as a direct spot, reflected off other surfaces, or used behind diffusers.

Portable system
Using two-pin tungsten halogen lamps, this lighting system is designed for handling even when hot, and is useful for major location work.

Photo flood
The simplest and least expensive photographic lamp, this is basically an uprated version of a regular domestic tungsten lamp. It is available in different sizes generally between 275-500 watts.

Luminaire
The fresnel luminaire is one of the most basic, traditional, tungsten lights. The front glass is a fresnel lens (a similar design to that in the viewing screen of most cameras) to concentrate the light into a tight beam.

Tota-light
This very small, portable lighting system has the same powerful output as most of the others, but can be fitted into small spaces. It is ideal for location kits (see page 31).

Equipment to diffuse light

With the exception of certain lamps which are specially built into their own fittings, such as Fresnel spotlights and troughs, most studio light sources are intended for use with additional fittings. These modify the quality of the light, and as a by-product, its quantity also.

There are basically three things that can be done with light in a studio: it can be diffused so that it is softer and broader, concentrated to intensify and sharpen it, and reflected off many different kinds of surface. Of the three, diffusion is probably the most important treatment, as the light begins small and intense with the source. All of the fittings shown here perform one basic function: they increase the size of the light, so that in use, the source is effectively larger. The most common materials for doing this are translucent – opal Perspex, white fabric (cotton, sailcloth or muslin, for example), gauze, frosted glass and tracing paper – while another method of diffusion is to break up the light through an open screen, such as a honeycomb or cookie.

In this studio arrangement of Thai farmer's hats, diffusing the single light avoids hard shadows, so displaying the curves clearly. The intention of the photograph was to emphasize the shape of the woven hats. In this example, an area light similar to that illustrated on page 73 (upper left) was used.

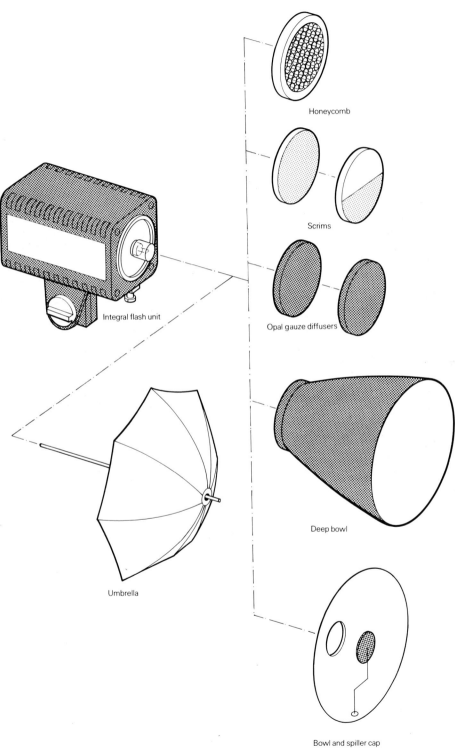

Honeycomb

Scrims

Opal gauze diffusers

Integral flash unit

Umbrella

Deep bowl

Bowl and spiller cap

Diffusing light.
The possibilities for diffusion are greater with a flash unit than with a tungsten lamp, because it is much less prone to overheating and so can be fitted with a greater variety of enclosing fittings.

Equipment to diffuse light

The quality of light from each of these fittings is slightly different, and the choice is largely a matter of taste. Generally, the more opaque the diffusing material, the more even the area of light, and the softer the shadows: opal Perspex, for instance, gives more diffusion than gauze. Some fittings, such as the boxed-in area lights, give greater control by preventing light from spilling out at the sides – they are more directional than, say, a translucent umbrella. The shape and appearance of the diffused light itself becomes important when shiny substances are being photographed, as they will be reflected – in this case, clean and simple shapes are usually preferred (see pages 96-99).

With electronic flash there are no restrictions on the choice of fitting, but tungsten sources, particularly high-intensity lamps, must be used with caution. They are not suitable for enclosed fittings and in proximity to flammable materials. They should not be used, for instance, with Perspex-fronted area lights.

In addition to softening shadows, a diffusing attachment for a studio light also has an important use with reflective objects. Under an undiffused lamp, the faces of these gold coins would be virtually illegible, but positioning an area light close and overhead give a gentle, even reflection.

Yashmak
Like its namesake, a fine veil (though gauze) for local diffusion and light reduction.

Collapsible area light
Also called a softbox or softlight by some manufacturers, this is ideal for temporary studios. The most common types either feature a metal frame that is screwed together and covered with fabric panels, or uses tensioned rods to hold taut a fabric envelope.

Trace frame
Well suited to DIY construction, a grace frame is typically about the size of a door, and can be made from wooden slats.

Cookie
Short for cucaloris, this open screen breaks up light into a dappled effect, rather as would leaves and branches on a sunny day outdoors.

Equipment to concentrate light

Although diffusion is the most common way of manipulating studio light, there are also occasions calling for the opposite – concentrating the light in a small area. This can, although not necessarily, intensify the illumination, but its principal use as a technique is to direct the light towards a specific part of the set. One consequence of this is that the light, as it falls, has a distinct shape, and this is set by the shape of the fitting.

Cones, or snoots, are the simplest method of creating a spot, and work by masking off all but a central, circular beam. The result is a soft-edged circle of light, ideal for say, giving a halo effect to hair in a portrait, but too imprecise for shaping exactly.

Barn doors are the standard means of masking the spill of light from a lamp, and can be used on other fittings, such as the area lights for broad diffusion. Typically, they give a straight shadow edge of four

sides, each adjustable. The more diffuse and distant the light source, the softer the edges of these shadows.

For the greatest control in concentrating light, and the sharpest edges to the shape of the light, some lens system is necessary. With tungsten, a Fresnel spotlight is the most common – the thin lens, composed of concentric rings, acts to focus the light. A focusing attachment that fits over an existing light housing to perform a similar function is a lens cone, as does a macro scale, the kind of illuminator used in microscopy.

Another possibility at close range is to use fibre optics. Bundles of these can be bought already prepared as flexible light channels; attached at one end to a focused light source, they provide a very efficient means of illuminating precise and otherwise inaccessible areas in small subjects. Generally, some clamp or tape is needed to hold the fibre bundle in position.

The combination of a focusing spot and a diffusing filter gives a distinctive style of lighting that has been heavily used in certain kinds of advertising photography, particularly food subjects. The result is highly atmospheric and romantic, evoking early morning or late afternoon sunlight. Introducing objects such as plants or pieces of card between the light and the subject makes the most of this technique, as does careful positioning to catch bright highlights, which flare slightly.

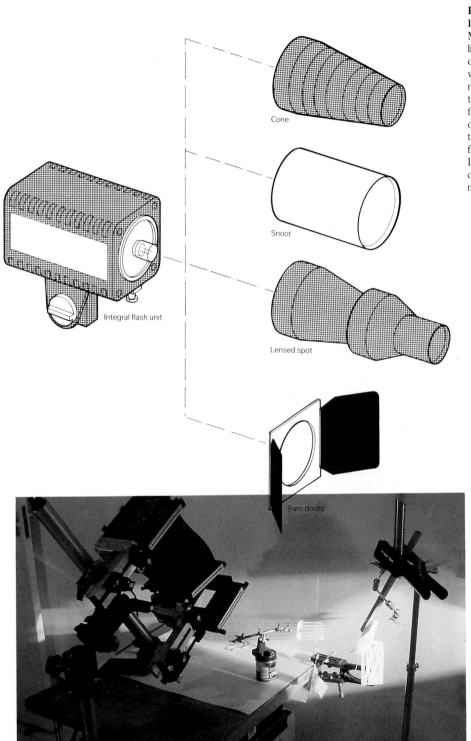

Cone

Snoot

Integral flash unit

Lensed spot

Barn doors

Equipment to concentrate light

Most methods of concentrating light enclose the lamp, which can cause the danger of over-heating with tungsten lamps. The safest method of concentration with tungsten is a purpose-built focusing spot, with its own cooling fan. Illustrated here are the attachments for electronic flash, which runs less of a risk. In both cases, a lensed spot capable of being focused is the most precise.

Photo technique using focusing spot and diffusing filter.

Equipment to reflect light

An alternative method of broadening a light source – although that is not its only use – is to reflect it. Bounced illumination is always much weaker than direct light from the same source, but if the surface used is large and white, the effect is extreme diffusion. White ceilings and walls, for example, with a lamp aimed at each, can provide virtually shadowless illumination.

In practice, more flexibility than this is usually needed, calling for a range of movable reflective surfaces. Thick card, plywood and polystyrene sheets are all suitable, depending on the size and on how rigid the reflector needs to be. Large sheets like these are known generically as flats, and to help position them, which can be tricky if they need to be tilted, they can be mounted as pivoting panels on a movable frame.

Another adaptation of a flat is a cupboard, in which sides and a top are added to contain light spill. With one or two lights placed inside, facing inwards, the effect is that of a large area light. In particular, this is a useful reflector for full-length portraits.

Umbrellas are available in a wide variety of shapes and sizes, and while some of them are made of translucent material for shooting *through* as diffusers, most are intended as reflectors. There is a variety of fabrics available, each with different reflecting properties. White is the broadest and softest in effect, silver the most concentrated.

The surface of any reflector is of vital importance. The most efficient is a mirror-finish (glass mirror or polished metal), which loses very little of the light. Mirrors are useful for redirecting light without changing its qualities, as in sets where there is insufficient space to introduce a light closely. Carefully positioned, one light source can be redirected via several mirrors to give multiple lighting.

By the same token, however, mirrors do not soften the light, and for this a less efficient reflecting surface is needed. In descending order (but increasing softness of effect) are matt and wrinkled silver surfaces, followed by glossy white and matt white. Any of these softer reflectors are especially useful for lightening shadows opposite a single main light.

To enliven the lower half of this glass head, crumpled aluminium cooking foil was placed just behind to reflect the light from the main overhead lamp.

The standard, most common studio reflector is the umbrella, combining efficiency (the shape concentrates light on the subject) with easy storage. Different materials and linings give a choice of effect – white cloth gives a gentler light than silvered. A black *outer* lining reduces the risk of lens flare.

A large panel on a moveable frame is an adaptable reflector for large sets, particularly if it is pivoted. Different materials can be taped or stapled to its surface. A hinged rolling flat, as shown on page 13, performs a similar function.

Useful on location as well as in the studio, a large white umbrella is useful for filling shadows or as a reflecting light source for full-length portraits.

Simple and stable reflectors can be made from flat sheets of various materials, cut to various sizes. Clamps and small tripods can be used to hold them in position.

Lighting supports

Often, the best position for a light is one of the most awkward for supporting it. Free positioning calls for some kind of cantilever, which creates some obvious problems with heavy lighting. The ideal lighting support system would be a zero-gravity studio, and the realistic alternatives all have problems.

The basic criteria for studio lighting support are that they can carry the weight and remain stable at the same time, that they occupy as little usable space as possible, and that they can hold lamps in the positions that the particular type of shot demands. In practice, all of these are interrelated.

Vertical tripod stands are the most common and most portable types of support, and, with the light directly on top, are mechanically efficient. However, the light position is limited, and the stands can intrude on the working space.

For still-life photography in particular, an overhead area light is highly desirable. Here, the choice lies between suspending the heavy light from a ceiling or a wall, and using a counter-balance floor stand. Some makes of area light are sufficiently bulky and heavy to be supplied with their own stands.

Ground positions are useful for back lighting translucent and transparent still-life backgrounds such as perspex, for graduated backgrounds, and for certain special effects. The alternatives are a low stand, ground plate, or a boom arm clamped low.

The weight of the lamp head is an important factor in choosing between supports. Some of the lightest are tungsten lamps, and among flash units the systems with separate power packs have lighter and smaller heads than those combining all the circuitry in each unit. The weight of fittings also varies.

The regular lighting support for most studio lamps is a tripod stand, and for the typical three-quarter top position used in many lighting arrangements it is the most convenient. High and low positions, however, increase the variety of lighting quality, and for these, more adaptable positions are needed. Although area lights are bulky, and often heavy, most light fittings can be supported quite delicately. Usually more important is the facility to place and direct lamps in any position.

Stands
A rolling castor stand (left) is possibly the easiest to move around in a studio, but a collapsible stand (centre) can be stacked when not in use. For stable high positions, a wind-up stand (right) is useful.

Counterweighted boom
A lighting boom enables one lamp to be placed in a wide variety of positions, from very high to very low, including the important position of directly overhead. The counterweight can be adjusted by sliding it along the boom, or by sliding the entire boom in its collar, or by adding or subtracting to the weight itself. Boom stands need care when being moved – they may overbalance.

A useful precaution when suspending heavy lights overhead is to attach the lamp separately to another ceiling or wall fitting with a wire or strong nylon cable.

Ceiling track
A highly adjustable system for overhead lighting is an arrangement of ceiling tracks.

Pantograph
A pantograph operated either manually or by an electric motor, gives adjustable height and keeps lighting off the floor.

Wall boom
A simple swivelling arm can be stored flat against the wall or swung out to take a single lamp.

Expanding sprung pole
This telescoping pole, padded at either end to give a firm grip, contains a powerful internal spring to lock it firmly between floor and ceiling.

Extension arm
A bar attached to a standard locking collar fits on any regular light stand, and enables a lamp to be aimed more downwards.

Low stand
For ground positions, useful for lighting backgrounds and cycloramas from beneath.

USING LIGHT

Photographers who work mainly on location and outdoors generally learn to treat light as a *condition* – something to be anticipated, assessed for its suitability, and exploited by various techniques. Essentially, a photographer must learn to make the best of any given lighting.

Moving into a studio, however, creates a fundamental change, not only in technique, but in attitude. The lighting is no longer a given condition, but one that is completely malleable. It is for the photographer to decide what lighting effect is desirable, and then to construct it.

Used intentionally, studio lighting can do much more than simply make the various parts of a set visible. It can emphasize certain aspects of a subject – the gloss on a lacquer-ware object, for example, or the texture of pastry in a food shot. It can enhance or suppress an emotional mood. It can bring visual drama and graphic surprises. Studio lighting is at the disposal of the photographer and can be used with as much imagination as possible. One of the worst faults is to allow the lighting to follow a set pattern and so dictate the rest of the photographic process. To use lighting well is to recognize its potential, to use it in the ways that suit the needs of the subject, and to treat each set as a completely fresh situation, without preconceived ideas of how such things are traditionally lit.

Exposure meters

In principle, exposure measurement in studio photography is no different to that on location. In practice, the controlled circumstances make it possible not only to measure light levels with great accuracy, but to alter the lighting to correct any problems, such as high contrast. In other words, whereas the exposure settings in typical location photography are often a compromise to make the best of the going conditions, there is never any good reason for deficiencies in a studio shot. The means are always available for calculating and adjusting the brightness of an image. In one sense this eases a potential problem area, but it also creates a greater pressure on the studio photographer to be accurate and craftsmanlike.

There are few sensible generalizations that can be made about the exposure conditions in studio photography – such a variety of imagery is possible that no single technique or rule of thumb can be used all the time. Nevertheless, there are some biases, more because they are common practice than because they have been deliberately sought after. One is the preponderance of shots which feature a single object or group against a plain, but different, background. This could be, for instance, a still life against a white Formica scoop, or a portrait against a paper background roll. Another is the

tendency of studio photographers to use the full contrast range of the film, so as to put as much 'snap' as possible into a shot. Both of these are conditions of fairly high contrast, and call for measurement of the *range* of brightness in a scene rather than just the average toll.

As a result, through-the-lens metering of the average weighted type – the most common in small-format cameras – is less useful in a studio than outside. By far the most common way of measuring exposure is directly, on the set, with an incident meter. If the meter itself is too large and bulky for making local readings in a small still-life set, the better models can be fitted with a small probe. In practice, both continuous light meters and flash meters are used in the same way, except that a flash meter is connected to the sync lead on the lamp so that the activating button triggers the flash (in darkened studio, the tungsten modelling lamp fitted inside the flash head reproduces the appearance of the flash and can be used as a basis for measurement).

A good alternative to on-set measurement is a meter probe that fits inside the camera. Although impractical for any small format, such a meter exists for a view camera. The end of the probe can be positioned

Flash meter.

Hand-held meter.

anywhere on the ground-glass screen to measure small areas of the image.

For many studio photographers, particularly those using view cameras, an important part of exposure measurement does not actually involve a meter. Instead a Polaroid back is fitted to the camera and a test made on instant film. This is now such a common practice that is probably the major use of Polaroid products in the studio. The films normally used for testing are type 55P/N which matches the exposure characteristics of Ektachrome 64, 6117 and 6118 quite closely, type 59 Polacolor to test colour balance (it is about a third of a stop faster than the above Ektachrome and is rather more contrasty), and type 52 (matches ISO 400 films or can be used with a 2⅓ smaller aperture setting to match ISO 64 Ektachrome).

Indeed, some photographers by-pass the meter reading process entirely and use one or more Polaroid tests as a means of actually working out the exposure settings. This method makes sense when a photographer is so very familiar with the arrangement of lighting and style of shot that a meter reading would be redundant. According to the way an individual photographer works, there may be several such standard situations that can be repeated easily – many portrait shots are typical of this.

There is some danger of reading too much into a Polaroid test, as the characteristics of the instant films are not exactly the same as regular camera films. Polaroid types 55P/N and 655P/N, for example, have a broad tonal range, and may misleadingly show details that may not be recorded on a transparency. Still, practice in using Polaroids, and in comparing the results, eventually teaches the limits of this testing method.

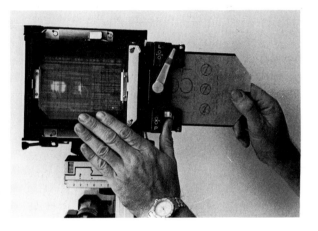

The most secure check of exposure accuracy is a Polaroid test, made with a back that attaches to the camera being used.

The choice of exposure measurement lies between regular hand-held meters, flashmeters, spot meters and the camera's own TTL meter system. Generally, the more complex or unusual the lighting arrangement, the less useful is in-camera TTL metering.

Needle-matching spotmeter. Digital display spotmeter.

Measuring exposure

Because of the potential variety of studio images, it is good working practice always to measure the range of brightness in a scene, at least until the exposure characteristics of certain kinds of shot become familiar. Just measuring the average brightness may be misleading, for if the range is high, the brighter and darker areas of the picture will simply not be recorded in any recognizable detail.

Even allowing for the many different styles of photography, there is one consistent objective in calculating the exposure: to fit the range of brightness of the important part of the picture to the exposure latitude of the film. The caveat here is the word 'important' – in the bottom picture on page 88, for example, the dark background is intended to be a dense black, and the white foreground in the top picture on page 87 is deliberately too bright to show any detail; in cases like these, the detail and colour of only certain parts of the picture are wanted on film.

The exposure latitude of films varies more according to their type than to individual makes, and is an indication of the range of brightness that they can record in one single image. Most transparency films can cover about five f stops without the highlight washing out and the shadows blocking up, although fast films have a more compressed range. Most negative films, on the other hand, can cover about seven f stops. The exact latitude of any particular film is, however, best measured by individual tests in the studio – shooting tests that are carefully measured to an accuracy of one third of a stop and then closely examining the processed results.

If the measured range of brightness in a set (see the specific examples on the next four pages) is less than the latitude of the film, then the only issue is to find the setting that best suits the subject and the photographer's taste. This is usually a matter as straightforward as averaging the meter readings from the brightest and darkest parts, or even of simply following a single incident reading from the main subject.

However, there are good reasons for pushing the brightness range in a set up to the limits of a film. It makes for a richer, more vibrant image, and in still-life photography, for instance, there is often a need to generate as much visual interest as possible. Doing this calls for a precise matching of the lighting and the film's latitude. It is important not to be fooled by those highlights and dark areas that *should* fall off the ends of the brightness range – specular reflections and pure back-lighting are better if they are completely white, for example. Confine the range measurements to the essential parts of the picture.

On location, if the brightness range in a scene exceeds the ability of the film to cope with it, the usual solution is simply to compromise, holding the highlights within the exposure range and allowing the shadows to go black. In the studio, however, the lighting is always controllable, and the usual technique is to shorten the

Making local direct readings
These are rather more straightforward than incident readings, being more obvious.
1. With a spot meter and continuous (that is, tungsten or daylight) illumination, measure the brightest and the darkest areas, and also what seems to be an average mid-tone in the key area of the set. These three figures define the absolute brightness range and show how near to the middle of this range normal tones lie.
2. With a viewing-screen probe, make a similar set of readings. The more readings, the better.

Shadow

Average

Highlight

Using an incident probe

Because studio lighting tends to be fairly consistent (the output of individual lamps is fixed), incident readings are among the most convenient, given certain precautions. The small white dome of the meter for its probe has the practical effect of representing the reflectivity of a typical subject. As a result, what is measured is the lighting rather than the particular characteristics of objects and surfaces.

Average incident reading.

1. For a quick, average, reading, hold the probe at the position of the main subject and point the dome towards the camera. For uncomplicated lighting arrangements and familiar sets, this is an adequate measurement (top right).
2. When the lighting arrangement seems to have the potential for high contrast, make two other readings in addition to that aimed towards the camera. Take an incident highlight reading in the brightest part of the set, aiming the dome towards the light (centre right), and take an incident shadow reading in the darkest part of the set, by aiming the dome towards the camera while shading it from direct illumination. A typical high-contrast situation is shown in the top photograph on page 89, where a forward-facing main light creates highlights and foreground shadows. Note that the brightness range measured by this method makes no allowance for unusually light or dark surfaces within the set. If there are such, a direct meter reading may be better.

Low incident reading.

High incident reading.

range by lightening the shadow areas. This is easily done by extra, diffuse lighting or by introducing reflectors. An additional control often used to make small adjustments is to push or pull the processing of the film by half a stop. If allowance is made for this at the time of shooting, by increasing or decreasing the exposure by half a stop, the effect is just a change in contrast – push-processing increases contrast slightly (that is, shortens the latitude), pull-processing decreases contrast slightly (that is, extends the latitude).

Sample exposure conditions

The annotated photographs that follow are examples of different types of studio set, seen from the point of view of exposure. Each in its own way is fairly typical of an area of studio photography, although it is not necessarily a good idea to follow rote procedures. These examples are intended to show a range of working methods rather than to be imitated exactly.

The values given in these examples are relative; although they are, in fact, exposure values (abbreviated to EV) based on a film speed of ISO 64, this is less important information on these pages than the brightness range and the identification of the important tones in the pictures.

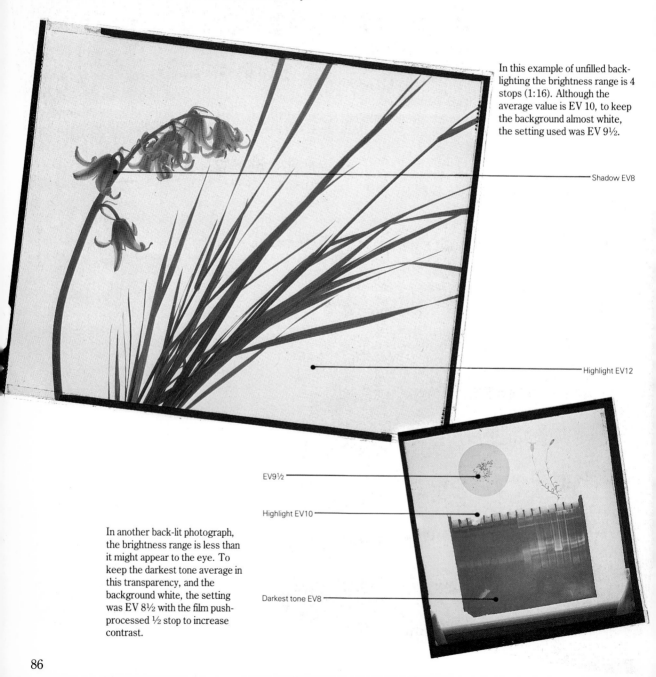

In this example of unfilled back-lighting the brightness range is 4 stops (1:16). Although the average value is EV 10, to keep the background almost white, the setting used was EV 9½.

Shadow EV8

Highlight EV12

EV9½

Highlight EV10

In another back-lit photograph, the brightness range is less than it might appear to the eye. To keep the darkest tone average in this transparency, and the background white, the setting was EV 8½ with the film push-processed ½ stop to increase contrast.

Darkest tone EV8

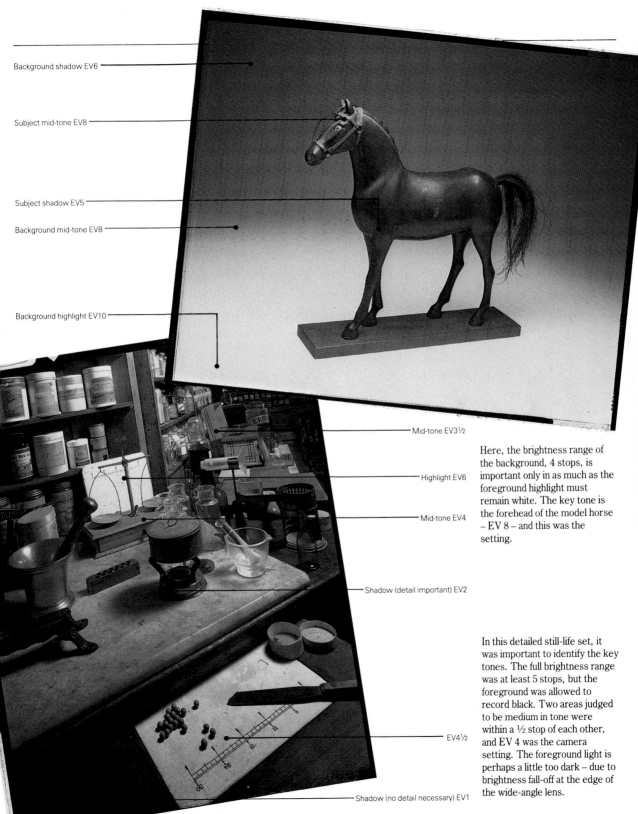

Background shadow EV6

Subject mid-tone EV8

Subject shadow EV5

Background mid-tone EV8

Background highlight EV10

Mid-tone EV3½

Highlight EV6

Mid-tone EV4

Shadow (detail important) EV2

EV4½

Shadow (no detail necessary) EV1

Here, the brightness range of the background, 4 stops, is important only in as much as the foreground highlight must remain white. The key tone is the forehead of the model horse – EV 8 – and this was the setting.

In this detailed still-life set, it was important to identify the key tones. The full brightness range was at least 5 stops, but the foreground was allowed to record black. Two areas judged to be medium in tone were within a ½ stop of each other, and EV 4 was the camera setting. The foreground light is perhaps a little too dark – due to brightness fall-off at the edge of the wide-angle lens.

Sample exposure conditions

Here, the black velvet background was intended to reproduce as a pure black, and so needed to be less than 5 stops below the highlight on transparency film. The key tone here was the highlight, to be recorded so as to show full detail – that is, 1½ stops lighter than the setting (EV6½).

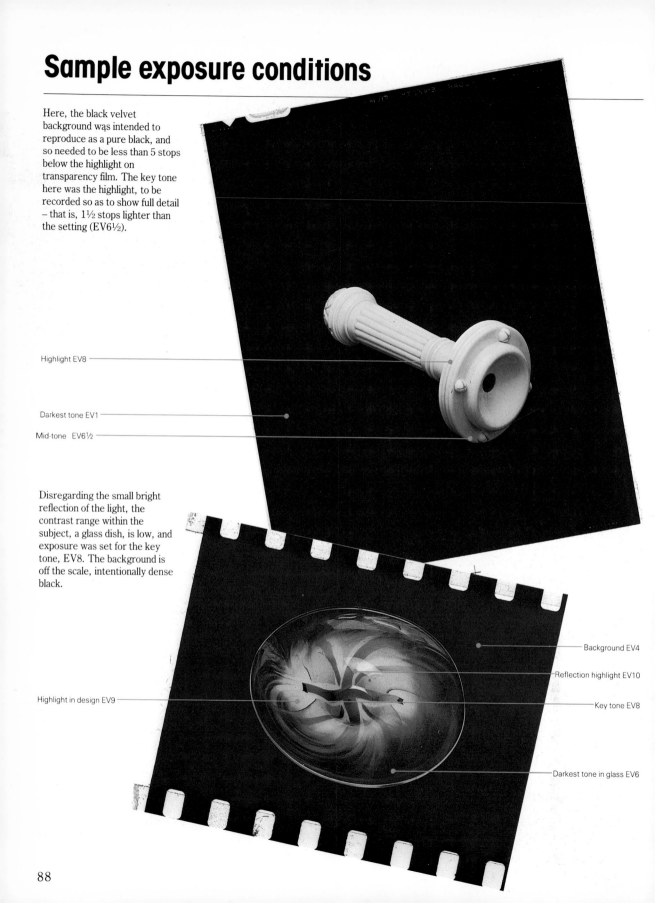

Highlight EV8

Darkest tone EV1

Mid-tone EV6½

Disregarding the small bright reflection of the light, the contrast range within the subject, a glass dish, is low, and exposure was set for the key tone, EV8. The background is off the scale, intentionally dense black.

Background EV4

Reflection highlight EV10

Highlight in design EV9

Key tone EV8

Darkest tone in glass EV6

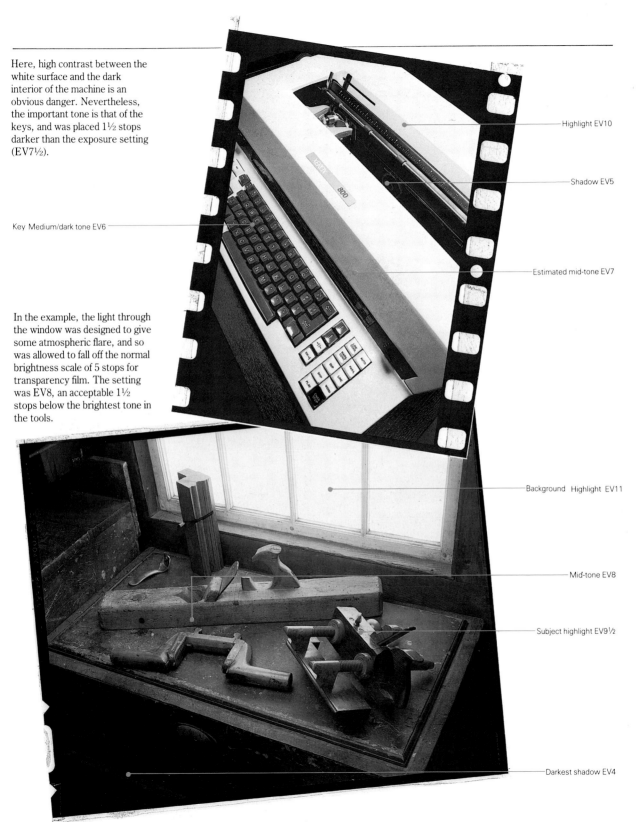

Here, high contrast between the white surface and the dark interior of the machine is an obvious danger. Nevertheless, the important tone is that of the keys, and was placed 1½ stops darker than the exposure setting (EV7½).

Key Medium/dark tone EV6

Highlight EV10

Shadow EV5

Estimated mid-tone EV7

In the example, the light through the window was designed to give some atmospheric flare, and so was allowed to fall off the normal brightness scale of 5 stops for transparency film. The setting was EV8, an acceptable 1½ stops below the brightest tone in the tools.

Background Highlight EV11

Mid-tone EV8

Subject highlight EV9½

Darkest shadow EV4

89

Emphasizing shape

Being so controllable in a studio, light can be made to perform a number of very specific functions. Used skilfully, its potential is much greater than just a way of making the various parts of a set visible, and one of its most basic uses is to enhance some of the physical qualities of a subject.

There are several ways of categorizing the visual characteristics of an object, but at its simplest, it has the properties of shape, form, weight, texture, and the colour. One of the skills of studio photography, and needed most in still-life work, is to be able to identify which of these characteristics is essential to the nature of a subject and should be promoted. There are no rules or guidelines that can help in this, and it is an individual decision influenced partly by what a photographer may think will be interesting, and partly by what he thinks he is capable of showing.

Of the several ways of revealing these visual characteristics, the quality of the lighting is probably the most effective and the most subtle, and it pays to be at least familiar with its techniques. Shape is one of the most obvious and immediate qualities of any object, and lighting, is ideally suited – displaying it principally by means of contrast.

Contrast is, in fact, the key to displacing shape, which is essentially a matter of an outline against a background. Making shape dominate in a picture means suppressing, other, competing qualities, such as texture. It means, therefore, simplifying the image, and this can be possible with lighting alone. At either extreme of lighting – intensely bright or very dark – detail disappears, and the variety of tone is reduced.

So, shading off the background so that it remains unlit, or else concentrating so much light on it that it appears a featureless white are both efficient alternatives for enhancing an outline. A light object against a dark background is one obvious approach, as is a dark object silhouetted against white. In either case, for an extreme effect, the lighting must be directed onto one or the other parts of the set, but not both. Barn doors, and other directional fittings are useful for this, while purer back-lighting, with a broad area light directed frontally towards the camera, will create a silhouette of any object, even transparent glass.

Another method is to treat just the edges of the object, either lighting them or darkening them. Spot-lighting from behind will do this to any surface that has some definite texture, while an area light from slightly behind will give edge reflections on a shiny surface. Conversely, black masking just out of the picture frame will help to define the edge of glass by darkening it.

In this photograph of a coiled strip of film, the outline provides the mild illusion. To this end, three-dimensional information needed to be suppressed, and the most direct method was pure back-lighting.

With dark objects that have at least some reflective qualities, lighting just the edge can reveal outline very effectively. To show a camera without the details that would identify the make, the lighting arrangement here was a broad area light above and behind the subject, which was set against black by means of a suspended black velvet drape. Precise masking for flare (see pages 106-107) was essential.

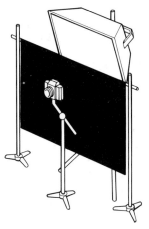

A plain contrasting background is the least complicated of all methods of emphasizing shape, here a mainly white murex shell was suspended vertically over a sheet of black velvet (on a thin rod hidden from the camera's view by the bulk of the shell). The lighting was normal – a diffused light at one side, faced by a white reflecting card on the other – and the effect, visually, is the reverse of the picture of the film strip opposite.

Showing form and weight

Shape in a picture is a two-dimensional property; projected into three dimensions it becomes form, and closely related to this is weight. Both form and weight are matters of the solidity of materials – their massiveness or delicacy of structure. Conveying this adequately in a single image is not quite as straightforward as dealing with shape, as the extra dimension is missing in a picture. Nevertheless, lighting can go a long way towards giving a sense of these structural qualities.

The methods of stressing shape just described dwelt on a kind of abstraction, simplifying the tones and flattening the scene so that it actually appears two-dimensional. Form, however, demands an opposite technique, using the light to show depth. The fuller the range of tones, the better, and particularly if they are smoothly graduated. In other words, conservative well-modulated lighting tends to give the clearest and least complicated rendering of form. For example, a single, well-diffused light placed at right angles to the view gives a tonal range, from light to dark. Moreover, the softness of the shadow edges from a broad light source helps to keep things simple (a hard light source tends to produce sharp shadow edges which more often then not break up the unity of form).

Both top-lighting and side-lighting, therefore, are especially suitable. In addition, top-lighting has a psychological effect of creating the impression of weight. This is largely due to the dense shadows that form underneath a top-lit object and the grading of tone, from light above to dark below. If the background is then shaded in the opposite direction, from light below to dark above (a straightforward effect with an overhead light and a smoothly receding background), this effect is graphically enhanced .

A broad, simple reflection can be one of the most effective ways of showing the shape of an object. Here, a rectangular 'window' of light, positioned upright to one side, is sufficiently regular that its distorted reflection shows the exact curves of the bottle and glass.

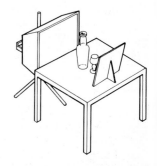

Lighting from above gives an expected distribution of tones – bright above, shadowed beneath – and appears to most people as a natural lighting direction. As a result, it is an easy matter to judge the volume and shape of any object placed in such standard, diffused illumination. The gentle variation of tone gives a full impression of weight and solidity, here emphasized by the dark reflections underneath, on black perspex.

As in the photograph of the Cowrie shell, diffused toplighting is used for this picture of a lily as a natural direction that gives an expected distribution of highlight and shadow. However, to emphasize the depth of the view – and so its three-dimensionality – the graduated tones of a white formica scoop are visible behind.

Revealing texture

The fine structure of a surface is its texture – essentially a tactile quality. At its roughest, as in the skin of a pineapple, for example, texture begins to merge with the shape of an object; at the other end of the scale, the smoothest textures of all have a highly reflective gloss. In between is an infinite variety – the weave of a textile, wrinkled skin, the pitted surface of an old iron pan, the grain of wood, and so on – each supplying visual information about the way an object feels to the touch.

As a general principle, lighting reveals texture best when it skims the surface at a low angle, creating a distinct pattern of small shadows. These shadows will be less distinct with a broad light than with a small, hard spot light.

1

Emphasizing texture is largely a matter of selecting an appropriate angle of lighting. In general, the more acute, the more the texture is revealed, but this must also take into account the degree of relief in the object, and the diffusion of the light. There are, naturally, no set rules, and result must be governed by personal taste.

An acute angle, in the top example about 20°, will bring out even shallow relief with a moderately diffused light source. The surface here is Victorian glazed tiling. A more extreme angle gives a more dramatic effect, with deep shadows, as in the close-up, at right, of a Chinese carving. Here the light is virtually at right angles, but is well diffused. Reflective surfaces, such as these axe-heads, reveal their textures best with angled reflected light, as illustrated in the diagram.

2

1. Acute angle.

2. Extreme angle.

3. Moderate angle, reflected.

Controlling reflections

Shiny surfaces need more care than usual in a studio. They are not necessarily problem objects, but they do possess two qualities that have an important bearing on the lighting and construction of the set: they act like mirrors, to pick up images of their surroundings, which can include the camera and other elements outside the set, and they have a tendency to create high contrast by picking up reflections of lights.

Brass, polished metal, and lacquerware are typical of objects that are inherently reflective, while liquids can turn normally matt surfaces shiny. The basic principle of photographing such surfaces is that the reflection itself is a part of the subject. In other words, the surroundings that will be reflected in the surface must be anticipated and controlled. Fortunately in a studio this control is possible.

If the surface is simple, such as flat, it will reflect only a limited part of its surroundings, and this can be controlled, either by altering the angle of the object, or by rearranging the surroundings. If, however, the surface is convex or concave, such as the bowl of spoon or the glass of an electric light bulb, the reflection is likely to cover a wide angle, and this will probably include the camera and nearby photographic equipment, none of which is likely to be wanted in the picture. The light source will also probably be included.

In dealing with a shiny surface that has any complexity of shape, the classic lighting response is to acknowledge that the light will appear in reflection, and to shape and diffuse the lamp so that it becomes an

Step 1 Having set up the camera and subject to calculate the size of the picture area and lens-to-subject distance, cut a sheet of tracing paper to size and roll it as shown.

Step 2 Tape the rolled tracing paper into its cone-like shape, and trim both ends so that it will stand vertically.

Step 3 Fit the cone of paper under the camera so that the smaller end just encircles the lens and the larger base end of the cone just rests on the surface to be photographed. Some slight adjustment may be necessary for a perfect fit. It is easier to raise the camera or the tripod's centre column and lower it into the cone than to try and buckle the paper to squeeze it into position.

The several planes of this brightly-plated pair of scissors would normally catch some of the studio area and lights. Surrounded by a light-tent, however, they appear smooth and unfussy. One single lamp was used, aimed at the outside of the light-tent from the upper part of this picture. The background is black velvet.

unobtrusive part of the picture. Even with a curved shiny surface, if the light is large enough and smooth in texture, its reflection will envelope the object. For this reason, area lights and large reflections are useful sources, with the illumination either even across the area, or graduated. However, with strongly convex and concave surfaces, more drastic measures are usually necessary, in the form of surrounding the object or the set with a continuous, smooth shape of diffusing material (a sheet of large tracing paper rolled into a cone, for example, with the camera lens positioned at one end). Lights are then aimed towards this 'light tent' from outside. The camera's reflection is then the one remaining problem, but can be solved, at least partly by cutting a hole in the light tent just large enough for the lens. If it is possible to position the object in such a way

For highly reflective surfaces such as these proof coins, one of the most straightforward approaches is to treat them as mirrors and angle the lamp and camera so that the light is fully reflected in each. For this, an area light, acting like a perfectly diffuse window, is ideal. The reflected light levels in a shot like this are extremely high, so that any non-reflecting background would appear very dark. To avoid this, perspex was used here, itself reflecting the light.

Controlling reflections

In this photograph of a golden Cowrie, the lighting was arranged so as to retain some sense of the shiny surface, an important quality of the object. Dulling techniques such as using dulling spray or dabbing with plasticine would have given a misleading impression, and were rejected.

An adaptation of the light-tent method shown on page 96 was used, in which the basic overhead area light was modified by a sheet of tracing paper that was taped into a curved shape to coincide with the curve of the shell. This gave even and largely inconspicuous lighting, at the same time leaving an edge at the top to show the degree of shininess.

that a less reflective part faces forward, even the reflection of the lens can be hidden.

Using as broad a light source as possible, the method which was just described on the last two pages is the classic treatment for reflective surfaces, and works on the principle of simplifying the reflection. In a scene, it is a way of countering the shininess by making it less obvious, and although this helps the clarity of the picture, it also goes some way towards concealing the surface characteristics of the subject.

Another approach is to use the lighting to show just how reflective the surface is, deliberately letting the edge of the reflected light source fall across the subject. An area light is still the most useful, but instead of trying to flood the surface with reflective light, the shape of the source is made prominent. Side-lighting a bottle of wine with a rectangular diffused light, for

example, produces a graphic two-toned effect of quite high contrast, with the edge of the light following the vertical contours. A variation of this technique is to tape vertical and horizontal slats across the area of light to give it the appearance of a natural window. Another adaptation is to re-shape the area light so that it reinforces the outline of an object – a useful technique with objects that have strong or unusual shapes. One method is to use masking tape along the edges of a rectangular area light; another is to cut and position diffusing material such as tracing paper.

The light source included in the reflection inevitably creates conditions of high contrast, and there is every possibility of this being too great for the film to handle adequately. In a traditional still-life set-piece, it may be necessary to increase the shadow fill or secondary illumination in order to narrow the difference in brightness, and the standard rendering of the brighter parts of the reflection would be just noticeable density. There are some situations where the only way of recording both the reflective and matt surfaces in a set is to introduce, from another direction, a second light that is almost as powerful as the main, reflected light. On other occasions, however, the extreme contrast can be used to make strong graphic composition, deliberately allowing the background or surroundings to record as a dense black.

Objects with multiple facets are usually best treated by varying the reflection of each surface, otherwise their shape is likely to be obscured by the very evenness of a consistent tone. For example, a large area light can provide the brightest tone for the planes that face one direction, a silver card can be positioned to reflect in another surface, a white card for another direction, and so on. Such a lighting arrangement is usually difficult to construct.

Finally, there are ways of killing reflection completely, although they are somewhat drastic in their visual effect. One is to use dulling spray, a commercially available product that deposits a greasy layer that effectively creates a matt surface. It has some practical problems, namely that the texture of the spray may be visible in a close-up shot and that it smears easily, but a more severe aesthetic one: it changes the nature of the surface completely. Another method is to polarize the light, using large polarizing sheets over the lamps and a polarizing filter over the lens. This works most effectively with flat reflective surfaces, and it is the angle of the reflected light that determines the effect.

Several distinct shiny planes on a metal sculpture that needed to be photographed with a background were each treated separately. A single area light was reflected in the upward facing surfaces, the front and side surfaces reflected white cards, while dulling spray was used on the lower part of the curved surface to blend the edge of the reflection.

Lighting transparent objects

Just as reflective objects display part of their surroundings, transparent ones show their background. In both cases a photograph always takes in more than just the object itself. An extra complication in the case of transparent objects is that their surfaces are often reflective as well.

The classic treatment for a transparent object is similar in principle to that for a reflective surface – a flood of light, and allowing the structural details to define themselves as shadows and edges. With a transparent object, this means back-lighting, or trans-illumination as it is sometimes known; a broad, even light source forms the background, and the object is placed in front. The more complex the shape of the glass, or whatever the subject is, the better defined it will be, because reflection will cause the edges and thicker parts to record the outline against the bright background.

Practically, trans-illumination can be created within the studio either by using an area light directed full-face towards the camera, or by reflecting light from a white background. If the object is small enough and suitable to be laid flat, the bright background can be placed underneath, pointing upwards towards a vertically mounted camera (the object can be protected from heat by placing it on a transparent glass or plastic sheet between the light and the camera). With standing objects, such as a drinking glass or a decanter, one potential problem is the horizontal surface, which can interfere with the trans-illumination; one solution to this is to choose a reflecting surface such as glass or smooth plastic and to use a low, almost horizontal, camera position so that the foreground occupies a very thin area at the bottom of the picture and carries the

A transparent glass filled with liquid is the classic subject for full back-lighting, here achieved by aiming one light through a sheet of opal perspex. The lamp was placed well behind so that the illumination would be even across the background. Because strongly curved transparent edges tend to disappear by blending into the back-lighting, they were masked by black card, as shown above. This defined the edges in black (reflections of the cards), and had the extra function of reducing lens flare.

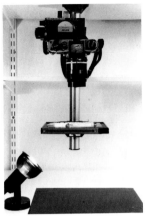

Darkfield lighting is used here at a Macro scale to highlight the edges of a string of seed-pearls and make them stand out prominently against a black background. A single small spot gives illumination from beneath and slightly to one side of a thin sheet of glass used as a support for the pearls there is some danger of lens flare with an arrangement such as this, and the effect must be checked carefully in the viewfinder.

strongest reflection of the background light (as the photograph opposite shows, such a foreground surface can seem to blend almost perfectly with the bright background).

The structure and edges of a transparent object photographed in this way stand out clearly, mainly because they are reflecting the dark surroundings at the side. This gives the photographer an important control, because the size of the illuminating light source can be varied. The edges of the object will appear darker and thicker if the light covers just the area of the picture and no more, and if the surroundings are pitch black. This can be achieved by placing the light further back or by using masking tape or black paper to reduce the area, and also by flagging off the sides with black card or cloth. Reducing the area of the trans-illumination has the additional advantage of removing flare problems.

The success of trans-illumination is due to its simplicity of tone – the light appears more as a neutral setting rather than as an indentifiable light source. An opposite treatment that can work with some transparent objects is to make the background black. This method, known as darkfield lighting at macro scales, involves directing quite thin beams of light towards the edges of the object to the sides (and slightly behind).

The effect is almost exactly the reverse of trans-illumination, for it is the edges and structural details that refract and reflect the light, while the bulk of the object appears black. To confine the illumination to the edges, the light or lights must be efficiently flagged with card or barn doors, and particular care needs to be taken to protect both the background and the lens from light spills (this would weaken the density of the black and introduce a risk of flare). Black velvet absorbs light very efficiently, and is one of the most useful ways of creating a black background.

These two basic techniques are both ways of treating isolated objects. Dealing with transparent subjects in the context of a full set, however, is more difficult, as both trans-illumination and darkfield illumination are rather extreme for regular still-life compositions. Usually, the rendering of glass and similar subjects suffers, but there are a few partial solutions. One is to place a reflective backing behind the glass, so that its centre does not appear 'empty'. For this to appear acceptable, however, fairly strong refraction is necessary to blend the shape of the backing reflector into that of the glass, and it is a technique that is usually confined to containers filled with liquids, as the photograph opposite shows. In many ways, it is an extreme technique, and there is always a danger that it will appear contrived.

On a pale background, one way of helping to define the shape of the glass is to place dark objects close to its edges. At the sides of the set, black cards or paper can also be positioned so that their reflections are picked up in the glass.

Balancing colour

In location photography, neutrality of colour is generally not much of an issue, with the exception of strong blue reflections from a clear sky into areas of shadow. On the whole, the considerable variations in colour temperature from low sun to heavy clouds are accepted as natural conditions.

Controlled lighting in the studio, however, is *expected* to be neutral, simply because it is light that is being provided intentionally. The effect of this, paradoxically, is that *small* colour cast appears as the most glaring fault while strongly coloured lighting is assumed to be deliberate. Consequently, in normal studio photography considerable effort is usually placed against balancing colours. The neutral and familiar elements in a set (mid-greys and flesh tones, for example) are the most susceptible to noticeable colour cast.

Practically, there are two scales of colour variation – colour temperature and hue. Colour temperature is principally a matter of the light source while hue can be affected by a variety of things, from the dye response of the film to reflection from studio surroundings.

The colour temperature of studio lighting is usually known to within fairly close tolerancy, and only daylight suffers from major variations. The general practice is to make a broad match between the film type and the light source, and then to refine this precisely with colour-balancing filters or, occasionally, coloured gels over the light (filters offer measured control). So, daylight film is the natural selection for daylight and flash, type B tungsten film for 3200K photographic tungsten lamps.

Daylight colour temperature can vary in a studio from around 4000K to around 8000K, depending upon the location. Electronic flash usually varies insignificantly, and most are within 100 degrees of 5500K although a new flash tube may appear a little 'cold' at around 5600K or 5700K. Tungsten lamps can vary a little more, losing colour temperature and appearing slightly 'warmer' with age, as the burnt filament redeposits on the inside of the glass envelope. Halogen lamps remain

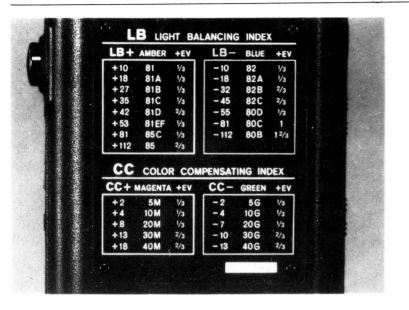

LB LIGHT BALANCING INDEX					
LB+ AMBER		+EV	**LB−** BLUE		+EV
+10	81	1/3	−10	82	1/3
+18	81A	1/3	−18	82A	1/3
+27	81B	1/3	−32	82B	2/3
+35	81C	1/3	−45	82C	2/3
+42	81D	2/3	−55	80D	1/3
+53	81EF	1/3	−81	80C	1
+81	85C	1/3	−112	80B	1 2/3
+112	85	2/3			

CC COLOR COMPENSATING INDEX					
CC+ MAGENTA		+EV	**CC−** GREEN		+EV
+2	5M	1/3	−2	5G	1/3
+4	10M	1/3	−4	10G	1/3
+8	20M	1/3	−7	20G	1/3
+13	30M	2/3	−10	30G	2/3
+18	40M	2/3	−13	40G	2/3

A colour measuring meter is the most reliable means of checking accuracy, and can even eliminate the time and expense of colour tests. The best design of meter uses three filtered photocells to measure, simultaneously, the ratio of three colours of a light source. A model such as the one shown here can display colour temperatures (in Kelvins), colour compensation, and light balancing, and at the same time recommend the filters necessary. The indexes shown at left are in mireds, and shown alongside the Kodak Wratten filter number and the necessary increase in exposure.

more consistent.

A colour-temperature meter is an intermediate guide to selecting the right filter, but ultimately a film test is necessary. As this testing procedure is also needed to correct hues, most photographers establish their own procedure. As neutral and familiar colours are the easiest to judge, one useful test is the photographer's own hand against a graduated white scoop; the mid-tones of the graduated edge reveal minute differences to a trained eye. Another useful addition is a colour chart such as the Macbeth ,colour checker or Kodak separation guide, and a neutral tone, such as a Kodak separation grey scale or 18 per cent grey card. Checking and filter selection procedures are described on the following pages.

Balancing colour

The colour test just described, for checking colour temperature balance, will also reveal any differences in hue, and as this can be in any direction – toward cyan, yellow, magenta, red, blue or green – it may not be easy at first to decide exactly where the colour cast lies. Often, a combination of light-balancing and colour-correction filters may be needed.

Using a filter for shooting is standard practice in the studio, and should not be thought of as an unusual procedure needed to overcome some deficiency in photographic techique. Nevertheless, the less filtration needed, the better, as even thin gels can sometimes affect image quality through being scratched or by catching reflection. Certainly, the fewer individual gels, the better, as several surfaces in the light path reduce transmission and can also degrade colour saturation and

contrast. Consequently, it is sound working practice to eliminate colour cast at source, wherever possible.

One source of colour cast is the studio itself, and in particular the walls and ceilings. Black, white or neutral grey are the only recommended paints, and a test, by photographing a swatch, is very important before committing the entire studio to a coat of paint. The colour layers in films do not respond in exactly the same way as the human eye, and a visually neutral colour may have a noticeable cast in a photograph. Some paint manufacturers make industry-approved netural colours, and these are worth investigating.

Another likely source of colour cast is any diffusing or reflecting light fitting, and the same precautions apply as for paint. Always run a test before installing translucent faces to area lights, or you will find that the

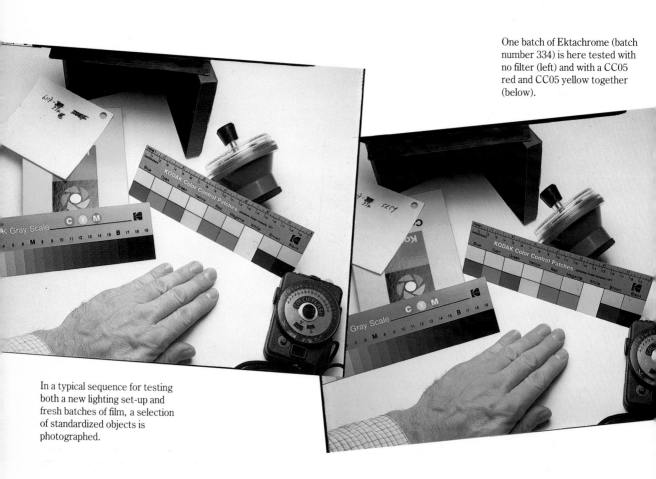

One batch of Ektachrome (batch number 334) is here tested with no filter (left) and with a CC05 red and CC05 yellow together (below).

In a typical sequence for testing both a new lighting set-up and fresh batches of film, a selection of standardized objects is photographed.

alternative will be permanent filtration.

Lenses also vary in their colour transmission, particularly if lenses from different manufacturers are used. Careful testing will show up any differences.

Finally, different batches of even the same make of film may vary. With professional emulsions, the filter correction information is included in the pack, but this should always be treated as a starting point for tests.

Having neutralized the conditions as far as possible, run a colour test as recommended on page 103, with only the filter indicated for the film batch, using transparency film (negative film can only be properly judged when printed, and this introduces far too many extra variables). Assess the results on a light box that is known to be colour-corrected, with as little ambient lighting as possible (a darkened room is best, even if this does strain the eyes a little.

Lay the transparency on the light box and take a set of weak colour-correction and light-balancing filters. Start by deciding the direction of the colour cast, and select the opposite colours from the filter set. There may well be some confusion between a colour temperature bias and a hue bias, and this can only be solved by experiment, laying different filters over the transparency. Do this until the filter or filters have been selected that neutralize the colour cast, but use no more than two.

The actual strength of filter, however, may not be exactly the same as those selected on the light box. Depending upon the photographer's eye, the filters needed for future use are likely to be about half the strength of those that appear right on the light box.

Also with a CC05 red and CC05 yellow filter pack, a second batch of film (number 659) appears slightly more cyan.

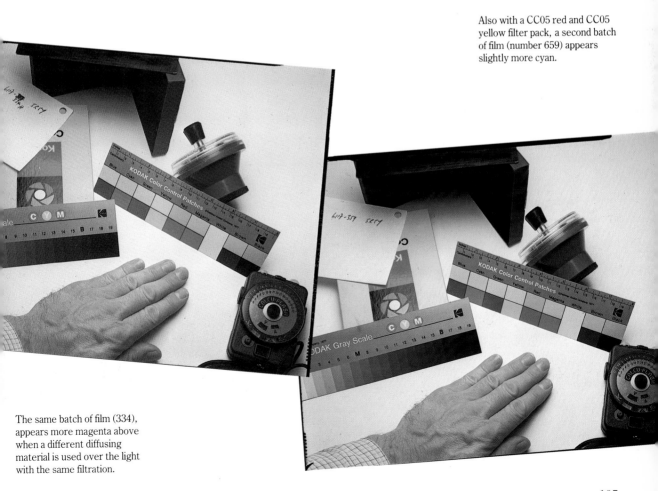

The same batch of film (334), appears more magenta above when a different diffusing material is used over the light with the same filtration.

Eliminating flare

While there are occasional shots in which flare adds a desirable visual quality, most studio photography can well do without it. It requires special precautions in the studio because lights are so often used close to the edge of the picture.

Technically, flare is non-image-forming light – that is, any light reaching the back of the camera that does not help to record the picture. There are a number of possible causes, of which the most common by far is light spill – light shining directly onto the front element of the camera lens. The effect is an apparent fogging or streaking of the picture, or a pattern of shapes that correspond to the multi-angled aperture, and its severity is compounded by dirt or grease on the lens, by buckled gelatin filters and by too many filter surfaces.

The basic cure, nevertheless, is to make sure that no direct light falls directly onto the lens, and there are two practical methods of doing this. One is to fit a lens shade onto the camera, the other is to fit a flag or barn door to the light. There is no harm in doing both. Lens shades in studios do not need to be unobtrusive and robust, and so can be more efficient than the normal circular design. Ideally, a lens shade should mask the surroundings down to the exact picture area, and the best models are adjustable to do exactly this. For fixed-bodied cameras, a bellows shade on a fixed track is sufficient – the front of the shade can be extended or retracted, generally by rack and pinion, to fit the focal length of lens aperture setting.

For a view camera with movements, it helps if the shade can be rotated and shifted in combination with the front or rear standards. When making camera movements, always check that the shade is properly adjusted, and does not cut off part of the view. This is most easily done by shifting the rear standard in all four directions to see where the mask begins to cut off the image. A good check for the efficiency of the masking is to examine the lens from the front. Any direct light should just be cut off from the glass, as the diagram shows.

Masking close to the lens like this may be difficult if the shadow edge cast by the light is soft, as it will be

Filters are a potential source of flare, and the thin gelatin filters commonly used in the studio can easily buckle and catch reflections. One solution is to tape the filter inside the camera behind the lens.

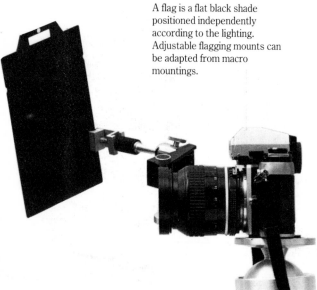

A flag is a flat black shade positioned independently according to the lighting. Adjustable flagging mounts can be adapted from macro mountings.

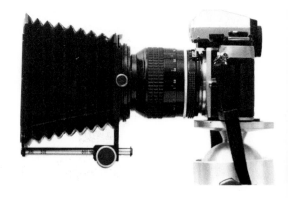

A professional lens shade features an adjustable bellows, which can be extended or retracted according to the angle of the view of the lens. It is intended to mask right down to the edges of the picture area.

from a broadly diffused lamp. More precise masking is possible closer to the light, with barn doors or flags clipped to stands. Once again, check that the masking does not intrude on the picture by examining the edges of the ground-glass screen, and check the efficiency by seeing where the mask's shadow falls close to the front of the lens.

Extra precautions are to use only well-coated lenses, to keep them clean, and to tape gelatin filters *behind* the lens if possible.

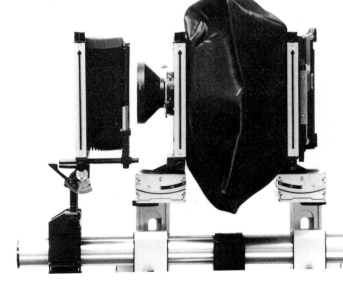

Even a white surface, if it extends much outside the picture area, can create some flare. While this may not be obvious, it will reduce contrast and overall image quality. Standard procedure is to mask up to the edges of the picture with black cards (note the divergent shape because of the camera angle).

View camera bellows shades offer the ultimate in precise masking. The one illustrated below, on a Sinaris assembled from standard parts – principally a regular standard and normal bellows. The swing, tilt and shift movements available on this standard can be used to match the altered picture area when the camera's lens and film back movements are used, see pages 52-53.

Standard lens hoods are generally efficient, but for convenience and cost they are usually shallow and round (screw fittings make alignment of a rectangular shape difficult). They offer the minimum protection.

Creating atmosphere

Terms such as mood and atmosphere are widely used in photography, and reasonably understood in a general way, yet they tend to resist precise and sensible definition. Visually, a picture that has a distinct atmosphere is usually more evocative than literal.

In the studio, the technicalities of this rather vague quality need to be mastered in order to create it to order. In principle, the methods used are mainly concerned with degrading the image quality in certain areas, and by deliberately choosing not to use the full technical capabilities of the film and camera. This usually means flouting the objective standards of strong colour saturation, good contrast and high resolution. This is not to suggest that there is a formula technique which involves simply being careless – creating atmosphere actually requires *more* precise judgement and control at aiming at the maximum image quality, as there are no set limits to the effective degree of image degradation. It is easy to go too far.

The position of the main light is one of the most important controls. Colour saturation is generally at its highest if the light is fairly frontal – from a position close to the camera. Placing the light further behind the subject, so introducing an element of back-lighting, tends to de-saturate colours, create highlights, and generally show off the reflective surface qualities in a set. With solid objects, a reasonable guide is that the more back-lighting, the less colour. The contrast of the picture also tends to rise.

Direct back-lighting, with the light source directly in front of the camera and behind the subject, is the most extreme of these conditions, and can create silhouettes if the source is larger than the subject (say, an area light,) or a rim-lit darkfield effect if the source is smaller (such as a spotlight behind a person's head). In either cases, the high contrast and lack of colour are ways of reducing the visual *information* in the picture, a prerequisite for atmosphere.

This reconstruction of a nineteenth century pharmacy was lit for atmosphere rather than maximum detail of information.
Accordingly, the overall levels were kept low, and contrast was raised by highlighting the glass-enclosed counter figure in the right foreground. Basic illumination came from the shop windows off-camera at right, and from the half-hidden pharmacy area behind the shop proper. An earlier lighting alternative, with an extra lamp below the counter, is shown on the left. This was rejected for having insufficient atmosphere.

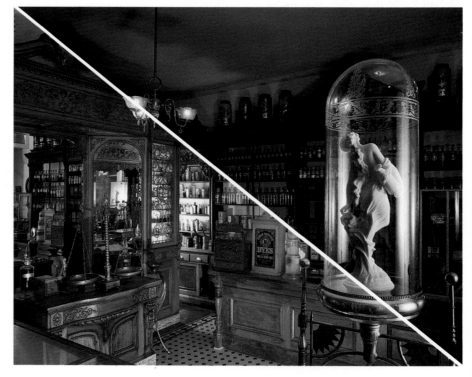

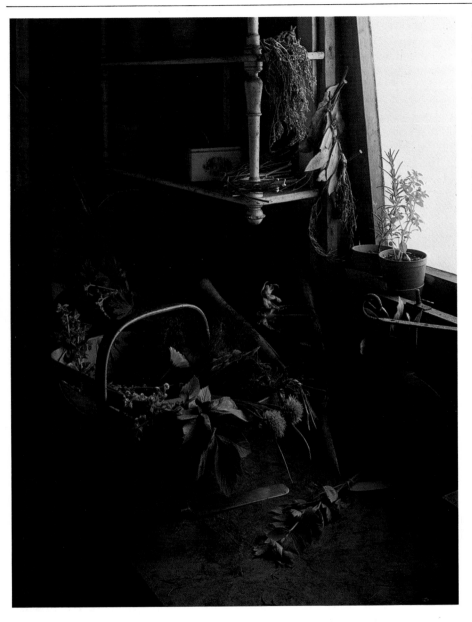

Another method of creating atmosphere is induced flare from shooting towards the main light source. In this set of a garden shed arranged with herbs, part of a large roll of tracing paper was suspended on the other side of the window and lit with two large flash heads. The result was simulated diffuse daylight and an acceptable degree of flare – not too much to degrade the image inside the shed, but enough to add character.

Creating atmosphere

While some degree of back-lighting encourages atmosphere on its own, it is even more effective when combined with deliberate techniques for degrading the image. These all have in common some method of diffusing or flaring the light before it enters the camera. One of the most obvious techniques is to allow flare-indeed, to go further and deliberately to induce it. As already described on pages 106-107, the flare that is likely from any back-lighting is enhanced by dirt, grease and extra surfaces in front of the lens. One simple method, therefore, is to smear petroleum jelly – not directly on the lens, but for ease of cleaning on a plain glass filter. The quantity of grease, which part of the lens it covers, and the pattern of applying it, determine the effect, which can range from almost complete obliteration of the image to a halo around the edge of a light.

In addition to grease, there is virtually no limit to the range of materials and screens that can be placed just in front of the lens to create different kinds of flare. Muslin, gauze, wire-mesh, buckled gelatin, imperfect glass, can all be used, as well as large selection of proprietary effects-filters. Of the filters for subtle atmospheric effects, soft-focus, diffusion and fog designs are the most useful.

An alternative is to work at diffusing the light well in front of the camera. Semi-translucent screens, such as muslin and scrim, can be hung at various distances in a deep set, provided that they are large enough to cover the width of the picture area. If the texture of the screens is likely to be noticeable and a problem, one solution is to use continuous light and a long exposure, moving the screens to blur them.

Finally, the most literal of all methods of creating atmosphere can be the most effective – introducing smoke into the set. Over a small set, cigarette smoke may be sufficient, or for medium sets a bee gun of the type used by beekeepers for tranquillizing hives. The most effective, however, is an oil-based smoke machine, which pumps out a fine suspension of oil droplets. Its major problem is the damage it can cause to props and equipment, and using it is usually a major procedure involving blocking off the area with drapes and protecting the camera behind glass. A fan may be needed to keep it in circulation.

Frozen carbon dioxide gives a different kind of atmospheric effect – a ground-hugging fog that quickly disperses. It can be used in a special dispenser that pumps it out or placed directly into a bowl or tray of warm water.

Smear petroleum jelly on a clear filter, not directly onto the lens. Even a tiny quantity will give a pronounced diffusing effect.

A proprietary alternative is a soft-focus filter. This version is engraved with concentric circles for an equal effect over the entire image area.

Variety of proprietary diffusing and soft-focus filters.

Vaseline smeared on plain glass filter.

Bursts of smoke from a generator of the type illustrated below produce a mist-like effect with a time exposure. With the camera shutter open for 3 seconds, individual wisps of smoke are only faintly visible, most of them blurred by movement. The nozzle of the generator was directed towards this wind-tunnel model of an aircraft from a few feet off-camera at right. The model was mounted on a pylon projecting from behind, out of sight.

Collapsible frame to take variety of diffusing screens or mesh materials.

Studio fan for dispersing and controlling flow of smoke.

Fog generator produces a fine mist of oily droplets

FILM

For most types of studio photography, the choice of film is actually simpler than for outdoor shooting. By and large, the conditions are predictable, because the photographer can plan the work, and with the exception of daylight studios, the characteristics of the lighting are extremely consistent. Many films designed for outdoor use must cope with inadequate lighting, and fast emulsions are an important category; in studios, however, the lighting can, or should, be adequate, and slow, fine-grained films are the norm.

Accuracy of colour reproduction, however, is a special problem for the studio worker, not because the shooting conditions change, but because the expected standards of consistency are so high. Any colour shifts or inaccuracies are very noticeable, and maintaining consistency – in particular of neutral white and greys – calls for extra care and testing procedures. Film batches themselves vary, and most professional photographers prefer to buy a large quantity of a single batch and store this at low temperature to prevent it ageing. This makes it possible to be confident of repeatable results after the initial testing.

Polaroid films play an important role in professional studio photography as a means of testing a wide range of picture properties, from the exposure level to contrast, colour, lighting alterations and compositions. Their use is not simply to make sure that nothing has gone wrong, but to produce an immediate two-dimensional image that can be studied and discussed before committing the image to regular film.

Colour film

Most of the competitive brands of film are very similar in image quality. Compared side-by-side, some differences are obvious, but seen individually, as they are normally used, distinctions are extremely difficult to make. Mainly due, in fact, to the competition, there has been increasing standardization, and most transparency and negative films use the same chemistry: E-6 for reversal processing, and C-41 for negative processing.

Many films are available in two forms: Professional and Amateur, and Kodak, the major manufacturer, classifies all its films in this way. The essential difference is that professional films are manufactured to a more reliable standard (this is a relative difference,

and a small one at that) and are designed for immediate use. Amateur films are intended to survive a longer shelf or storage life in ordinary room conditions without suffering, and so are more tolerant of maltreatment.

Transparency film

The most common reversal process is Kodak's E-6 which can be used not only for the Ektachromes but for Fujichrome.

The one outstanding anomaly among transparency films is Kodachrome, of which there are just three varieties, 25, 40 and 64, all in 35mm format only. This is a unique process, in which the colour dyes are

Colour Transparency Film	Film speed (ISO)	Format	Balanced for
Kodachrome 25	25	35 mm	5500K Daylight
Polachrome	40	35 mm	5500K Daylight
Agfachrome 50RS	50	35 mm, 120, 70 mm, sheet	5500K Daylight
Fujichrome 50D	50	35 mm	5500K Daylight
Fujichrome Velvia	50	35 mm, 120, sheet	5500K Daylight
Kodachrome 64	64	35 mm, 120	5500K Daylight
Ektachrome 64	64	35 mm, 120, 70 mm	5500K Daylight
Ektachrome 6117	Nominally 64	sheet	5500K Daylight
Fujichrome 64	64	35 mm, 120, sheet	5500K Daylight
Agfachrome CT 100	100	35 mm	5500K Daylight
Agfachrome 1000RS	1000	35 mm, 120	5500K Daylight
Agfachrome R100S	100	120, sheet	5500K Daylight
Ektachrome 100	100	35 mm, 120, sheet	5500K Daylight
Polaroid Presentation Chrome	100	35 mm	5500K Daylight
Polaroid Professional Chrome	100	sheet	5500K Daylight
Fujichrome 100	100	35 mm, 120	5500K Daylight
Ilfochrome 100	100	35 mm	5500K Daylight
3M Color Slide 1000	100	35 mm	5500K Daylight
Agfachrome CT 200	200	35 mm	5500K Daylight
Agfachrome 200RS	200	35 mm, 120	5500K Daylight
Kodachrome 200	200	35 mm	5500K Daylight
Kodachrome 200	100	35 mm	5500K Daylight
Ektachrome 200	200	35 mm, 120	5500K Daylight
Ektachrome 6176	200	sheet	5500K Daylight
Ektachrome 400	400	35 mm, 120	5500K Daylight
3M Color Slide 400	400	35 mm	5500K Daylight
Fujichrome 400	400	35 mm	5500K Daylight
3M Color Slide 1000	1000	35 mm	5500K Daylight
Ektachrome P800/1600	400-3200	35 mm	5500K Daylight
Fujichrome P1600	1600	35 mm	5500K Daylight
Kodachrome 40	40	35 mm	3400K Tungsten
Ektachrome 50	50	35 mm, 120, sheet	3200K Tungsten
Ektachrome 160	160	35 mm, 120	3200K Tungsten
Polaroid Professional Chrome	64	sheet	3200K Tungsten
3M Color slide 640T	640	35 mm	3200K Tungsten
Ektachrome Infra-red 2236	100 (with Wratten 12)	35 mm	5500K Daylight
Colour Negative Film	Film speed (ISO)	Format	Balanced for
Agfacolor XR100	100	35 mm, 120, sheet	5500K Daylight
Kodacolor Gold 100	100	35 mm	5500K Daylight
Ektapress Gold	100	35 mm	5500K Daylight
Vericolor HC	100	120, sheet	5500K Daylight
Fujicolor HR100	100	35 mm, 120	5500K Daylight
3M Color Print 100	100	35 mm, 120	5500K Daylight
Vericolor IIIS	160	35 mm, 120, 70 mm, sheet	5500K Daylight
Konica SR-V100	100	35 mm, 120	5500K Daylight
Ektacolor Gold	160	35 mm, 120	5500K Daylight
Fujicolor 160	160	35 mm, 120, sheet	5500K Daylight
Kodacolor Gold 200	200	35 mm	5500K Daylight
Fujicolor HR200	200	35 mm	5500K Daylight
3M Color Print 200	200	35 mm	5500K Daylight
Konica SR-V200	200	35 mm, 120	5500K Daylight
Ektapress Gold	400	35 mm	5500K Daylight
Kodacolor Gold 400	400	35 mm	5500K Daylight
Vericolor 400	400	35 mm, 120, sheet	5500K Daylight
Ektacolor Gold	400	35 mm	5500K Daylight
Agfacolor XRS400	400	35 mm	5500K Daylight
Fujicolor HR400	400	35 mm, 120	5500K Daylight
3M Colour Print 400	400	35 mm	5500K Daylight
Konica SR-V400	400	35 mm, 120	5500K Daylight
Ektapress Gold	1600	35 mm	5500K Daylight
Agfacolor XRS1000	1000	35 mm, 120	5500K Daylight
Kodacolor VR1000	1000	35 mm	5500K Daylight
Fujicolor HR1600	1600	35 mm	5500K Daylight
Vericolor IIL	100	120, sheet	3200K Tungsten

introduced by the processing laboratory and are not contained in the film as it is used. Its special advantages are its extremely high resolution and fine grain, and it is an important film for professionals because it partly compensates for the size disadvantage of the 35mm format.

Negative film

Whatever small differences exist between different brands of reversal film are submerged almost totally among negative films by the possible variations in printing. In other words, the printing stage of the process allows so much control over tone, colour and density that any original differences between makes of negative are in distinguishable.

Reciprocity failure

In the terminology of film, reciprocity is the condition whereby altering the shutter speed and the aperture in opposition to each other, and to the same degree, makes no change to the density of the image. For example, halving the shutter speed, say from 1/30th of a second to 1/60th of a second, while making the aperture twice as large, say from f4 to f2.8, allows exactly the same amount of light to reach the film (only the depth of field and the ability to freeze movement changes).

At most speeds with most films, the result is a predictable absence of change, but at very short and very long speeds films do not react proportionately. At an exposure of several seconds with a daylight colour film, doubling the exposure produces less than double the response. The reciprocity in other words, begins to fail. As the failure is progressive, becoming more severe with increasing exposure times, the problem tends to compound itself making additional allowance in time simply runs into a weaker and weaker response. With colour film, an even more serious effect is on the overall colour. The three dye layers in the films experience reciprocity failure at different rates, and the result is a colour shift.

As the table shows, some films show less reciprocity failure then others. Tungsten films, which are generally used at fairly slow shutter speeds, are the most useful for long exposures, to the extent that long daylight exposures are usually easier with tungsten film balanced with an 85B filter. One of the special problems encountered with an 85B filter. One of the special problems encountered with some films – the ones carrying the NR tag – is that the effect of the reciprocity failure is not predictable, and can vary from batch to batch.

Reciprocity correction for colour transparency film (NR=not recommended)			
	1 sec	10 sec	100 sec
Kodachrome 25	+ 1/2 stop, No filter	NR	NR
Kodachrome 40 (Type A)	+ 1/2 stop, No filter	NR	NR
Ektachrome 50 (Tungsten)	None, + CC05R	NR	NR
Fujichrome 50	None, No filter	+ 1/2 stop, No filter	NR
Agfachrome 50	+ 1/2 stop	NR	NR
Kodachrome 64	+ 1 stop, +CC40R	NR	NR
Fujichrome 64	None, No filter	None, No filter	+ 1 stop, +5M
Ektachrome 64	+ 1/2 stop, No filter	+ 1 stop, No filter	NR
Ektachrome 6117	+ 1/2 stop, + CC10M	+ 1 1/2 stops, + CC15M	NR
Ektachrome 6118	Varies: see film instructions (intended range 1/10 sec to 100 sec)		
Ektachrome 100	NR	NR	NR
3M 100	+ 2/3 stop, + CC05Y	+ 1 1/2 stops, + CC10R	+ 2 1/2 stops, + CC15R
Fujichrome 100	None, No filter	+ 1/2 stop, +5R	NR
Agfachrome 100	—	+ 2/3 stop, No filter	+ 2 1/2 stops, + CC10G
Kodachrome 200	NR	NR	NR
Ektachrome 200	+ 1/2 stop, No filter	NR	NR
Ektachrome 6176	+ 1/2 stop, + CC10R	NR	NR
Ektachrome 400	+ 1/2 stop, No filter	+ 1 1/2 stops, + CC10C	+ 2 1/2 stops, + CC10C
Fujichrome 400	None, No filter	+ 1/2 stop, +5Y	+ 2/3 stop, +5Y
3M 400	+ 1/2 stop, No filter	+ 1 stop, + CC05R	+ 2 stops, + CC10R
3M 640 (Tungsten)	+ 1/2 stop, No filter	+ 1 stop, No filter	+ 2 stops, + CC10Y
Ektachrome P800/1600	NR	NR	NR
3M 1000	—	+ 2/3 stop, + CC10B	+ 1 1/2 stops, + CC15M
Colour negative film			
Vericolor II & III	NR	NR	NR
Kodacolor VR100 and Kodacolor	+ 1 stop, + CC10R	+ 2 stops, + CC10R + CC10Y	NR
Kodacolor VR400	+ 1/2 stop, No filter	+ 1 stop, No filter	+ 2 stops, No filter
Kodacolor VR1000	+ 1 stop, + CC10G	+ 2 stops, + CC20G	+ 3 stops, + CC39G + CC10B
Kodacolor Gold 100 and Kodacolor Gold 200	+ 1 stop, + CC20Y	NR	NR

Colour film

As studio conditions are such that it is usually possible to provide an adequate amount of light, there are very few occasions on which a high-speed film is needed. Virtually all studio photography is performed with films that are relatively slow, have fine resolution and show little grain. Fast films, rated higher than around ISO 100, have more specialized uses; in daylight studios and when a grainy texture is needed.

Because good image is possible in studio photography, it has become one of the most important standards for judging results – more so than in regular location photography. Most people involved with studio photography accept without question that the image should be sharp, have resolved fine detail, have good tonal gradation, and show little, if any, grain structure. This, after all, is the main justification for using large – format cameras.

Sheet films have the advantage of size, as for any given type of emulsion, the image quality as defined by the criteria above is proportionately better. Current emulsions can meet the most rigorous standards in 4 × 5 inch and 8 × 10 inch film format. With small-format films, however, the degree of enlargment needed to use the pictures under normal circumstances stretches the limits; in 35mm photography, the difference in quality when compared with sheet film is very noticeable. The very existence of high standards of image quality puts small-format film at a disadvantage. Fortunately, in transparency film at least, the existence of Kodachrome, with its special process and extremely fine grain, goes some way towards compensating for 35mm film's inherent disadvantages.

There are two main divisions of colour film: transparency versus negatives, and daylight versus tungsten. The choice between the first pair is determined by how the pictures will be used: for photo-mechanical reproduction, in books and magazines, the separation-makers prefer transparencies, and these consequently dominate professional studio photography intended for publication. If a print, on the other hand, is the end-product, a negative is usually better original material. Transparency and negatives can be made from each other by using special copy materials, prints can be used for publication, and transparencies can be

Daylight-balanced transparency film is, professionally, the most commonly used emulsion (right). Matched to electronic flash, it is designed for short exposures.

Colour negative film (far right) is more useful when prints are the end-product and when these have to be to a high standard.

116

Tungsten-balanced film (far left) is useful in situations where there is ambient light, and when a continuous light source is needed.

For mixed-lighting set-ups (left), either daylight-balanced or tungsten-balanced film is suitable, but partial filtration will be needed (see text).

turned into display prints, but as a rule, the highest image quality comes from using the materials designed for that specific use. The choice between daylight and tungsten film is mainly determined by the kind of lighting. Daylight film produces neutrally-balanced colours with 5500K light (see pages 62-67) – that is direct noon sunlight and flash. Tungsten (type B) gives

neutral results under 3200K illumination (type A is balanced for 3400K). Under normal circumstances, therefore, the choice is straightforward with electronic flash or with tungsten studio lamps. With daylight, a set of light-balancing filters is an essential addition because of the variability of daylight as seen through a skylight, but daylight film is the normal choice. However, tungsten film with an 85B filter becomes balanced for daylight and has one special advantage for static sets: it is designed for longer exposures. Whereas daylight films used in exposures of several seconds or longer display the unpleasant characteristics of colour shifts and a weaker response to light (reciprocity failure – see pages 118-119), tungsten film is reliable at long exposures.

On occasions, it may be necessary to mix tungsten and flash lighting. For instance, one type of shot conveys movement by combining a frozen image of the subject with a blurred trail as it moves. One method is to use two lamps – one flash and one tungsten – and to place a colour-balancing gel over one. Another method is to split the shot into two exposures, placing a light-balancing filter over the lens in the pause between. In either case, the unreliability of colour when using daylight film at long exposures favours tungsten film (using and 85B gel over the flash head or an 85B filter over the lens during the flash part of the shot).

Although graininess is normally not wanted in a studio shot, it can occasionally be useful as a special effect. In such a case, the smaller the format the better, and for extreme texture, the answer is to enlarge a small section of a 35mm frame that has been shot on ultra-fast film.

Filters with colour film

There are two division of use for the many different kinds of filters available: to normalize the image, and for special effect. Normalization means compensating for deficiencies in the lighting or colour, and is basically a matter of producing an efficient, neutrally-balanced picture. In the result, filters used in this way should not be noticeable. Special effects are a matter of creative approach rather than practicality; they are usually additions to the image.

Normalizing filters

Light-balancing filters are available in sets of different strengths along a single scale of colour temperature (see pages 62-63). For most practical purposes, the strongest are the 80B and the 85B in the Kodak series, which correct, respectively, 3200K tungsten to 5500K daylight, and 5500K daylight to 3200K tungsten. An 85B filter in other words, fits type B tungsten film for use in daylight or with flash, while an 80B makes it possible to use daylight film under studio tungsten lighting. In between is a range of weaker filters that can be used for finer adjustments. Except for where the colour temperature value is on record, as with photographic lamps, a colour-temperature meter is essential.

Colour-correction filters have a different function: compensating for hue differences. The most common reason is that different batches of the same film are often not exactly the same in their balance of dyes. Colour-correction filters are available in all six primary and secondary colours: cyan, yellow, magenta, red, blue, green, and in incremental steps, from 05 to 50.

Neutral-density filters are self-explanatory: they simply darken by specific amounts. For example, a ND 0.3 filter has a factor of 2, which means that it blocks one-half of the light passing through it, and so is equivalent to one f stop.

In practice, neutral-density filters are useful for reducing exposure when there are no other means (admittedly a rare need in studios) and when switching between films of different speeds without changing depth of field (particularly common when making a Polaroid test with an instant film that has a different speed rating from the regular film).

Neutral graduated filters provide a useful means of altering the tonal balance across a picture. The graduated edge, if aligned carefully to the distribution of tones in the image, smooths the transition so that the effect is not obvious. The rate of graduation across the

Without any filter, this angled view of a watch, in glass enamel and gold, picks up too strong a reflection, and the watch face is virtually invisible.

Fitting a polarizing filter and rotating this to its maximum effect reduces the reflections, including those of the wood background, which now appears much darker. This polarization works naturally on daylight, but studio lamps must themselves be fitted with polarizing sheets.

Effects filters have a number of uses. Here, coloured artwork is given a staggered, overlapping appearance when photographed through a step-prism filter.

picture depends on the focal length of the lens (the shorter, the sharper the change) and on the aperture (the smaller the sharper the change).

Polarizing filters when used with a polarized light source (daylight, or else studio lamps fronted with sheets of polarizing materials) are useful for controlling – that is, reducing – reflections.

Special-effects filters

There is an enormous range of these, with many new designs produced in recent years. As they create an intentional and obvious effect on a picture, and are a step away from straight, realistic photography, they need to be selected with great caution. The examples, here are a selection from many.

119

Black-and-white film

The choice of black-and-white films is considerably simpler than that of colour. Virtually only the negative/ print process is used (reversal processing is possible with some fine-grained films, but unusual), and questions of colour balance and colour correction are largely irrelevant.

The major difference is between the traditional silver-image negatives and the newer dye-image films. Silver-image films work by the conversion of light-sensitive silver halides into black metallic silver (the foundation of nearly all photographic chemistry) and the final clumps of silver grains embedded in the emulsion gives the image a distinct grain structure. The pattern, coarseness and definition of this granular texture varies slightly between some makes of film, although these differences are visible in side-by-side comparison only and at considerable magnification. Dye-image film uses a different approach – that of colour-film chemistry. In

essence, the silver image is replaced with dye clouds, so that the final negative contains no silver at all. Of more practical importance for photography is the effect on image quality. The outstanding property of dye-image negatives is that they have extremely broad latitude, to the extent that with normal processing the makes of film currently available can be rated as if at any speed from ISO 200 to ISO 1600. To put it another way, this exceptional latitude makes it possible to cover a brightness range of about ten stops, as opposed to about seven stops with silver-image films. In addition, dye-image emulsions have very high resolution and a fine textural structure.

The benefits, nevertheless, are not entirely in favour of dye-image emulsion. The very lack of a definite grain structure is not necessarily pleasing and there is a tendency, in mid-tone, featureless areas of an image, for the texture to appear mottled. This is

Brand Name	Film Speed (ISO)	Format	Process	Sensitivity
Slow, fine-Grained Capable of great enlargement before appearing grainy.				
Kodak Technical Pan 2415	25 (for normal contrast)	35mm, sheet	Regular silver (Use Technidol LC for normal contrast)	Panchromatic with extended red sensitivity
Kodak Technical Pan 6415	25 (for normal contrast)	120	Regular silver (Use Technidol LC for normal contrast)	Panchromatic with extended red sensitivity
Kodak Technical Pan 4415	25 (for normal contrast)	sheet	Regular silver (Use Technidol LC for normal contrast)	Panchromatic with extended red sensitivity
Agfapan 25	25	35mm, 120, sheet	Regular silver	Panchromatic
Kodak Panatomic-X	32	35mm, 120	Regular silver	Panchromatic
Ilford Pan F	50	35mm, 120	Regular silver	Panchromatic
Polaroid Positive/Negative	50 (prints) 25 (negatives)	Polaroid cameras, holders to fit 120, sheet	User (instant)	Panchromatic
Agfa dia-direct	32	35mm	Reversal	Panchromatic
Medium speed, medium grain General-purpose films.				
Agfapan 100	100	35mm, 120	Reversal	Panchromatic
Kodak T-Max 100	100	35mm, 120, sheet	Regular silver	Panchromatic
Kodak Plus X	125	35mm, 120, sheet	Regular silver	Panchromatic
Kodak T-Max 100	100	35mm, 120, sheet	T-grain silver	Panchromatic
Ilford FP4	125	35mm, 120, sheet	Regular silver	Panchromatic
Polapan CT	125	35mm	User (rapid)	Panchromatic
Fast, grainy General-purpose films, useful under a wide range of lighting conditions. At modern enlargements, graininess is not significant.				
Kodak T-Max 400	400	35mm, 120	Regular silver	Panchromatic
Kodak Tri-X	400	35mm, 120, 70mm	Regular silver	Panchromatic
Kodak T-MAX 400	400	35mm, 120, sheet	T-grain silver	Panchromatic
Fuji Neopan 400	400	35mm	Regular silver	Panchromatic
Kodak Tri-X Professional	320	220, sheet	Regular silver	Panchromatic
Ilford HP5	400	35mm, 120, sheet	Regular silver	Panchromatic
Agfapan 400	400	35mm, 120, sheet	Regular silver	Panchromatic
Kodak Royal Pan 400	400	sheet	Regular silver	Panchromatic
Kodak T-MAX P3200	3200-5000	35mm	T-grain silver	Panchromatic
Very fast, very grainy For low light photography at fairly high shutter speeds.				
Kodak Recording Film 2475	1000	35mm	Regular silver	Panchromatic with extended sensitivity
Dye-image films				
Ilford XPI 400	200-1600	35mm, 120	XP/C-41	
Special-purpose films				
Kodak High-Speed Infra-Red	80 (no filter)/ 25 (87 filter)	35mm, sheet	Regular silver	Infra-Red

Even a great enlargement from a section of a fine-grained silver emulsion (the inset picture is here a 12× magnification from the negative) shows good detail and a little grain. The film speed is ISO 32.

A medium-fast black-and-white film is ISO 400 (this film speed has more widespread use in monochrome than in colour). Enlargement shows more graininess, less contrast and a little less detail than above.

At ISO 1275, recording film is the fastest regular black-and-white emulsion. In enlargement, the graininess is very obvious, contrast is lower and sharpness less than either of the two above.

basically a matter of taste, and many photographers prefer a distinct, tight granulation.

Because of the enormous latitude in dye-image emulsions, one variety meets most normal lighting conditions. Among silver-image films, however, there are ranges based on speed and graininess. Slow films naturally have the least grain, but the deciding factor in choice is usually the degree of enlargment. Sheet film may need a little, if any enlargement, and the graininess of a fast, ISO 400 film may be virtually invisible.

Filters with black-and-white film

While black-and-white film obviously displays no hues, it certainly records them, and in a manner that can be determined by the photographer. By the judicious choice of strongly coloured filters, the monochrome appearance of particular hues can be lightened or darkened, often with quite a dramatic effect on the picture.

Modern black-and-white film is called panchromatic, to distinguish it from the earlier or ortho-chromatic variety that was insensitive to red (ortho-chromatic films are still used in graphic arts and in certain types of dark-room material, so that they can be worked by inspection under a red-safe light). Nevertheless, despite its name, panchromatic film does not respond to colours in exactly the same way as the human eye. Specifically, it is under-sensitive to red and over-sensitive to blue, so that used without filters, it records red darkly and blues too brightly.

A basic corrective filter for when this tonal rendering is important is a strong yellow – about Wratten 12 in the Kodak series. However, black-and-white studio photography is, on the whole, less concerned with the natural appearance of things than is outdoor photography, which more often includes objects that are very familiar, like sky and vegetation. As a result, there is great scope for manipulating the tones of an image with filters.

The method is straightforward. A coloured filter will pass the light from any part of the scene of that colour, while blocking other colours to some extent. The result is that anything of the same colour as the filter will print light, while anything of the complementary colour will print distinctly dark. A red apple photographed through a Wratten 25 filter will appear pale and bright in a normal printing, but almost black if photographed through a Wratten 58 (green) filter.

This principle has real value in separating tones and in altering the balance of attention in a photograph. For instance, red and green together frequently appear similar in tone in a black-and-white print, and there are occasions when this may be confusing visually. Using either a green or a red filter will separate them distinctly, or else a more subtle separation can be achieved with a filter that has a partial effect, such as orange or cyan.

In portraiture, one special use is to reduce the prominence of red blemishes on skin – spots, for example – by using a red filter.

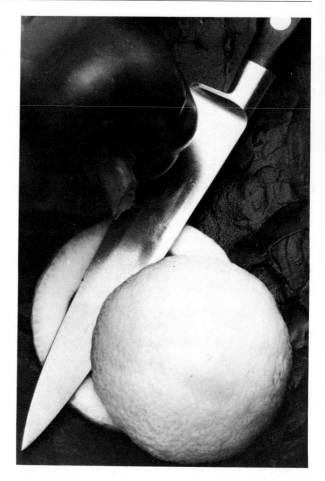

Strong colours can be rendered in a wide variety of tones, from pale to very dark, by using appropriate filters. A yellow filter gives a close-to-normal version of the colour image, except that the lemon is white; a red filter lightens the pepper; a green filter darkens the pepper but lightens its stalk; a blue filter makes the lemon unusually dark.

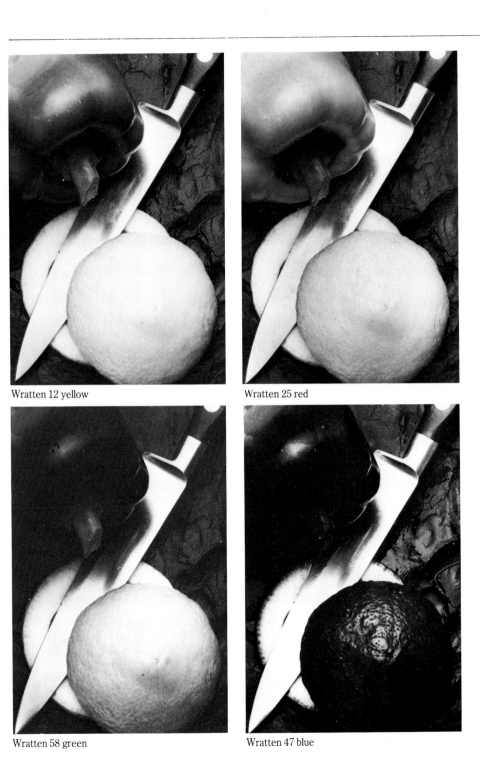

Wratten 12 yellow

Wratten 25 red

Wratten 58 green

Wratten 47 blue

Special processing

Standard development normally allows a film to show its best qualities – good density, colour saturation and tonal range. Films and processes are designed by their manufacturers to perform optimally when used as recommended. There is, however, no compulsion to follow processing instructions to the letter and variations in the development can have some very useful effects. These go well beyond the rather obvious use of correcting exposure mistakes.

The flexibility in processing is principally one of the intensity of development, and is a service regularly offered by laboratories that service professional photographers. By altering development time, solution strength or temperature (usually the first), all film can be processed more than standard (push-processing) or less (pull-processing). This said, the degree to which the processing can be altered is quite limited – with an effect of more than one f stop, the image quality deteriorates noticeably, particularly in the graininess and the maximum densities. Special processing used for positive control normally goes no further than half-stop differences.

In theory, push-processing is a useful means of overcoming insufficient light, but practically, a half- or full-stop gain is not usually worth aiming for. The two *principal* uses of special processing are to alter the contrast range and to make fine adjustments to the densities. These are both alterations made to specific shots, and are consequently used mainly with sheet film, which can be processed one shot at a time.

Push-processing increases the contrast slightly, so that if the exposure is reduced and set in anticipation, the effect is to brighten up the whites. In still-life photography in particular, this is a specially favoured technique. Side effects are a slight shift in colour (towards red with Ektachrome, for example), less maximum density in the shadows, and slightly more grain. A filter can take care of the colour shift – generally no more than a CC05 strength is needed.

Pull-processing flattens out the tones and reduces the contrasts in regular photography. This is normally less useful than the opposite, but it is particularly valuable when copying other transparencies, to compensate for the inevitable increase in contrast (see pages 240-241). The colour shift in Ektachromes is towards cyan or blue.

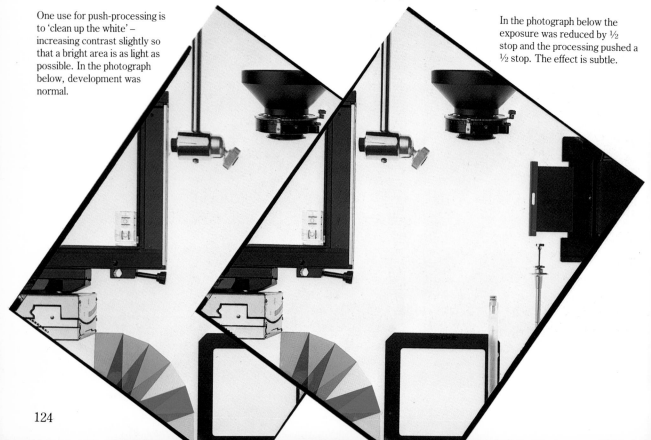

One use for push-processing is to 'clean up the white' – increasing contrast slightly so that a bright area is as light as possible. In the photograph below, development was normal.

In the photograph below the exposure was reduced by ½ stop and the processing pushed a ½ stop. The effect is subtle.

Processing + ½ stop
On ISO 64 Ektachrome, push-processing gives a little more contrast and a slight reddish cast.

Processing normal

Processing − ½ stop
Reduced processing on the same film gives a little less contrast and a slight bluish cast.

Instant film

The Polaroid products that are designed specifically for use in regular cameras (as opposed to films that work only in special Polaroid cameras) are a valuable addition to the normal range of film emulsions. Instant films and prints have some distinct pictorial qualities that can make an occasionally welcome change from films that are mainly geared to making an objective record. Moreover, being instant, they can sometimes be used for intermediate steps in a complicated shooting to speed up the whole process.

All of these films except 35mm Polaroid Auto Processed Film and the Integral Films are designed for use in special holders that replace the regular film back or holder. The cameras that are equipped to make the best use of them are those rollfilm models with interchangeable film backs, and view cameras, which accept film sheet by sheet. With any of these cameras in position for shooting, emulsions can be changed within seconds. Polaroid backs can also be specially fitted to cameras without the capping shutters that allow interchangeable film backs – to 35mm SLR's, for example – although with these, films cannot be replaced in mid-roll without rewinding. 35mm Polaroid Auto Processed Film is available in black-and-white (known as Polapan) and in colour (known as Polachrome) – in both cases there is a normal version and a high-contrast version. Polaroid colour print film (Polacolor) is available for rollfilm cameras in $3\frac{1}{4} \times 4\frac{1}{4}$ inches (similar holders can be adapted to fit 35mm SLR s), and in 4×5 inch and 8×10 inch sheets, and is rated at ISO 80. The process involves recording the image on an intermediate film and developing it by squeezing a pod of chemicals over the surface; this image is than transferred by contact onto the final print, which is then peeled away. The intermediate stage is discarded. Development takes about 60 seconds at a temperature between 75°F (24°C) and above; to ensure an even spread of chemicals, the 8×10 inch film is passed through automatically operated rollers. As with all contact-printed photographs, resolution and image quality is high, and the colours very stable. In particular, shooting can be continued until the print appears exactly as the photographer wants it to, so eliminating any uncertainties.

Manipulating the image

Most Polaroid films allow the photographer to make some changes in contrast and colour. Extended development time of all the black and white films except 55 P/N and 665 P/N darkens shadow areas, leaving the lighter tones unaffected.

Strawberries photographed normally on Polapan fine grain (left) appear much lower in contrast than when the film has been left to develop for one minute instead of the recommended 15 seconds (centre). Even more contrast is possible by underexposing and then delaying application of the coating (right).

Polaroid Positive/Negative film delivers high-resolution negatives as well as the usual prints. These can be stored before washing and drying by placing in a special polaroid bucket filled with sodium sulfide solution.

By far the most common use of instant film in the studio, and one that gives it a case of special importance, is as a means of testing and refining shots that are to be taken on regular film. This is virtually standard practice in professional studios and Polaroid testing is now an integral part of the process of judging exposure. lighting and composition.

Most studio photography involves a considerable investment in time and effort, not to mention the cost of models, props and special equipment. All this is sufficient to make it essential for the photographer to know that each stage has gone according to plan. Moreover, the controlled conditions in a studio usually allow shots to be repeated accurately, so that testing is a relatively straightforward procedure.

Types 54, 554, and 664, for example, were specifically designed for use with flash lighting to complement the range of ISO 100 films available from most film manufacturers. Types 55 and 665 are useful

The black-and-white print films offer greater variety: in tone, speed and spectral response. There are three types of fine-grained emulsion (but more designations, because of the different film sizes). Both types 52 and 54 (large-format) and their pack film equivalents 552 and 554, together with the medium-format 664, give fine-grained prints. Types 52 and 552, which are older, have a relatively fast speed of ISO 400. The newer 54, 554, and 664 are rated at ISO 100 and are coaterless, an increasing trend in Polaroid films. Types 55 and 665 also give a high quality print, and a high-resolution negative as well; the negative should be cleared in an 18 per cent sodium sulfite solution before being washed and dried. The rating for this positive/ negative film is ISO 50 for the print, but ISO 32 if you want a properly exposed negative.

In addition to these regular instant films, there are more specialised emulsions, including high-speed and high-contrast types.

Take care over inspecting test prints, particularly if the regular film to be shot will be enlarged. In judging the general appearance from a Polaroid print, it is easy to overlook small defects, such as of sharpness.

Instant film

Fine Grain (Type 52, 54)

High Contrast (Type 51)

High Speed (Type 57)

Polachrome
35mm colour transparency film, available in 12-exposure and 36-exposure cassettes. There is a normal version and a high-contrast (HC) version. Intended mainly for audio-visual slide shows.

Polapan
35mm monochrome transparency film, ISO 125, in 36-exposure regular cassettes for ordinary use in 35mm cameras.

Polagraph
35mm high-contrast monochrome transparency film, ISO 400, in 12-exposure regular cassettes, for ordinary use in 35mm cameras.

Positive/Negative (Type 55) Polacolor (Type 59) Image camera film

for testing ISO 50 and 64 tungsten films, particularly at long exposures. Its reciprocity characteristics are very similar to these films which are designed for exposures longer than a second (in contrast, types 54 and 664 suffer very badly from long exposures; they lose contrast and behave as if they were much slower).

For colour checking, Polacolor is useful for a general impression, but beware of using it for an exact colour balance: the dyes used in the film are not the same as those in normal transparency film. Be careful also to view Polacolor prints in daylight whenever possible. If you view them under fluorescent strip lights, they are likely to appear tinged magenta.

An important precaution when making a Polaroid test is to spend sufficient time checking the instant print. Being a contact print, errors that may affect an enlargement, such as soft focus, will not be so obvious. Use a magnifying glass and a bright light to examine it by.

In professional studio photography, Polaroid prints have extra uses, as layout guides and for sending by messenger to clients for approval to conclude shooting.

The negative from Polaroid Positive/Negative film (above) needs approximately twice the exposure suitable for a print if it is to be the end-product. The resolution is extremely high.

PORTRAITS

The portrait is *the* classic use of photography. Most people's favourite subjects are themselves and the people they know, followed closely by the people they would like to know more about. Still-life, landscapes and other photographic subjects can be made into powerful and memorable images through the skill of the photographer, but none of them tap the fundamental appeal of studying people. In a photographic portrait the subject is *already* interesting, and the work of the photographer is principally to reveal what is there rather than to construct a picture from his imagination.

The role of the studio in portrait photography is to provide neutral territory – an area where the photographer can exercise technical control over the lighting and the setting, and where the photographer can also control the tone and progress of the session.

When the object is to show some aspect of the subject's personality, as is the case with most portrait photography, the elements of success lie more in the photographer's powers of observation and the relationship with the sitter than with technique.

Important though technical skills may be, in portraiture they are simply a necessary framework. A lighting diagram can show how to create an elegant still-life picture, but it cannot guarantee a successful portrait.

Showing character in the face

Even at a distance, occupying a small part of a larger scene, a face in a photograph is like a beacon for the viewer's attention. A face is a natural focus of interest, particularly if it is looking directly towards the camera. It is where we look in order to find out anything about someone's personality, thoughts and intentions, and even when it is photographed alone and unadorned it can make, not surprisingly, the most compelling type of portrait.

Possibly the most important point to make in portrait photography, although it has a curiously negative ring to it, is that there is absolutely no formula approach. Even a superficial glance at the work of the most renowned portrait photographers shows a variety, and even a contradiction, of methods. Some, like Irving Penn, achieve results by isolating their sitters, both physically in a bare studio and emotionally, even to the point of allowing them to feel self-conscious and uncomfortable. Others, like Annie Leibowitz, become as intimate as possible to gain a sometimes extraordin-

ary co-operation. Cecil Beaton, specializing in portraits of the famous, imposed a distinct personal style on all his portraits, which are typically lit and directed in the grand manner.

Later pages in this section deal with the techniques of portrait photography, but the essential element, as the work of the above photographers shows, is in the manner of dealing with the subjects. This is inevitably a very personal matter, because however short the session may be, it involves some form of relationship. This is something that studio photographers acquire with experience, but perhaps the most sensible guide to developing a method of directing a sitter is to follow one's own inclinations: acting out of character in order to elicit a certain kind of response from a subject is

Annie Leibowitz pushed portraiture in a new direction. An important part of her working method in producing photographs such as this, of actress Meryl Streep, was to become sufficiently involved with her subjects that she could persuade them to perform all kinds of outrageous actions.

more likely to confuse the occasion. Given mastery of the given techniques – a matter of no great difficulty – success depends principally on the interplay between two personalities: that of the photographer and that of the sitter. A dominating attitude on the part of the photographer may work just as well as a retiring one, while the character of the sitter more often than not unpredictable – gives portrait photography an air of uncertainty. This alone is a source of interest and excitement usually lacking in still-life photography.

Cecil Beaton's portrait of a young Sir Michael Tippett relies heavily on a pose that emphasizes the eye contact (leaning forward, head slightly down, eyes up, catchlight) and so communicates some of the composer's intensity to the viewer. The wilfully shallow depth of field and back spotlighting seem mannered now, but were fairly conventional at the time that this portrait was made in the 1940s.

Best features

There is an important distinction between pictures taken for the benefit of the photographer and those taken for the sitter. In fact, a large proportion of portraits are made with the intention of producing not just a likeness, but a *pleasing* likeness, and as the criteria for judging them are substantially different, the photography itself uses different methods.

While it may not necessarily be easier to make a flattering portrait than one that probes character, it does at least provide a definite direction and an identifiable result to aim for. Moreover, while the kind of portrait photography that does not begin with pre-set objectives is not really suitable for a point-by-point analysis, with portraiture that aims to please there are a number of regular techniques that will usually help.

First of all, the photographer must be able to identify the best features in the sitter's appearance – and also the worst features, to know what to suppress or avoid. Compare, for example, the full-face with the profile: if the eyes are relatively large and well-spaced, a full-face view with the sitter looking directly at the camera is likely to make the most of them, while a well-proportioned nose or chin would favour a profile. In a specific situation, a choice like this would probably only be one of several, including the lighting, the personality of the subject, and so on. Conversely, features that seem unattractively prominent can be suppressed by choosing an angle or lighting arrangement that neither shows them in outline nor lets them cast a strong

Reflections in spectacles can be distracting, particularly when, as here, the lenses are tinted. To avoid the image of a reflector (right), a sheet of black paper has been positioned so as to reflect in the spectacles instead (far right).

Using a cigarette as a prop to encourage a relaxed attitude in the sitter, the photographer has encouraged a variety of facial poses during the session. The final selection from the contact sheet works successfully partly because the man's eyes, one of his most compelling features, are emphasized by broad side-lighting and the suppression of other details by strong shadow.

The shorter the focal length of lens, the greater the distortion of nearer features – here the forehead and hair. Generally, the most attractive proportions are those from a telephoto lens.

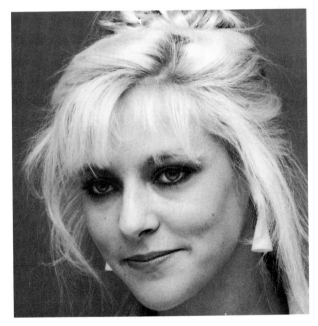

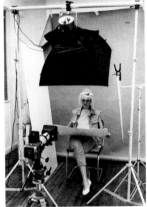

One reliably attractive lighting arrangement, particularly with make-up, is a large area light, frontally positioned just over the camera's line of sight. Reflectors at either side, and crumpled foil held by the model give a high-key, low-contrast effect.

shadow. A nose, for instance, is least prominent from directly in front, and with diffused frontal lighting; large ears can seem less obvious in a three-quarter profile. Also, as a general rule, a long-focus lens will compress the perspective in a face and will produce a more attractive view than a standard or wide-angle lens.

A few problem features are sufficiently common to have standard solutions. Reflections in spectacles obscure the expression and are usually unwelcome; with a typical overhead and frontal light position, have the sitter tilt the head slightly down, and if necessary position a black card out of shot in a position where it, rather than the light, will be reflected. Skin folds and double chins can often be eliminated from the photo-graph by having the sitter lean forward slightly toward the camera – this stretches the front of the neck a little. Wrinkled skin can be made to seem smoother by diffusing the light strongly (the ridges then cast no shadows), and spots can be reduced in a black-and-white photograph by shooting with a red filter.

Diffused lighting is in any case the most generally attractive, particularly from an overhead frontal direction. This is not to say that is is necessarily better in any instance, but it is safe. Two subsidiary lighting effects that can flatter a subject are catch-lights (a small spot or naked light reflected in the eyes, to give them, usually, a sparkle), and the halo-lighting from a spot light behind the sitter (this works most effectively behind a full head of hair). These lighting arrangements are shown in the examples on pages 152–153.

Certain poses and demeanours are also flattering in a general sense. By and large, people appear at their best when they are either relaxed and comfortable, or when they are bright and alert.

Poses

The formality of any studio portrait is such that there is always some deliberation in the pose. As most people have not been trained in acting, they often feel self-conscious about having to perform actions that normally require no thought, and unless the photographer eases the way, the simple issue of how to sit or stand in front of the camera can be an unnecessary source of tension at the beginning of the session.

Even if the sitter is not particularly concerned about how to pose, there are other more positive reasons for the photographer to take an active part. The setting and props that are provided for the sitter have a direct influence on the way in which the photography continues – on whether the sitter feels comfortable, tense, talkative, elegant, awkward, and so on. In most ways, the photographer has some control over the sitter, and encouraging a particular pose is one of the less obvious – and so often one of the most effective – methods.

There are two ways of influencing the pose: by direct suggestion and by providing a setting that allows only certain ways of sitting or standing. A certain amount of commonsense psychology is involved, and the photographer must at least consider all the possibilities even if, in the event he chooses not to exert any strong influence. Ultimately this all stems from the personal approach of the particular photographer.

Many people need encouragement to relax, and can be helped by natural, easy positions that give the subjects something to do with their hands and feet (otherwise a typical problem for many people). With a head and shoulders portrait, the appearance of the sitter's figure is less important than the muscular effect it has on the position of the head and whether it encourages relaxation, alertness or concentration. The best way of judging the subtle influences that different types of seating have is to try them out in front of the mirror. A low deep chair tends to encourage slouching, and is usually awkward for the camera as it pushes the sitter back; a high stool, on the other hand, particularly if it keeps the feet off the ground, encourages attentiveness (arm rests make this more comfortable). A small range of chairs and stools kept in stock in the studio provides a useful choice for different occasions and sitters. It is an advantage to have at least one chair of adjustable height.

Standing positions generally call for more self-confidence in the subject, and a prop for one hand or arm, such as the edge of a table, or something to hold, may be helpful. Moving poses are usually better left for professional models, when the photographer can provide encouragement and direction.

The contact sheets on these and the following pages are both an example of the variety of poses that are possible, and a reference file with practical use. Among the 180 poses illustrated, at least one is likely to meet the needs of a particular situation and subject. Although these are all shown as full-length poses, they have a strong influence on more closely-cropped views, such as a head-and-shoulders portrait. Even if you are photographing only a face, do not ignore the position of the rest of the body.

Poses

Simple settings

However bland and irrelevant it may seem to the portrait, the setting for a portrait always has to be selected, and always has some relationship with the subject. The relationship, in fact, is a dual one: graphic and in content. Even in a close facial portrait, the background is a design element, and the photographer has to choose the proportion of the picture area it occupies, its tone, texture, and often its colour. In addition, it is open to choice as to whether the setting should actually be relevant; whether, in other words, it should contribute to the content of the photograph by complementing or contrasting with the personality, interests or position of the sitter.

In practice, studio settings for the majority of portraits tend to have more of a role in the design of the photograph than its content; most photographers most of the time allow their subject to carry the picture. A basic stock of settings, therefore, comprises of a

number of relatively plain background materials – the more neutral the tone, texture and colour, the more regularly they can be used.

Nine-foot rolls of heavy, seamless paper are the most widely used of all portrait backgrounds, and are available in a number of different colours. The usual way of handling them is to suspend them horizontally on a bar, which is either attached to wall brackets or between two vertical poles tensioned between the floor and ceiling. The free end of the paper is then pulled down to the floor – its own weight keeps it hanging straight. For a full-figure shot, the paper can be draped carefully onto the studio floor and the two free corners weighted down; allowing the paper to fall into a smooth curve eliminating a sharp edge at the junction of floor and ceiling. One necessary precaution with seamless paper is to avoid creasing, which can happen easily when unrolling the paper and which is distracting even if

White background paper is the simplest option, but for maximum tonal control, and to separate it visually from the subject, separate lighting is best.

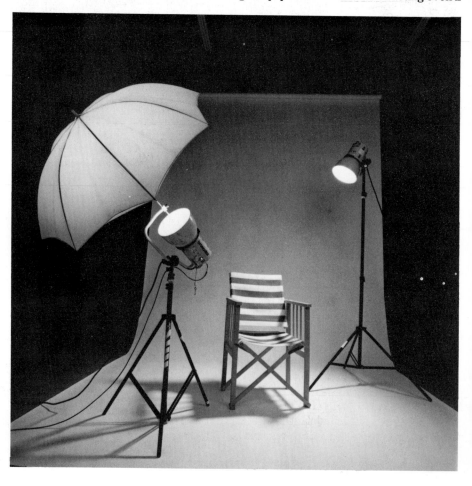

A dark background of velvet or felt can be used to give interest and mood, either by using it straight, as here, or by hanging it loosely in folds.

A plain white background has been used for this portrait of a couple to emphasize the stark quality of their dress and pose.

slightly out of focus. Hang the paper carefully and cut off the used part at the end of a session.

Seamless paper is, however, one of the least imaginative of background materials. Different kinds of fabric offer more interesting possibilities, although there may be some difficulties in finding them in sufficient widths (full-figure shots need more than head and shoulders portraits). Two ways of achieving different texture and tone are to use old fabrics (such as old velvet drapes or tenting material), and to apply paint (spray-painting can give smooth variations in tone).

The photographed appearance of any background depends also on the lighting, and for the greatest efficiency it helps to be able to light the material separately from the subject. The light should generally be behind the subject, and flagged to prevent spill. For even lighting, trough lights are the most convenient.

Props and location settings

Although plain backgrounds have a special value in portrait photography, where the subject is often interesting enough visually to carry the picture alone, related settings can produce interesting and different styles. This usually introduces a documentary element to the photography, by illustrating some aspect of the subject's interest or work. In the studio, it means bringing in some relevant props, or even building a special set, but an alternative is to take the studio on location – this may be easier if the props are large or if the setting is very specific. In either case, the precepts of studio portrait photography apply.

This style of photography, in which the subject is linked to his work or achievements, can be handled either by choosing a suitable location or by constructing the setting in the studio or as a room set (see pages 224-227). Arnold Newman was one of the pioneers of this kind of environmental portraiture.

In this portrait of Dr. Rogers Ritter, an American physicist, the high-tech equipment used in his experimental work seemed a natural prop, particularly as the magazine feature, for which this photograph was commissioned, described his work in the text. Some re-arrangement of the setting was necessary to strengthen the design of the photograph (including hanging black velvet to block off cluttered areas of the laboratory). A single, diffused 750-joule flash was used for the illumination.

The subject's own home, place of work, some other relevant place is often worth considering; the difficulties of transporting the photographic equipment and adapting the location to a temporary studio may be more than offset by its advantages as an interesting setting. For the practicalities of working on location, see pages 30-33.

In looking for relevant props, it is obviously easier if the subject is someone well-known for a particular reason – previous publicity has already established the focus of interest, and it is then up to the imagination of the photographer to find a visually suitable object and work it into the design of the picture. As the work of someone like Annie Leibowitz illustrates, it is not always necessary to be obvious – oblique or obscure references often have the advantage of being intriguing. In approaching a portrait in this manner, the result may, of course, be to abandon a studio approach altogether.

For period costumes, a contemporary period location is one natural choice – in this case, the Café Royal in London. Location interiors are likely to need additional lighting (see pages 226-227) in this case, tungsten lamps partially filtered with blue gels to give a colour balance that appears naturalistically warmer than the daylight through the window.

Projected backgrounds

Studio lighting can be more than just an adjunct to the background – it can be used to *create* certain types of setting. One of the simplest uses is to produce the backdrop for silhouettes, a matter of back-lighting a large screen of diffusing material, such as paper or thin white cloth stretched over a trace frame. To light this evenly, two or more lamps are best, sited some distance behind the screen.

For the highest contrast between a silhouette and its background, it is important to prevent light spill from the background lamps and shadow fill. A large, dark-painted studio is best; if the space is small and has reflective surfaces close to the set, it may be necessary to hang black drapes around the subject and camera. A simple method of calculating the exposure is to take a direct reading of the bright background, and then to *increase* the setting by about 3 f stops. This pegs the

brightest tones out white.

Variations are possible even with silhouette back-lightings. The colour can be altered with gels over the lamps or a filter over the lens. With more than one lamp, colours can even be mixed. Tonal variations can be introduced – for instance, using a ground light close to the screen for a graduated effect becoming darker above. Objects and shapes introduced between the lights and the screen will cast shadows that can be used as design elements.

A more complex kind of projected background is front projection. Essentially, this is a sophisticated adaptation of ordinary slide projection, which for various reasons cannot be used to make a convincing background for a portrait. The front projection system, which features axial projection and a super-reflecting screen, overcomes the basic problem of combining an

In this version of a front projector, the projector points vertically upwards so that the image is reflected by a semi-reflecting mirror.
The projector part of the unit can be fitted with a variety of variable focal length so that the background image can be enlarged or reduced to choice.

efficiently lit subject with a brightly projected background.

The screen consists of a large number of very small transparent beads, each of which acts as a mirror to reflect light back exactly to its source. This makes the screen super-efficient in one direction only – the direction of view. A half-silvered mirror in front of the camera lens directs the image from a slide projector (usually flash-powered rather than tungsten) along the lens axis, the effect being to reflect the picture directly back towards the camera. The efficiency of this system is such that the reflected image is extremely bright *without* interfering with the subject; also, light spill onto the screen has only a small effect.

There are only a few technical problems. Even though the screen is uni-directional, care should be taken to avoid light spill (by using barn doors, flags and directional diffusers such as honeycombs and egg-crates). Against a very bright part of the background image there is some risk of a dark shadow outline if the subject stands close to the screen. Finally, there are limited sizes of screens; larger ones may be custom-made by sticking together sheets of 3M Scotchlite – making sure that they overlap away from the centre, so that no shadow lines are cast.

More important are the aesthetic considerations. Matching the background to the subject, particularly in terms of the lighting, calls for some care if the object is realism. The quality and direction of the light should be consistent, as should clothing and props. Joining a visible studio foreground to the image on the screen is rarely easy; one method is to use related props. Sometimes a diffusing filter over the lens can help to blend the two parts of the shot.

Apart form the advantage of being able to select an enormous variety of backgrounds – basically any existing stock photograph – front projection makes it possible to use backgrounds out of scale.
In this instance, a transparency of the Stars and Stripes has been greatly enlarged to provide a continous graphic background.

Portrait lighting/the face

Given the variety of fittings for altering the quality of a studio light, the possible lighting positions from virtually anywhere surrounding the subject and the choice of multiple lights, the permutations of portrait lighting are probably endless. Nevertheless, certain lighting arrangements have particular advantages and have become, for one reason or another, more popular than others. Certainly, there is an element of convention in this, and it is reasonably important to beware of formular approaches that can limit more imaginative treatments. However, it is useful to look at the standard lighting arrangements that have already proved themselves.

For the camera, the face has two sets of physical properties. One comprises its physical appearance and the way its shape responds to light; the other concerns the aesthetic qualities. In shape, the face is rather more complex than it might at first seem; although the head is roughly spherical, the face has a number of planes in different directions. Some face up and out: the forehead, cheekbones, upper lip and the ridge of the nose all catch an overhead light more strongly than the rest of the face, particularly if the skin is shiny. The downward-facing planes – the underside of the eyebrow ridge, the lower cheeks, under the chin and the two small areas under the nose and lower lip – tend to be shadowed under overhead lighting. The nose projects, and can cast a strong, definite shadow, while the eyes, which are recessed, usually need some frontal element of lighting. In addition, the face is bilateral, which means that any degree of side lighting tends to bisect it. In general, the contrast in a facial portrait tends to be greater than most people expect.

Aesthetically, by far the most important feature is the dominance of the eyes. They attract such immediate attention that if they are not adequately lit, the face appears expressionless. Second in importance to the eyes is the mouth, the other major component of expression. The least highly-regarded facial features are the nose and ears; although occasionally they can be prominent and handsome at the same time, for most tastes they are best when subdued in appearance.

Taken together, all these visual characteristics encourage a strong element of conservatism in portrait lighting. By far the most popular style is diffuse frontal overhead lighting, not because it is particularly elegant, but because it is a fair reconstruction of the general run of natural light and because it is efficient, lessening contrast, reducing shadow size and definition, and

Spot Top

Umbrella Top

Spot Top front

Umbrella Top front

Main light only

Main light only

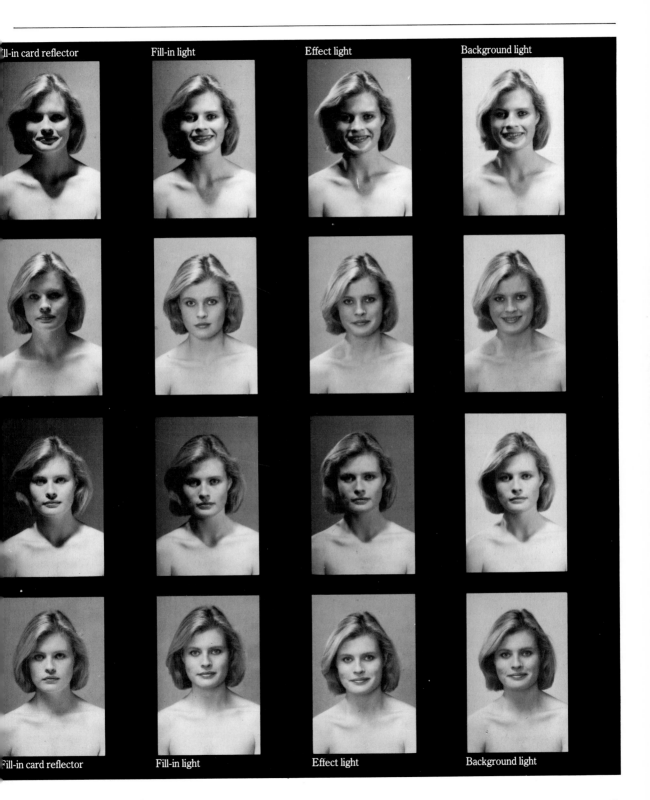

Fill-in card reflector

Fill-in light

Effect light

Background light

Fill-in card reflector

Fill-in light

Effect light

Background light

Portrait lighting/approach and effect

delineating the eyes and mouth clearly. As the object in most portrait photography is to show character through expression (a generalization, certainly, but largely true), there is less of a need for lighting virtuosity than clarity. Portraiture is not intrinsically similar to still-life photography.

Even within this range of diffuse frontal overhead lighting, there is considerable choice of effect, and the seemingly slight differences between the many diffusing and reflecting fittings on pages 70-76 can be seen to be important when used with a facial portrait. Umbrellas usually work well and are probably the most common fitting, although their effect may be so diffuse and directionless that they give insufficient structure to the face. Also, they are difficult to use close to the face because of the support fittings, and because their light spill is largely uncontrollable and can easily cause flare. Area lights are more precise and controllable, but as they are also more directional should be used very close.

A popular variation of position is over and in front of the camera, as close to the lens axis as possible. This, combined with efficient reflectors beneath and to the sides of the face, gives gentle, symmetrical shadows; when used with make-up that can be adjusted to strengthen or lighten tones on the various planes of the face, this frontal, enveloping style is attractive for cosmetic shots (see pages 160-161). For practical reasons, this technique needs an area light.

If the light is moved back to a position directly over the face, the effect is more dramatic and emphasizes skin textures. It also produces heavy shadows under the chin, mouth, nose and eyebrows. While less conventional than most frontal positions, this style can be powerful if used sparingly.

Single-light arrangements like these nearly always need some kind of shadow fill if all the facial planes are to remain within the latitude of the fill. Reflectors of varying efficiency and size are the simplest method, and the degree of shadow fill is largely a matter of taste. The strongest reflectors – mirrors and metal foil – often work too well, making themselves obvious rather than unobtrusively balancing the tones. An alternative is a secondary light, but if this is used only to fill shadows, and not for effect, it only needs to be heavily diffused and of relatively low power (one quarter of the main light's output is reasonable). Second shadows from this light are distracting, and complicate the picture.

Other lighting directions and arrangements tend to

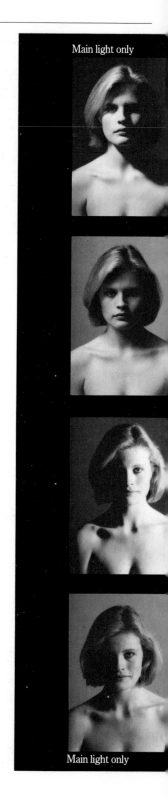

Spot
Top

Main light only

Umbrella
Top

Spot
Side lighting

Umbrella
Side lighting

Main light only

l-in card reflector Fill-in light Effect light Background light

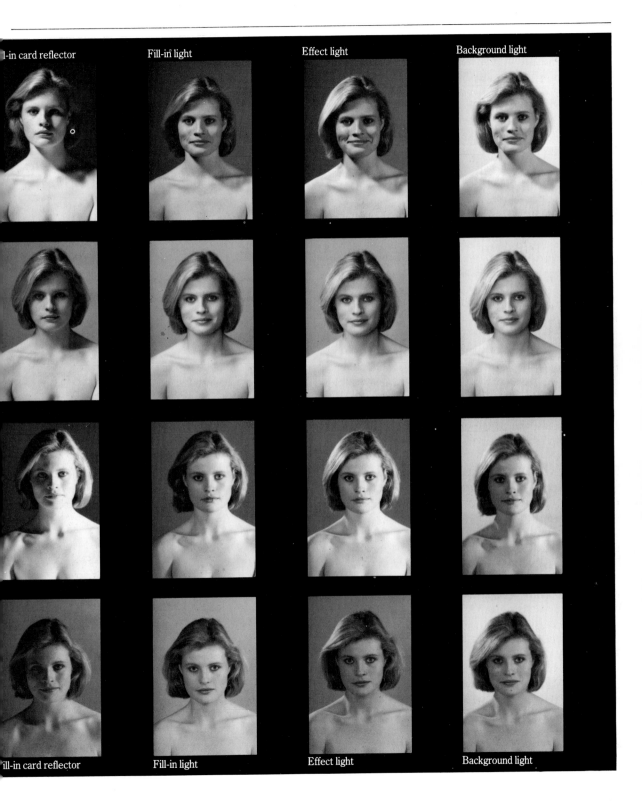

ill-in card reflector Fill-in light Effect light Background light

Portrait lighting/approach and effect

appear more stylistic. Indeed, certain of these have become either fashionable for a period or associated with the work of a particular photographer. An example of this is (or rather, was, as the fashion has largely passed) axial lighting, using either a ring flash or a white-painted box reflector containing a hole for the camera lens. Being flat, except for thin, shadow outlines, the effect is distinctive, and can work quite well with appropriate make-up (strong in tone and colour to compensate for the lack of form in the face).

Side-lighting, because of the bilateral symmetry of the face, produces a half-and-half effect in a full-face shot (hence one name for it, 'hatchet' lighting). Although a little unusual, this can be graphically strong; with the head turned to a three-quarter profile, however, the shadows tend to be complicated. In many ways, a full profile is the most appropriate pose for side lighting – the picture becomes a side view of a frontally lit face. Rim-lighting, which uses a single lamp from behind and to one side of the face gives high contrast, particularly against a dark background, and is one of the more extreme directions not to say mannered. Its graphic advantage is that it outlines its subject, and for this reason can be useful for profile. Using two lamps, both spots, on either side of a subject photographed full-face, is an even more theatrical version but has only specific uses.

A number of lighting techniques are so special and unusual that they are essentially effects lighting. If used at all, they require caution and restraint; lighting effects that might seem fortunate if caught in natural circumstances tend to seem contrived and flamboyant if designed deliberately in the studio. Spotlighting is one of these, and needs some flare to carry it off successfully. Ground lighting, from below the face, produces such *grand guignol* effects that it almost inevitably appears as a pastiche.

Two effects lights of more general, but subsidiary, use are back-spots and catch-lights. Back-spots give a rim-lighting effect, which on certain hairstyles can be prominent. Catch-lights are the small bright reflections in eyes that can appear to enliven expressions; a small low-power spot or mirror can produce these, although a frontally-placed main light will create its own reflections. The danger with such effects lights is that they can become part of a standard, and therefore boring, repertoire. Lighting should be designed and selected on its merits, not on its popularity.

Spot
Side back

Umbrella
Side back

Spot
Front

Umbrella
Front

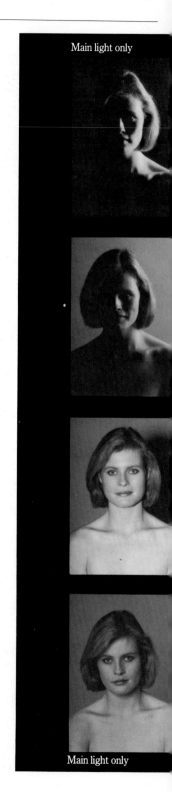

Main light only

Main light only

l-in card reflector Fill-in light Effect light Background light

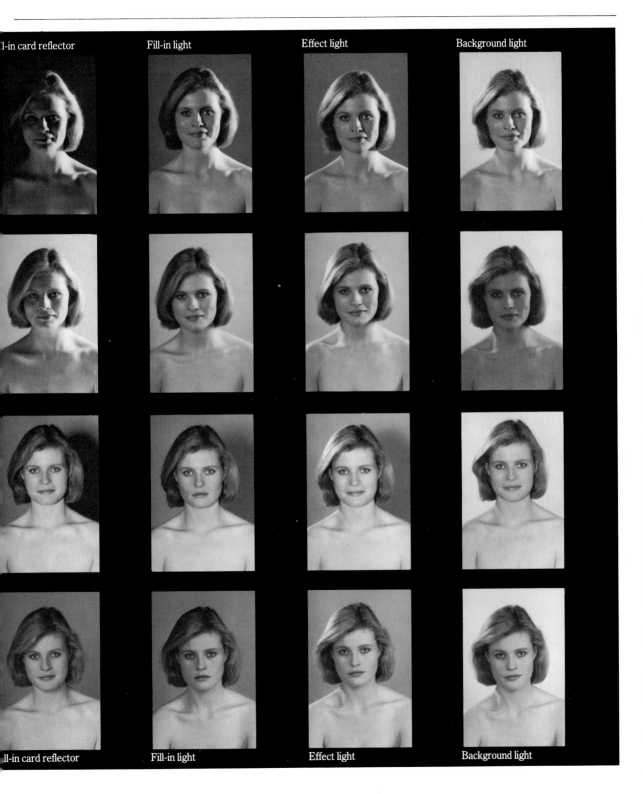

ll-in card reflector Fill-in light Effect light Background light

Portrait lighting/the figure

Pulling back from the face to the complete figure creates a new set of lighting requirements, in both scale and type. Not only is the picture area now in the region of a couple of metres in each direction, but the form of the subject has changed from being approximately spherical to long and angular. Fortunately, at this greater scale, fine close-up details are less important, and there is usually less need for the lighting to be precise, but the more distinct shape of a human figure restricts the style of the lighting.

A standing figure favours a strong element of side-lighting. An overhead position for the light has distinct problems, as not only will shadows tend to pool underneath, but the difference in the distance from the light to the head and to the feet is so great that the contrast is likely to be excessive. Frontal lighting can be used successfully, but in this instance there may be *insufficient* contrast and modelling.

There are several ways of providing horizontal lighting, all of them requiring more working space than a facial portrait. Umbrellas are a fairly simple method, and by using either large ones or by placing a number of

This portrait of a mime artist was lit by bouncing the flash from a large white reflector placed close to the camera.

A large diffusing screen was used to create a soft even light at about 45° to the camera position.

Portrait lighting/the figure

small ones close together, the area of the light can be made large enough (as a general rule, the size of the light source should be no less than that of the figure, approximately two metres by one metre).

Another method, more directional and producing less light spill, is a cupboard, basically a vertical, open-sided box painted white, into which two or more regular lamps are aimed. The effect of this, using low-cost reflection, is very similar to the more expen-sive large area light commonly known as a swimming pool. A third alternative that can produce a similar effect is a trace frame, backed by ordinary lamps and flagged off to protect the lens from flare.

In all these cases, some shadow fill is usually needed for the opposite side of the figure. In a small studio with light-toned walls and ceiling, the shadows will be filled naturally, but otherwise, a large reflector such as a white-painted flat or rotatable panel is standard.

Even with a broad light source, a full-length figure is large enough to cast a quite definitive shadow. A typical mistake, shown at left, is to place the model close to the background. For a less distracting result, move the model forward, pull out the base of the background paper for a gentler curve, and consider lighting the background separately.

In this efficiently lit full-length portrait, there is modelling to the figure and a sense of depth. One virtually undiffused light (with only a standard reflector bowl) is used frontally, from slightly to the right of the camera, a well-diffused side-light from the left and slightly behind the model, and a small spotlight trained on the shoulder and hair from above right.

With a figure lying down, an overhead diffused light gives good modelling particularly if placed slightly behind the model and pointing towards the camera.

Working with more than one model

Photographing two or more people together introduces new elements in both composition and direction. It is not necessarily more of a problem than a single portrait – indeed, a group is much less likely to be self-conscious than one person alone – but different preparations are needed.

As with any portrait, the faces will naturally dominate as the foci for attention, so that how they appear in relation to one another is crucial. With two people there will inevitably be a twin focus of attention, with the axis between the faces an important element in the composition (if they are far apart, the viewer's eye will be encouraged to scan the picture; if the faces are close together, or overlap, the attention will tend to move rapidly between the two pairs of eyes, reinforcing their juxtaposition).

There are, as might be imagined, an infinite number of satisfactory arrangements for several people, and it is as important to beware of formular compositions as of haphazard grouping. A broad-based triangular composition, for example, has much to recommend it, but it is by no means the only one. What is usually necessary, however, is to provide some sort of structure to the design. This can follow a geometrical shape with the faces at the corners, or it can be a pattern or rhythm. On a practical level, the grouping must allow each face

to be clearly visible, and the more people in the photograph, the more care has to be taken. Arranging a group in depth, particularly if more than two lines deep, means either positioning them at different heights (sitting versus standing, for example, or using chairs and stands of different heights) or shooting downwards from a high camera position. A large group inevitably requires a large studio, and appropriately large-scale lighting; a wide-angle lens is one method of overcoming space problems, but in a group shot this would tend to create distortion of the nearer people.

One of the advantages that a group shot brings with it is that the people nearly always have something in common, and this can often be exploited. If they share a common work or interest, for instance, this may suggest an appropriate prop (the members of an orchestra with their instruments is an obvious example of this kind of shot) or dress (as seen in the picture of the ballet dancers below).

Simply organizing a group of people into position requires some fairly firm direction, and once they are there, expressions and poses have to be orchestrated. As a rule, the possibilities of unwanted facial movements and gestures increase in proportion to the number of people, and multiple shooting is only prudent.

The photograph (far left) of two leading dancers from of the London Festival Ballet was lit by three flash units, one with a red filter, placed behind the background screen, while another was placed behind a Reflectasol panel to the right of the shot. The main light came from two standard reflectors placed to the left of the dancers.

This portrait of the members of a rock band (left) relies on careful positioning of their heads to create a pleasing and effective compositon.

This double portrait (below) was strong side-lighting and also a profile combined with a full face to produce a composition of contrasts.

Make-up for photography

When applying make-up tie hair back to keep it away from the face.
Spraying it with water also helps to hold down stray ends.

Pluck stray hairs if necessary and then pencil in eyebrows.

Eyeliner defines edges of eye.
Then add mascara to lashes, but avoid clumping which will show strongly in a photograph. Use the tip of the mascaara wand for extra control and to separate lashes after drying.

Use eye make-up to enlarge appearance (working outwards makes eyes seem more widely spaced) for colour effect and to lighten sockets. Apply under eyes by dabbing spots and then blending with a small natural sponge.
Use brush for shadow.

Outline lips with liner, drawing down into the centre of the upper lip to emphasize the bow of the mouth. Fill in with colour. Lip gloss applied over the colour adds sparkle.

Foundation applied with sponge to give overall smooth surface.
Face is then freely powdered to set foundation, and to eliminate shine.

After make-up is complete, carefully remove all traces of loose powder with a large soft brush.

Blusher applied after shading completed under cheekbones to give shape and also to define jaw line.

If photograph is to be in black and white, use weaker red than normal to avoid over dark appearance (this also applies to the lips).

If top lighting is to be used, make neck foundation lighter than normal.

At one extreme of the photography of people is what might be called the cosmetic portrait, usually commercial in motive and fashion-oriented. In a sense, this is the logical conclusion of flattering portraiture – applying make-up to enhance the best features of a face and to correct its blemishes and worst features. For obvious reasons, it rarely applies to men (reducing highlights by wiping off natural skin oil and applying a light dusting powder is about as far as it is possible to go without looking unnatural).

The techniques of make-up are very specific, and the basic ones are illustrated in the stages opposite. Before this, however, there are some decisions to be taken to make the most effective use of facial cosmetics. In a number of ways, make-up for photography differs from that for normal use. Firstly, while most women have developed a few basic permutations that suit them for certain occasions (a formal evening, for example, or day-time city use), there always has to be a purpose to make-up for the camera. It may be to produce a sophisticated face, or a glamorous one, or one that has a fresh, country appearance.

In practice, the make-up and the specific photographic techniques of lighting, camera angle, filtration (and possibly even diffusion) work together rather than separately. If the make-up is designed to suit the lighting (such as softening or enhancing contrasts), the results are likely to be better. Because cosmetics can be applied more discriminantly than the light, the most common lighting techniques are those that envelope the face and produce low contrast. Shadows and highlights to define structure can then be painted on. Although it is inconvenient to apply make-up under the studio lighting it must always be checked there before shooting. If the lighting arrangement is frontal and diffuse, as is usual, a regular theatrical make-up mirror, with a surround of tungsten lamps, is a very close match.

As the primary objective is usually to make the subject look as attractive as possible, an important skill is to be able to identify best and worst features. Specifically, at the risk of over-generalizing, eyes look best when large, well-defined and fairly widely spaced; the mouth looks best with moderately full lips which have a well-defined shape; the facial structure looks best when the cheek bones are well defined, the jaw delicate and the outline smooth; and the skin is most attractive when smooth and free of blemishes. All of these idealized properties can be aided, if not actually created, by make-up. The apparent size of the eyes can be increased by pencilling, lining and applying colour shading, their spacing can be altered by shading outwards; lipstick, liner and gloss take care of the shape and fullness of the mouth; foundation and blushers can alter the structure and outline of the face; foundation and powder smooth the skin texture.

Photographing the human body

In the photography of people, the face nearly always dominates. The one major exception is when the subject is the body, and in this instance, for aesthetic reasons it is usually naked. There are two possible components in this field of photography, the sculptural and the erotic, and though it may not always be possible to suppress one or the other completely, the photographic approach tends to have some bias. When the erotic content is important, the pose and lighting are directed towards an essentially emotional appeal, and the subject's expression is usually a help. Sculptural nude photography, on the other hand, is closer to the treatment of a still-life, and the face is more often an unnecessary distraction.

As an object, the human body is complex, with a rich variety of texture, form and outline. After several decades of serious attention from photographers, it can still produce visual surprises, and is probably an inexhaustible source of fresh images. The studio is particularly suitable as a location because the lighting, so important to a sculptural treatment, is under full control, and the pose and composition can be arranged precisely. Also, for practical reasons of comfort for the model, a studio offers more relaxing surroundings than most outdoor locations.

Photographically, the body has tended to encourage experiment, and contrasts in this respect with regular portraits. A torso, after all, is less adept at expressing character on its own, without the help of photographic technique. Lighting, choice of lens, framing and arrangement have all been used successfully by different photographers to show different aspects of the body.

For a very concentrated modelling effect, a single flash head was used for this photograph. Diffused with a 3ft x 3ft area light (fronted with translucent paper), the 1500 joule/watt-second light was suspended high over the model and behind, to emphasize the outline and musculature.

For this full length photograph, two lights were used to cover the entire side of the body – a 3ft x 3ft area light for the torso, and below it a large white reflecting umbrella. As in the photograph opposite, black background paper was used; this was additionally burnt in at the printing stage.

Photographing the human body

Abstraction enables use to be
made of dramatic and unusual
lighting, and of close framing. It
is a technique for isolating a
particular structural component.

A stylized pose and almost
silhouetted lighting has
produced a more graphic image.

With a single light, a medium-toned background provides just enough outline contrast on both the lit and unlit halves of the figure.

STILL-LIFE

A good case can be made for claiming that the still-life is the purest form of studio photography. Studios are built for control, as a means for letting the photographer's instincts and ideas hold sway. The remaining variable is the subject, and some are easier to manipulate than others. Where the subject is a person, the results are likely to be unpredictable, for his or her personality will play a major part – indeed, this is one of the delights of making portraits.

Inanimate objects, the basic stuff of still-life photography, have much less presence than a person, and so depend almost entirely on the photographer. Their choice, and the way they are treated in lighting and arrangement, governs the success of the pictures. Some objects have certain properties that restrict some of the photographic techniques that can be used – reflective surfaces and glass are notorious for this, while some specialized subjects, such as food, have inherent viewer expectations – but the photographer's taste is the final arbiter.

Still-life photography, like portraiture, is not limited to the studio, but on most occasions it is certainly easier to perform there. A still-life picture needs to be made rather than snapped, and the studio has the facilities for manufacture. It allows a full choice in lighting and setting, as well as one essential but easily overlooked commodity – time.

Special images from everyday objects

Traditionally, in painting and in the early days of photography, there has been some notion of what is a fit subject for a still-life. Ideas of propriety changed with fashion, but generally excluded the mundane, and favoured objects that were felt to have inherent aesthetic interest. Flowers, decorative objects, attractive items of food such as fruit, fish and game, and objects that had acquired a patina of age were considered acceptable, but common, inelegant household utensils and fittings received virtually no serious attention.

Photography, and in particular advertising photography, has changed this narrow aesthetic. The relative ease of making pictures with a camera has had a democratic influence on the general choice of subject matter, and no serious investment of time and effort is necessarily involved in photographing any found object. More specifically, however, photography has an important commercial role in displaying mass-produced consumer goods, and as these are often mundane in the extreme, and occasionally numbingly dull, advertising photographers have been called on to inject the maximum visual interest. Perversely, this challenge, to make the best of objects that most people would

Rather than the soft enveloping light from a diffused lamp – the normal treatment for shiny still-life subjects – here a single small, powerful spot has been trained on two lighters. The high contrast, bright specular reflections and hard shadow edges that this lighting method produces have had an unexpected effect on the sense of scale, which appears peculiarly large. This exaggeration of scale has been further enhanced by tilting the camera back forwards, so distorting the closer parts of the larger lighter.

ignore, has been met so well that advertising still-life photography has established new standards of imaginative treatment and has given respectability to a large family of lowly objects.

Essentially, what advertising still-life photography has demonstrated is that visual interest can be found if it is looked for, and depends more on the photographer's eye and technique than on the aesthetic properties of the subject. Some of the most successful still-life pictures have been a result of determined experiment – determined, that is, in the sense that the photographer met the challenge of finding a striking image without necessarily knowing in advance how it might turn out. This is more a question of philosophy than anything else, and it demonstrates a fundamental premise of still-life photography – that pictures are created by applying imagination to the raw material of the subject. This is not to say that each still-life object must receive the royal treatment, with every last drop of drama squeezed out of the lighting, camera angle and composition – restraint can sometimes be more effective in drawing attention – but the choice of treatment lies with the photographer. Only rarely, for commercial reasons, does the subject dictate particular methods.

The curves of the wine glass and cherry here complement each other in a still-life that relies on great magnification for its effect. Instead of showing the full glass, the photographer has cropped in closely to make the setting less obvious. The cherry has been positioned carefully so that its stem converges with the curve of the glass, an effect helped by refraction in the water. Behind is the green stem of a second, up-turned glass; *its* refraction adds more concentric curves of colour.

Back-lighting and side-lighting were used together, the former to give a strong outlined structure to the image, the latter to show the textures and colour of the cherry. Shot on 4 × 5 transparency film with a 150mm lens (standard for the camera format), the total camera extension was 450mm.

Special images from everyday objects

Although the battery-operated penlight (left) measures only 3 inches, in this still-life treatment it appears monolithic. Photographed with a 4 × 5 inch view camera, its proportions have been exaggerated by an extreme backward tilt of the camera back (see pages 52-53). The tilted frame and tiny light aimed from the lower left (to cast the sharp shadows normally associated with larger-scale views) add to the enlarged effect.

To add visual interest to a cheque, normally an unexciting subject for photography, different elements have been photographed separately onto high-contrast line film, with the paper held in different positions. These line negatives have then been copied, through strongly coloured filters, onto one piece of film, together with a base image of the ordinary cheque photographed on black velvet. For multiple-exposure techniques, see pages 216 - 217.

The classic set-piece

In contrast to the individual and distinctive treatments used to generate interest in extremely commonplace objects, there are traditional procedures for tackling less problematic material. The objectives are efficiency and clarity, to display an object or small group simply, without fuss or drama but with some elegance and sensitivity. This basic approach to still-life is also valuable as a procedural exercise, and demonstrates the kind of stages and judgements that are common in the studio.

Some assumptions are necessary: that the object or objects have already been selected, and have no unusual properties that would demand special lighting, and that the setting is simple, complementary, and closely surrounds the objects. In fact, these preliminaries apply to a large proportion of still-life photography.

The general procedure is one of refining the image, gradually narrowing down the choices until the photograph is ready to be taken. The areas of choice involved are: arrangement, camera position, lens focal length, camera movements (together these determine the composition of the picture), lighting and filtration. In practice, most of them are interdependent, and changing one usually means that something else must be altered. Moving the position of the light, for example, may cast a shadow over one small object, which must then be moved slightly, and this in turn may call for a camera movement, and so on.

This interdependence is one reason why the development of a standard still-life photograph involves continual adjustments. The other is that, even though the photographer may have a fairly clear idea at the start of how the final image should look, the very process of assembling the different elements frequently suggests alternative treatments. In advertising photography, the layout may be predetermined, but otherwise it usually pays to remain flexible and open to experiment. Not surprisingly, even a simple set-piece still-life can take two or more hours to complete.

With an approximate idea of an image, the usual first step is to make a rough arrangement of the set and the lighting (or at least the main light). At this point, the camera, with selected lens, may also be positioned approximately, or the set may be judged by eye alone – this is a matter of personal practice. It is a great advantage to be able to block off any ambient lighting.

From this point on, the adjustments are specific, as the example below illustrates. To keep the procedure under control, it is fairly important to try and make the changes smaller as time goes on. Reflectors and masks are generally positioned towards the end as they tend to restrict access. The final step is a thorough technical check, of contrast, flare protection, focus and colour fidelity. At all stages, Polaroids are ideal for checking.

The actual studio area needed for this photograph was relatively small. A main area light was situated on the left, and a second background light behind that.

The shadows added to the background were controlled by clamping poles and black paper into position. In the photograph on the opposite page, they appear softer through being outside the depth of field.

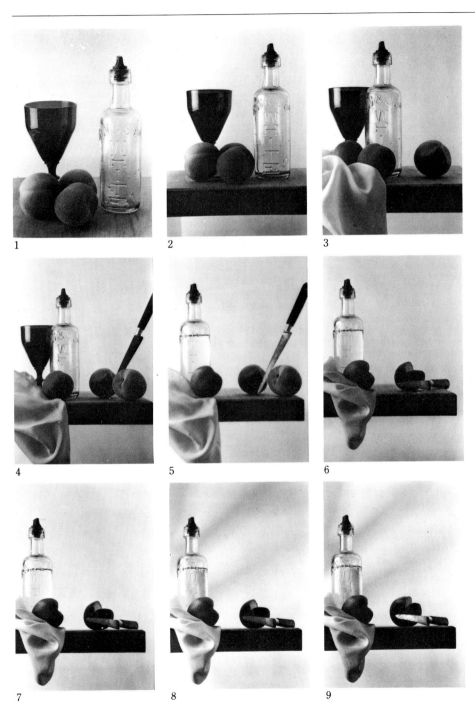

1 2 3 4 5 6 7 8 9

Stage 1 Rough positioning of objects, camera and lights.

Stage 2 Re-framing, with camera lower.

Stage 3 to 6 In these steps, the photographer has experimented with different groupings, finally discarding the dark glass and making a simpler, more geometrical design. In stage 6, a 'stand-in' cut peach has been put into the set.

Stage 7 The camera is levelled and the film back lowered (see pages 48-49). This removes the convergence.

Stage 8 Shadows are added to give depth and to strengthen the angular design.

Stage 9 A freshly-cut peach replaces the 'stand-in' and a mirror at right gives a reflection to the blade of the knife.

Using different backgrounds

While a simple, plain background is as much a safe choice for a still-life as it is for portraits, there are more occasions when objects need imaginative settings. There is such a great variety of composition possible in still-life photography that the background can play an important part in the arrangement. At the opposite extreme from plainness, it can become an integral part of the set.

A still-life background has a number of functions, although not all at the same time. These range from solving practical problems of lighting and reflection to aesthetic contributions, to altering the content of the shot. The choice of materials, consequently, is limitless, and apart from the standard, widely-used range of Formica, black velvet, perspex, paper, various kinds of stone, wood and leather, includes such unusual surfaces as liquids and conglomerates made up of large numbers of identical objects.

The most practical function of a background is to help the lighting, particularly if the object is reflective or transparent. In any rounded object with a shiny surface, the edges will reflect the background, and because of the acute angle, more efficiently than any other part. As a result, the tone and colour of the background must be selected with this in mind. A silver teapot on a black

These two photographs of a Vernier rocket engine demonstrate the value of a plain black background on certain occasions. Not only can it remove distracting background elements simply, but, provided that the subject is bright rather than dark, adds contrast that can enrich tones and colours – in this instance, the gold plating of the machinery. The simplest way of producing such a 'drop-out' black is to drape black velvet, the least reflective of all background materials.

Natural surfaces, such as earth, unworked wood and stone, have connotations of solidity and weight, and also rough textural qualities which can be used to complement or contrast with other objects.

Liquids – even plain water as in this still-life – offer the advantage of interesting and variable surfaces, as well as offering very clean, smooth reflections if lit appropriately. They can give a sense of life and movement if used either when pouring or splashing, or in a pattern of drops and puddles.

One of the simplest of plain backgrounds is the top-lit white Formica scoop, in which the natural fall-off of illumination produces the impression of a deeply receding background.

ground, for example, will appear to lose some of its outline in black reflection. In contrast, a flattish reflective object, positioned so as to reflect the full flood of illumination from an area light (see pages 96-99), will be very much brighter than any normal background, and unless this is intended to appear black, the material chosen will have to very light in tone.

Another function is in the design of the picture, to complement, for example, the visual qualities of the subject. Diffuse overhead lighting on a sloping, receding white background performs a kind of cross-over effect that heightens the contrast between subject and background: the gradation of tones in each is in opposite directions.

The associations created by certain surfaces can also be useful in suggesting qualities for the subject – often important in advertising, where more has to be implied than can be stated. Some smooth metals and plastics, for instance, can suggest precision and efficiency; a rough hewn block of stone can suggest natural origins and solidity; and so on. Directed more towards the content of the image, specific backgrounds can imply the pedigree of an object – a standard advertising technique. Value, for example, can be endorsed by a plush setting containing other valuable objects, such as jewellery and rare old books.

Props

Although props usually play a supporting role in a still-life set, they tend to receive very close attention. In a film or television scene, props are generally glimpsed in passing, but in a still image they are available for scrutiny. This means that not only must a prop be of the correct type (for instance, the right period for the historical reconstruction), but it must be of prime quality and selected with some good taste and a sense of style. The quality is obviously important because scratches, tears and any other imperfections stand out more clearly in a still picture than in real life. The style can make the difference between a run of the mill, workaday shot and a really successful still-life image. Among the important functions of props in this type of photography are establishing the flavour of the scene and, on some occasions, its authenticity. How effectively these are done depends very much on the care and effort put into selecting them. Usually there is a premium attached to items that are rare, unusual and elegant, but often what are needed are simpler, more commonplace objects, and finding these in an attractive form can be particularly difficult.

There are a number of possible sources, depending on the type of subject. In cities that support a professional motion picture, video or photographic industry, there are usually props hire companies. In some ways these are ideal, although the fact that the stock is rented out constantly often means that the condition of items is not perfect, something that may not be so important in film or video, but certainly is for

Here, the subject was an illuminated parchment, and the function of the props was to augment the composition without distracting attention. Two classes of related props were looked for – drawing instruments and contemporary books. In both cases, they were supplied by dealers: a specialist in antique scientific instruments and an antiquarian bookseller.

In this photograph (left) of a collection of Victorian children's shoes and boots, the props had to do two things – to provide a related setting (that is, contemporary), and to show the scale of the footwear. The solution, without complicating the design, was a period rug and a child's chair, both to show size and to give a hint of a playroom setting.

In this collection of whaling tackle (below), the rope and sail are modern, but in the context of a naturalistic layout this is unimportant. Tight cropping made larger set surroundings unnecessary.

still photography.

Antique shops are a good general source of old and unusual items. Some dealers may be happy to hire goods without question; others are likely to respond favourably to an offer of the full value as a deposit. Ten percent of the cost per week is a standard rental.

For new items, regular stores may supply goods on loan for publicity, or for an arrangement similar to that suggested for antique dealers. Damage, of course, must be paid for, and if expensive props are hired, it may be wise to take out insurance.

Professional advertising photographers, who generally have a budget to cover it, often hire professional props consultants, known as stylists. A stylist will take the responsibility of suggesting and supplying props for a shot, and a good stylist can contribute significantly to the success of a still-life photograph.

Finally, certain objects make such good reusable props that studio photographers assemble, in time, a permanent collection. This is particularly useful if a photographer concentrates on one specific field, such as food: drinking glasses, bottles, and various utensils might, in this case, be worth buying.

Still-life accessories

As many of the photographs in this section demonstrate, the techniques for preparing and manipulating ordinary objects for still-life photography can be so precise and complex that they need their rather special tools and materials. Very few can be found on a photographic dealer's shelves, and the eclectic array below and opposite is a result of practical experience in the special fields of still-life photography.

What these tools and materials represent is the gap between the way still-life objects and surfaces actually appear and the way photographers think they *should* appear. One area of concern is simple cleanliness – any still photograph gives viewers the opportunity to examine a scene in great detail, with the result that flaws, streaks, finger prints and specks of dust always appear more prominently then they would in real life. At close range they are even more obvious, and smooth, reflective surfaces are the most susceptible.

Holding things in place is another special need, both within the set, where some objects may have to be

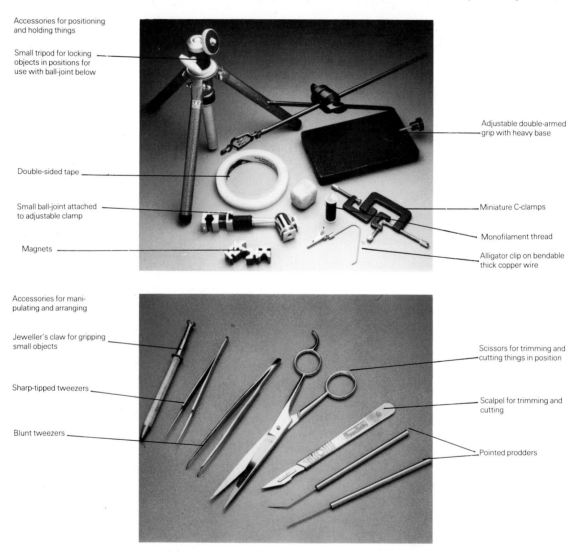

Accessories for positioning and holding things

Small tripod for locking objects in positions for use with ball-joint below

Double-sided tape

Small ball-joint attached to adjustable clamp

Magnets

Adjustable double-armed grip with heavy base

Miniature C-clamps

Monofilament thread

Alligator clip on bendable thick copper wire

Accessories for manipulating and arranging

Jeweller's claw for gripping small objects

Sharp-tipped tweezers

Blunt tweezers

Scissors for trimming and cutting things in position

Scalpel for trimming and cutting

Pointed prodders

angled in a certain way, and surrounding the still-life, where various reflectors and accessories may have to be positioned precisely.

At an advanced stage in composing a still-life, making changes to the final arrangement of the set is quite a delicate operation. Moving one object can disturb others, and a small set of tools is useful for making fine adjustments.

On some occasions, water and other liquids may need to be introduced – in the photography of food and drink, for example, or in certain kinds of special-effects work. Sprays, steamers and freezers are different ways of coating surfaces with moisture (the last two create condensation). Compressed air and pipes are a means of creating bubbles or agitating the surface, while pipettes and syringes can be used for adding liquids precisely or injecting coloured dyes into liquids. Glycerine is a useful substitute for water, particularly for coating surfaces and creating pools and drops – it is thicker and so holds its shape well in globules.

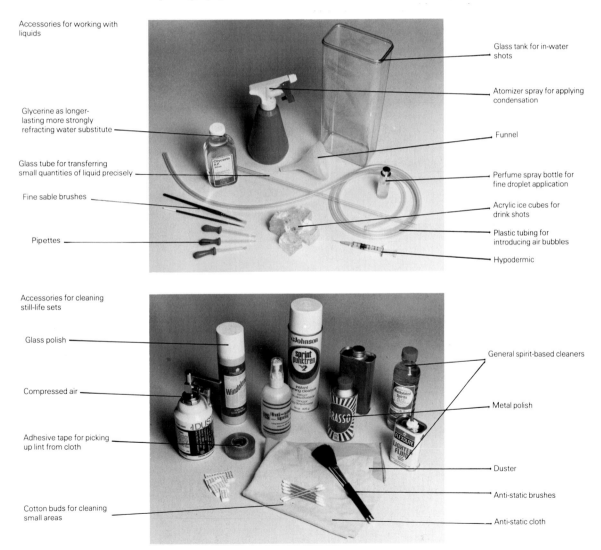

Accessories for working with liquids

Glycerine as longer-lasting more strongly refracting water substitute

Glass tube for transferring small quantities of liquid precisely

Fine sable brushes

Pipettes

Glass tank for in-water shots

Atomizer spray for applying condensation

Funnel

Perfume spray bottle for fine droplet application

Acrylic ice cubes for drink shots

Plastic tubing for introducing air bubbles

Hypodermic

Accessories for cleaning still-life sets

Glass polish

Compressed air

Adhesive tape for picking up lint from cloth

Cotton buds for cleaning small areas

General spirit-based cleaners

Metal polish

Duster

Anti-static brushes

Anti-static cloth

Constructing a simple still-life

Just because there *is* so much choice in still-life photography, from the arrangement of subjects to lighting, it helps to follow a generalized procedure. This makes it easier to organize the many decisions that are involved into a manageable order. In practice, each still-life session poses its own special problems, often calling for unique solutions, but in principle many of the steps in the progress of a still-life, from selecting the props to the finished image, are the same.

As an illustration of how a typical, straightforward still-life can be constructed, one simple subject was chosen here as a working example – a cocktail glass. Unlike an advertising commission or the design for a magazine cover, the photography had no ulterior motive: the only purpose was to exercise studio skills and produce an attractive image. Like many still-life compositions, most of the preparation was possible *before* placing the camera in position.

The clean, elegant lines of the glass suggested an uncluttered approach, both in terms of composition and lighting. Thus, a fairly steep camera angle was chosen for a horizon-less view, and a sheet of dark Plexiglas

selected for a background of almost clinical simplicity. One of the special advantages of Plexiglas is that it has a *reflective* surface; experience suggested that the cleanest rendering of the glass on its liquid contents would be some form of back-lighting, and in anticipation of the next stage in the process, the Plexiglas was placed flat up against a white wall. Purple Plexiglas was used for delicacy – this is a colour which is recorded weakly on most colour films, the more so when back-lit, so that the final effect would be only a slight hint of a normally opulent colour.

The next step was to arrange the lighting and, in keeping with the theme of simplicity, only one, diffused light was used. However, because the main influence on the lighting would be the refraction and reflections from glass and liquid, the fine adjustments were left until the cocktail glass had been filled – right to the top so that the surface reflections would not be complicated by the rim. With the Plexiglas behaving like a dim mirror, it was important that the light source be sufficiently large that no edges would show. One way of increasing the area of a light is to shine it through a

The ingredients of the shot were, from left to right, pistachio nuts, a cloth for cleaning, cocktail glass, olives, a reflective plastic tube for blowing bubbles, pipette for adding and removing precise amounts of liquid, brush and tweezers for moving small things, and a bottle of gin.

An overhead light is angled to reflect off the white wall, to give graduated illumination.

The Plexiglas background is cleaned to remove marks and specks.

The glass is filled before making the final lighting adjustments.

A flash meter reading is taken for an exposure that holds the highlights.

The pistachio nuts are arranged and excess bits removed.

Just before shooting, bubbles are blown into the liquid.

Even small alterations to the position of the light can change the tonal values greatly. Moving the light too close to the white wall brings its reflections into view (far left), pulling it back reduces the wall shadows and gives a flatter range of tones (middle), while angling it downwards gives brighter internal reflections but less contrast with the background (near left). The position finally chosen was similar to that in the picture at far left, but with the light raised out of sight.

The final image reduces shape to the simplest, symmetrical components, and also emphasises the texture of the liquid through the graduated tones in its surface and the sparkle of reflections from the glass. Tonal control is the most distinctive photographic ingredient, with colour playing a deliberately restrained role – the red pattern in the glass and the small complementary green reflections from coloured cards placed far on either side provide the only colour accent. Ektachrome ASA 64, f32, diffused and reflected flash.

Constructing a simple still-life

large sheet of diffusing material, such as tracing paper on a trace-frame, but here an even simpler alternative was used – the overhead light was bounced from the wall opposite the camera. Small changes to the height and angle of the light could give a variety of effects, one of the attractive possibilities being a graduated background (the out-of-focus reflection of wall shadows in the Plexiglas). These final adjustments were made with the camera in position, as the angle of view affected the appearance of the lighting. No special focal length was necessary, and a standard lens was used. In the event, the shape of the glass created some unwanted reflections, and refining the position of camera and light was time-consuming.

When complete, the lighting set-up was measured for exposure. A deliberately dark image was wanted, to show off the fine gradation in the mid-tones, so that the exposure was calculated to hold the brightest reflections from becoming a featureless white. For this highlight reading, a flash meter was used, fitted for incident readings and pointed directly towards the light source behind (if tungsten lighting had been used instead of flash, a hand-held incident meter could have been used in exactly the same way).

The last stages in the process were taken up with details. To offset the starkness of the basic image, it was decided to add a small naturalistic note. An olive was tried, but disappeared in the refractions of the glass. A more successful addition was pistachio nuts, deliberately broken open. The composition was adjusted for these by shifting the camera slightly to the right. Finally, to bring a little life to the drink, bubbles

Mercury or its fumes are dangerous if ingested; rubber gloves and an air extractor were essential precautions.

The mercury drops are pipetted in place.

Gently, a ball-bearing is lowered onto the surface with tweezers.

A more unusual composition, using a large area of plain background, is in keeping with the choice of mercury as the drink, in this lopsided parody of an advertising photograph. Ektachrome ASA 64, f32, diffused and reflected flash.

One of the creative possibilities in extreme close-ups is to select one or two key details, so that the essence of a subject can be shown without being completely obvious. Here, the olive, its shape refracted in the gin, and the two curves of the edges of the glass are enough to give all the important information about the cocktail glass.

For the photograph of the olive, a monorail studio camera, taking 4″ × 5″ film, was used, although a rollfilm camera or 35mm SLR would also have been quite adequate. To compensate for the light lost at this great extension, the studio light was placed very close to the glass, and to prevent flare, a lens shade was used masked down to the exact picture area.

were gently blown into it several times, until two remained next to the far rim.

However, one polished image is not necessarily the end of a still-life session. Inevitably, the process of refining lighting, composition, and so on, closes off options at each step, but any number of routes can be followed, to give very different final images. To show just a couple of the possibilities with this example, the original set was taken down and the cocktail glass subjected to two quite different treatments, one an extreme close-up, the other slightly eccentric.

The close-view was a relatively straightforward matter of experimenting with the way the glass looked at high magnification, trying different angles and lighting positions while viewing it through the camera. Side-on and with back-lighting, here was an opportunity to use one of the olives; just enough direct light was allowed to spill onto the olive to define its colours.

For the other treatment, green Plexiglas was used to complement the small red patterns in the glass and similar back-lighting to the first shot was used. Encouraging bright, even reflections from the gin had been such a problem in the main shot that it was decided here to resolve the problem at a stroke by taking a much less serious approach and substituting mercury. A few drops of the liquid metal balanced the eccentric placement of the glass, and for a 'bubble', a steel ball-bearing was dropped carefully into the glass.

Simplifying the composition

In still-life photography more than most, the composition of the picture is of fundamental importance, and can occasionally be more significant than even the choice of subject. However, defining in general terms what makes an effective composition is no easy matter. There are certainly no rules, and for every guide line that appears to make sense in theory, there are more than enough examples to show that it can be successfully broken in practice.

Perhaps the only general approach that is inherently sound – and even then it is only a way of solving certain design problems – is simplification. The most common design deficiency in still-life photographs is confusion and disorder, with stray elements destroying the cohesion of the picture. While this can be tolerable in the kinds of location photography that are *not* under any

control, the very fact that it can be corrected in the studio means that it should be.

Real skill is needed to be able to handle a complex set with many elements and still make the picture hold together. A rather easier alternative is consciously to simplify the design, and there are a number of ways of doing this. The most obvious is to reduce the number of objects, or to avoid those with complicated shapes and patterns; this mainly affects the choice of props.

Another method is to alter the scale of the shot in whichever direction that produces a simpler design. Closing in is often useful as a means of concentrating on the cleaner lines of an object; for instance, the blade of a knife alone is likely to have more graphic potential than if the handle is also included. Pulling back from the subject, provided that there is a large, even back-

Probably the most basic method of reducing a complicated composition is to move in closer, selecting the simplest graphic elements in the set. In the overall view at right, the length of the knife, the various parts of the cut oranges, and the strong tonal contrast of the handle are awkward to arrange simply at this scale. However, as there are only two essential elements – blade and orange – both can be treated by showing only a small section. Both the lines of the close-up version (triangle and curves) and its colours (silver and orange) are reduced to their most basic.

ground, makes it possible to establish a figure – ground relationship.

Without making major changes to the set, one basic technique of simplification is to build the design around a basic geometrical figure, such as a triangle or a circle. These are inferred structures, as the examples here illustrate, and the reason why they appear to simplify the design is that they give it coherence, by providing a link between the different elements. There are also other geometrical ways of doing this: arranging the lines in the image so that they converge on a common point, or orienting the different elements in the same direction.

Even more subtle graphic links are possible. Colour provides an area of design that can be used to simplify, irrespective of the complexity of the objects, by means of the background, lighting, and the choice of appropriately-coloured props. Any established colour relationship, harmonious or otherwise, can work. Textural relationships also can give some sense of unity, either through contrast (rough against smooth), or similarity.

One simplifying technique that is easy to overlook works well with a mass of objects. This is to crop in or arrange the still-life so that the collection runs off the edges of the picture frame in all directions. The subject then tends to become a pattern rather than simply something on a background.

In this photograph of gold, the problem was to group all of the bars yet show each distinctly. Two graphic techniques were used. One was to use the oval shape of the balance to tie the group together (the rhythmic line of weights behind adds consistency). The second was to use a single dark neutral colour for the setting.

Abstracting the image

Exploring the graphic potential in a subject is one of the most interesting kinds of experiment in still-life photography, and involves both composition and lighting. Probably the most popular of all approaches is abstraction, and while it is not appropriate if the ultimate objective is a clear rendering of a subject, it is a good method of creating intriguing designs.

The principle of abstraction is to remove all the normal visual clues that display the physical properties of a subject; an abstract photograph is the direct opposite of the literal documentary picture. As a result, most of the techniques that can be used to abstract images are the opposite of those normally practised in photography, and virtually all of the lighting recommendations between pages 60-79 and can be reversed successfully. In particular, flouting the technical standards of photography favours the abstract. The contrast can be increased by concentrating the lighting to emphasize the bright parts of the subject and removing any reflections that would alleviate the shadows, and by using high-contrast materials and processes, such as duplicating, push-processing and lith film; this tends to obscure detail at both ends of the scale and creates distinct tonal blocks. The sharpness can be spoiled by de-focusing the image, by placing screens and special filters in front of the lens, or by emphasizing the grain structure of the film; the result of this is to make detail and texture less recognizable, focusing attention on broad colour and tonal relationships and on large shapes. Colour fidelity can be prevented by using filters, coloured gels over lights, or by altering the processing of the film in a gross way (see pages 124-125); the effect is to reduce familiarity. In a more extreme way, the image can be actively distorted by using special lenses and a wide range of special-effects techniques which are described towards the end of this section. These are the more positive techniques of abstraction, but there are also less strident methods that can be used to introduce just a degree of the abstract into a still-life. A careful combination of the arrangement of the subject, the camera angle and the framing can produce a composition that is slightly disorienting or unexpected, without being an obvious attempt at visual trickery. To a large extent this involves recognizing the most graphic elements in an object and concentrating on these – for example, aligning edges in the subject with the frame edges of the picture.

Eccentric composition, with parts of objects jutting into the frame from the edges, is another method of abstraction. The individual elements (laser, stress-polarized plastic, mercury and silicon chips) are themselves a little unusual, and their deliberately unconventional arrangement makes them even less recognizable.

In the photograph of a coin, two special effects techniques have been used to create abstraction. One is a posterization and alteration of the colours (by means of colour-key materials). The other is a multiple image using a prism filter. Finally, the series of coin images has been superimposed on a base of punched tape.

At great magnification (4× in the camera), an ordinary electric light bulb is hardly recognizable. Photographed lit, the central tungsten filament fills the frame. Two exposures were made: one with an 85B warm filter, the second, during which the camera was deliberately moved, through a green filter.

Composition and emphasis

One of the most important functions of the design of a photograph, apart from creating an aesthetically appealing or interesting picture, is the organization of the way in which the image is seen by the viewer. This organization and therefore the ultimate reaction of the viewer is dependent on a number of factors: picture content, shape and size of frame, distribution of tones and colours and the arrangement of lines, points and shapes.

The necessity of controlling all these aspects of composition exists, of course, in all kinds of image-making, but it is a necessity peculiarly associated with studio work. The key to successful still-life photography is *control*, which therefore makes it one of the easiest forms of photography in which to judge composition.

The various factors mentioned above are constantly at play in any one picture. To begin with, the frame of the picture acts as a gentle guide to the viewer's eye to move in a certain direction. This is generally in a slanting line from the top left corner of the image. This movement, however, can be modified in cases where the central image fills the frame and where the most salient individual element appears as a point. Pulling back, for instance, from a close view of a second object, so that it occupies a smaller place in a larger background, can often concentrate more attention on the object. Indeed, one of the most basic aspects of compositional control is the need to focus attention on one part of the image without making it more dominant in size. The other parts of the picture area can then be used more creatively to show other objects.

The lines surrounding a small object – the edges of other objects or the direction of their arrangement – provide one of the most effective ways of directing the eye off-centre and towards the object. Careful arrangement of such lines within the overall design can almost 'point' the eye to one part or other of the picture.

Two kinds of line, especially – diagonals and curves – seem to have the quality of expressing movement, encouraging the eye to travel along them. Even if the lines of the various objects within the picture are not arranged to lead towards a point of interest, then the lines of perspective can still guide the eye. A low viewpoint and a wide-angle lens will automatically make the eye travel from the foreground to a higher point of the picture, thus exercising another form of control over the viewer's attention.

Another noteworthy compositional technique is the use of striking graphic devices, which draw attention simply because they are unusual. An object seen close to the frame of the picture, for instance, will draw an immediate though probably unknowing response from the viewer, especially if its tone and colour are distinctive.

The theme of this magazine cover shot was Scottish Oil production. A centred geometrical design like this is one of the most direct means of drawing the eye to a single point.

In another cover illustration, money is shown as the lubricant for industry, but the intention was to have the viewer see the machinery first and the trick liquid later. To do this the 'money' was placed well off-centre and small. The attention starts higher and is then led down by means of the line of the oil can.

Experiments with colour

Unlike most fields of photography, the still-life allows enormous choice in all areas of design, and in many, if not most situations, even the colour design can be managed. In most outdoor location photography, the use of colour is largely a matter of recognizing and selecting combinations that already exist, and the opportunities for manipulating the colours in a scene are limited, mainly to the framing within the camera. In a studio still-life, however, the set must first be constructed, and then lit, and in both of these operations, colour demands attention.

One of the most practical methods of exercising colour control in a still-life is in the selection of the objects, particularly if there is some freedom of choice in the props. For instance, if the principal subject is a household item say a plastic container – then one obvious treatment would be to surround it with other appropriate household objects; as many of these are likely to be available from stores in a choice of colours, quite precise combinations are normally possible.

One particularly effective, and straightforward solution is to match the colours throughout the picture

One approach that can give both unity to the image and certain extra connotations, is a single dominant colour. Here, a blue background, refracted and reflected in the liquid, gives easy associations with the subject of the photograph – rain.

– a completely yellow arrangement, for example, or all blue objects. Here, the colour blends the different shapes and sizes and can create a relationship between different items. Also, simply by repetition, the exact hue is stressed, which can be important in advertising photography; for example, the colour of a rosé wine can be repeated and enhanced with appropriate props and background.

Colour matching is only one approach, and surrounding hues can be chosen for aesthetic reasons – for instance, complementary or contrasting – or for their associations. All colours have certain connotations, some more obvious and widely felt than others, and these can be selected to suggest certain qualities in the main subject. Adding a collection of green objects, for example, can suggest freshness, a very useful quality in advertising.

Even if objects and backgrounds of an appropriate colour are not available, they can sometimes be made so by painting. Spray cans allow even and graded tones to be applied. If the background is separate from the subject, it can be lit with coloured gels.

Backgrounds and settings can be chosen to match a subject, or in some other way have a distinct relationship. Here, torn art paper picks up the primary colours of a tulip and becomes part of the design.

Experiments with colour

While colour can be used in a supplementary manner, to support the subject of still-life, it can also be made the main focus of the photograph. This essentially means taking an abstract approach, using colours purely as design elements. In choice of objects, lighting and filtration, a still-life photographer has similar opportunities to a painter for experimenting with colour combinations. Some examples of colour relationship are shown figuratively opposite.

Intense, and sometimes unexpected, colours can be found in certain special conditions: back-lit liquids, for instance, thin layers of some kinds of oil, stress patterns in plastics seen through polarizing filters (see page 119) and even ordinary soap bubbles.

Ordinary bubbles, ordinarily lit by a well-diffused electronic flash, display a wonderful array of swirling colours – an unpredictable subject for colour experimentation.

Basic colour relationships

While there are no rules governing colour design, certain principles cover the ways in which two or more colours interact, and how most people perceive them. Generally, colour relationships are either harmonious, in which different hues seem to equalize each other, or discordant, in which some kind of tension or vibrancy is set up. There is no question of correctness or suitability in this: it is up to the individual photographer to decide what the relationship should be.

Complementary colours are those that appear to balance each other and which would, if mixed, produce a neutral tone. Among the six pure primary and secondary colours red, blue, yellow, green, orange, violet, the complementary pairs are as shown here; red/green, blue/orange, yellow/violet. The way in which they combine is modified by the psychological weight that each carries, and is illustrated here as the quantity of one colour that is needed to balance the other. Red and green, if pure, have about the same 'weight', orange appears about twice as strong as blue, while yellow, the most vibrant, appears about three times as strong as violet. These, and similar combinations of intermediate colours, are essentially harmonious relationships. All three primaries (red, blue and yellow) or all three secondaries (green, orange and violet) are also harmonious together.

Discordant relationships are more common, but only some of the most obvious are shown here (red/blue, orange/green, yellow/red, violet/green). Much depends on the relative brightness of the colours, but if they are similar in tone an optical illusion is set up at the edge where they join – known as vibration, it appears as an oscillating movement.

Most naturally-occurring hues are, in fact, degraded to some extent, and more 'earthy'. Such broken colours as sienna, ochre and olive green have similar relationships as the pure colours above, but the strength of their interaction is proportionately less.

Another type of colour relationship that can be explored in a still-life is to take a group of colours from one part of the spectrum, such as red, orange and yellow or blue, green and yellow. These are harmonious without being complementary.

The apparent relative brightness of red and green is approximately the same, so that a 1:1 proportion appears to be balanced.

The relationship between orange and blue is also complementary, but as the orange appears more or less twice as bright as the blue. Balanced proportions are about 1:2.

The third complementary pair, yellow and violet, has a more extreme brightness relationship, approximately 1:3. As with all colour relationships, judgement is subjective.

Photographing animals in the studio

Wildlife and nature photography is usually performed in situ, on the home territory of the subject. For large animals this is essential, and with many others it is simply convenient. However, some small animals are, for various reasons, very difficult to photograph in uncontrolled conditions, and the only practical solution is to capture them and bring them to the studio. Small mammals, which are normally too shy to allow the close approach necessary for a reasonable size of image, are one category. Another is small fish, for similar reasons. Insects and arthropods are particularly suitable for studio photography, as their entire environment can easily be transported to give a perfectly authentic setting; moreover, insect behaviour can be induced in controlled conditions.

As with any normal still-life set, the surroundings in the picture must look right, but in addition, with wildlife, the set must be sufficiently enclosed and shaped to control the movements of the animals. There are certain established techniques for doing this with different species, and these are illustrated here and on the next two pages. For all of them a pre-condition is that the welfare of the animals comes first, which means not subjecting them to stress and provocation, and afterwards returning them safely to wherever they came from.

For small mammals, it may be necessary to build a special container for the set. The problem is likely to be that the animal, if wild, will want to hide. However, if the container is built as shown, to approximately the shape of the field of view of the lens, the set can be designed so that the animal remains visible. This in itself can produce stress in some animals, and it is better, having built the set, to leave everything alone for a few hours to allow the animal time to settle down. Keep the lights dim and use flash for the photography.

This dog was chosen for its resemblance to the famous individual featured in the old HMV (His Masters Voice) record labels. In such cases, with specific demands, animal agencies are best equipped to locate and accompany the subjects.

Larger animals, and those that might be difficult to control, such as this hawk-eagle, should generally be accompanied by a handler. Even cats and dogs may behave oddly in an unfamiliar setting.

Although there are legal restrictions in some countries on keeping certain types of animal captive, for small amphibians, reptiles and insects, an enclosed studio setting may be the ideal method, offering control over lighting and the subject. A container built to approximately the shape of the camera's angle of view helps to arrange the animal in a suitable position for the camera. Diffused top-lighting as in both the photographs on this page, of a Phelsuma lizard (top) and an Arrow-poison frog (bottom), gives good, natural modelling that mimics soft daylight.

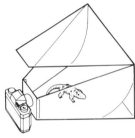

Many small mammals are nocturnal, and so are likely to become active only at night.

Certain larger animals can be hired with their trainers for photography, and this provides a more convenient and workable alternative. Trainers usually advertise in theatrical publications, and apart from dogs and cats, which are the staples of trained animal photography, they may have more exotic creatures, such as reptiles, primates, various birds and large cats. The trainer's advice should always be sought well before the session.

Small sets for insect photography, are usually easy to construct, because the area in view is small and the depth of field limited. However, if the subject is likely to jump or fly out, a small aquarium may be the most suitable container (see the following two pages).

Photographing animals in the studio

Photographing small aquatic animals, particularly if they are active, like fish, or if specific behaviour is wanted, is only practical under controlled, captive conditions. Most of the useful views are from the level of the animal, making transparent tanks the best containers (these also allow shots vertically upwards, for water-level silhouettes, such as of a frog with outstretched limbs and webs).

Most tanks need little more in the way of special preparation than an ordinary aquarium, but special care must be taken to keep electrical leads and equipment off the floor and well away from the water, to avoid a serious accident. Assuming a side-on view, the tank should be raised to a comfortable working height – somewhere between waist and shoulder level.

The tank has two functions to fulfil: providing a setting for the shot, and controlling the position and movements of the animal. Depth of field is likely to be shallow when photographing creatures measuring only an inch or two, and a tank width of several inches can be sufficient to throw the background out of focus. Cloth or coloured paper hung behind is usually adequate.

The standard method of controlling the position of a fish or something similar is to hang a separate sheet of glass inside the tank, parallel to the side facing the camera. This creates a narrower swimming space and can be adjusted so that it coincides with the depth of field. With a view camera, which prevents direct viewing at the time of shooting, the area of the picture frame can be marked on the side of the tank with a crayon or tape.

Overhead lighting is probably the most normal, with a flash unit suspended over the tank, but side-lighting and back-lighting positions are straightforward. If the bottom of the tank will not appear in the picture, a sheet of foil weighted down will give good upward reflections.

A possible problem is unwanted reflection from the glass side of the tank – of the camera, for instance. One solution is to aim the camera from a slight angle, hanging a large black cloth or card in a position where it will reflect in the glass. For a head-on view, the same cloth or card can be hung directly in front of the camera, and a small hole cut for the lens.

Some movement can be introduced into an underwater shot by piping air into the bottom of the tank. Plastic tubing and a can of compressed air are ideal for producing a string of bubbles, the size of which can be altered by fitting a porous block on the end of the tube (available from aquarium suppliers).

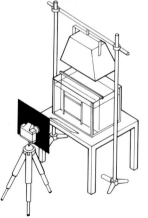

Side-on tank shots are most easily taken in a regular aquarium, with top- or side-lighting. Reflections can be eliminated by hanging a black cloth or card in front of the camera, cut with a hole just large enough for the lens. Place a suitable colour and tone of background inside the tank. The animal's movements can be confined by placing a thin sheet of glass close to the facing side of the aquarium.

Some aquatic subjects suit back-lighting, either because the animal is itself translucent or, as here, because other liquids are included. This photograph of a mussel pumping through a red dye was shot vertically downwards.

Where the conditions allow a black background, it may be more convenient and precise to photograph an animal separately from the other objects with which it is to appear, using multiple exposure techniques (see page 216). By doing this here, this very active terrapin could be positioned exactly, without disturbing the other objects.

Photographing food and drink

The logistics of food photography are such that it is something of a specialization, and commercially, for magazines, books and advertising, a number of photographers do nothing else. As far as preparation is concerned, there are three kinds of subject: the raw ingredients, cooked food and the process of cooking itself. The first requires no more facilities than those of a normal, small still-life studio, but the other two demand cookers (and power for them), plumbing, sufficient space for separating the photographic equipment from the food preparation, and fire precautions. These all need the kind of layout illustrated on page 16.

Unusually among the different branches of still-life photography, all food photography has just one common goal – to present its subjects as attractively as possible. The techniques vary, but idealization is constant. This is partly because of the strong commercial motive in food photography, and partly because people's attitudes about the way food should look are conservative.

There are certain necessary steps that need to be taken to meet these idealized standards. They are: knowledgeable selection of top-quality ingredients, expert preparation of dishes to a high visual standard, choice of clean, attractive props such as kitchenware and crockery, and a lighting arrangement that brings out the textural qualities of the food. All in all, this is an expert field, and aesthetic considerations apart, there are some fairly rigid rules of method and presentation. A shot of raw fish and vegetables, for instance, may be technically simple, but if the ingredients are in any way less than perfect and fresh, the picture will be largely invalid. Equally, there are certain ways in which some dishes *must* be cooked (or at least, there is a latitude in method that needs the judgement of an experienced chef). Stylists, or home economists as they are also called, offer a professional service in providing food and props, and sometimes in cooking.

Lighting has the very specific function of making the food look appetizing, and as a result styles tend to be a little conservative and vary relatively little. In practice, the strongest visual characteristic for conveying taste is usually the texture, and broad highlights of the kind cast by an area light facing slightly towards the camera are useful for showing glazes, pastry, liquids and most other textures. A slight degree of back-lighting has the advantage also of showing rising steam, if against a dark background (this can be simulated if a dish is not actually hot enough – see page 204).

Certain dishes, such as this chilli crab being prepared in a wok, are well-suited to being photographed during cooking. Ideally, a portable cooker should be available, to which the pan can be transferred directly from the cooker in the kitchen. This keeps the food cooking, and can, if necessary, be fitted with a variety of backgrounds.

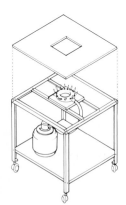

Simple settings can usually be built up from a few props, even on location in kitchens and restaurants. Two precautions for simplifying the background are to close in and keep the viewpoint high, looking down.

Some thinly-sliced foods can be back-lit, if sufficiently translucent. The simple, distinct pattern of Kiwi fruit cut across the grain is enhanced by tight framing. To preserve a fresh appearance while setting up the shot, sprinkle or brush with water, lemon or glycerine (see page 204) – back-lit sets like this tend to heat up quickly.

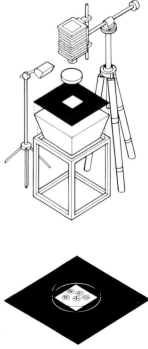

Photographing food and drink

Liquids, primarily drinks, pose some special problems in food photography, chiefly in the lighting. Without care, a liquid can appear bland, almost featureless and uninteresting, yet it needs to invoke the same appeal as other foods. When a drink can be photographed alone, then there a number of possibilities for controlling the way it looks, but on occasions where it is part of a conventionally-lit set its appearance may suffer.

Clear drinks, in particular, depend very much on photographic technique to bring them to life, and though not all the treatments are suitable for every drink, ways of brightening them and adding movement are the most common. Liquid colours appear most intense when they are back-lit, and if the subject is a glass, or glasses alone, there are no special problems. If there is a substantial volume, the drink may appear rather too dark, and it is often necessary to dilute with water.

Back-lighting, however, is extremely restrictive, and fairly unsatisfactory for opaque objects. If a drink, in a bottle or glass, has to be included in a normal set, there is still one method of brightening it up and

Photographed with a 55mm macro lens on Kodachrome, the 2× magnification of this tightly cropped view of the whisky glass (⅓× on the original transparency) concentrates the viewer's attention on the variations of colour and tone. Area back-lighting was used: probably the most basic technique with liquids, using a 750-joule flash unit enclosed in a box of diffusing material. With no opaque surfaces present, there was no need for additional frontal lighting.

creating partial back-lighting for the liquid alone. This is to place a small, shaped reflector behind the drink, angled slightly towards the main lamp to catch the light. Small mirrors and baking foil are often used, or white card for a more subdued effect. The success of this method depends on the liquid and its container refracting the light so that the shape of the small reflector merges with the outline of the glass or bottle. It is easy for this technique to *look* artificial, and it should be used cautiously.

Creating a significant amount of movement, by pouring or stirring, not only enlivens the shot, but gives a sense of shape to the liquid. Some degree of back-lighting helps to display refraction in the drops. Electronic flash is essential to freeze splashes, and a large unit (say, 2000 joules or more) may even produce a pulse that is a little too slow. A practical difficulty is the lack of fine control; coupled with the speed of the event, this makes it impossible to be certain of exactly what has been caught on film. One solution is prior testing on Polaroid to judge the range of effects possible, followed by a large number of frames to improve the odds. Another is to trigger two cameras simultaneously, one fitted with a Polaroid back. In between each shot, a thorough check and cleaning is necessary – stray drops have a habit of flying around the set.

Another kind of movement is that of bubbles. While obviously not suitable for many liquids, these may have to be added where necessary, as naturally aerated liquids like mineral waters go flat quickly. The standard method is to introduce a pipe and either blow down this or squirt a small amount of compressed air from a can.

Food shots that must combine transparent liquids in clear containers with solid objects often have conflicting lighting needs. Back-lighting is likely to be too restrictive a technique. One method, used here, restores vitality to the liquid by using an adjustable mirror. Hidden from view behind the glass, it reflects the principal light; the curvature of the glass and the refraction of the liquid bend this reflection to the shape of the jar.

Using substitutes

For a number of quite different reasons, there are several occasions in still-life photography when it is impractical, or even impossible, to work with the genuine article. This may be because of the ways in which studio conditions are different from the real world (lights too hot or bright, the preparations too slow), or because a certain object may be out of season or unavailable in some other way, or simply because there is no difference in appearance between one rare or expensive commodity and a more commonplace alternative. The first line of defence in these situations is to call for a substitute.

The use of substitutes calls for two general precautions – in authenticity and, though it may seem less obvious, morality. The problem with authenticity is that the nature of still-life photographs is to be searching, and an imperfect substitute can look quite glaringly wrong, without the photographer appreciating it. The problem with the morality of substitution occurs in advertising, where it is tempting to go one better than just replacing an object by improving it; indeed, in some countries industry codes of practice or the law may actually forbid certain kinds of substitution. An example of a substitute that is only marginally acceptable is when finely-mashed potato is used as a stand-in for ice-cream, which melts quickly.

This said, there exist some ingenious and practical replacements for certain intractable commodities. The heat of studio lighting and delays involved in setting up a still-life shot work against the photography of cold things (even the modelling lamps for a flash unit can make things melt and wilt). Ice is a sufficiently useful commodity to have a standard photographic substitute – hand-carved and polished acrylic, with a transparency and shape that is difficult to manufacture in a freezer. Rather than have to suffer rapid shrinkage and dilution (which is visible in some back-lit drinks), acrylic cubes can be positioned as carefully as any regular still-life object. Their one drawback is their density – unlike real ice, they do not float, and so usually need to be stacked sufficiently deeply in the glass for this not to matter.

The condensation expected on the surface of any cold object, like an iced drink, also disappears rapidly (and indeed has no chance to form if acrylic ice is used). For this, there are two standard substitutes; a freezer spray to cool down the object, or a small steamer of the type used for ironing clothes. In either case, applying too much and waiting too long afterwards causes the pattern of droplets to coalesce.

Water itself evaporates, and often leaves deposits

Condensation is often called for in photographs of drinks glasses and other liquid containers, to give an impression of coldness and freshness. One method is to make the temperature of the glass very different from the surrounding air, with a freezer spray. A quicker method is to use an atomizer spray.

Real ice has several disadvantages in photography: it melts (quickly under lights) and so both loses its shape and dilutes the drink. Positioning cubes to look their best often takes too much time. A standard solution is to use hand-carved acrylic cubes. Quality varies according to the maker, but the best show good refraction.

Using substitutes

that may be unsightly in a close-up shot. Glycerine lasts longer, and has the additional two advantages of higher viscosity and refractivity – in other words, drops have a good shape and sparkle. A film of oil encourages beading, on skin for example.

Snow not only melts quickly, but is usually unavailable. There is no perfect substitute but, at the scale of a typical still-life set and no closer, salt has approximately the right texture (for much bigger sets, beyond the scale of a still-life, shredded expanded polystyrene can work).

With food photography in particular, showing heat can be something of a problem, partly because in real life a hot dish is judged more by touch than by appearance, and partly because in the time taken to set up the still-life, the food may have cooled. A dark background in essential to show rising steam from a dish, and a common substitute is cigarrette smoke, gently puffed into the food through a straw.

Some substitutes are made simply in order to

Moist foods, once cut or sliced, rapidly dry out under studio lights. Any clear liquid will help, but glycerine will not dry out in use. Brush on lightly to retain a fresh look, and to keep the colours well-saturated. Do not use if the food will later be eaten.

The steam rising from a freshly-served dish helps to show that it is hot and appetizing. However, in a studio, even though the food may be hot, temperatures under the lights may be higher than normal, so that steam does not form. One substitute occasionally used is cigarette smoke, applied through a straw. A dark background is necessary to show it up.

exercise some control over otherwise unpredictable elements. Bubbles, for example, as mentioned on page 201 are useful additions to a drinks photograph, but virtually impossible to position exactly. Substitutes are small, hand-blown glass bubbles to sit on the water-line. For downward-looking shots – a bowl of soup, for example – a watch-glass shape bubble is used, placed on the surface.

Finally, though impossible to categorize in any major way, there are substitutes for things that are, if only temporarily, rare. Out-of-season flowers, for instance, can be made from paper and other materials, tea can be a substitute for whisky, water for gin or vodka, imitation jewellery for the real thing, and so on.

Bubbles convey a 'just-poured' look to drinks, and can add interest to simple, surface-level shots such as this. Difficult to control if real (blowing air through a tube or straw), bubbles are available hand-made in glass from specialist suppliers. There is usually a small hole in each sphere – position this *away* from the camera.

Scale-model photography

All kinds of models are built and used for studio photography, but one particular kind, the scale model, is a drastic form of substitute. Such models are not intended as miniatures, or objects in their own right, but to simulate the full-scale thing. As a solution to constructional problems they are drastic in as much that if they fall short of perfection by even a tiny amount they fail utterly, yet they are very tempting as a way of undertaking otherwise impossible images. They have a special value for spectacular and fantastic subjects, particularly large ones.

In advertising photography, where budgets are usually high, professional model builders are frequently used. Both skill and imagination are needed in preparing

a model, and a professional has the benefit of experience. One of the hidden problems in scale-model photography is the uncertainty of knowing whether or not the result will pass the minimum standards of being convincing. It is a help to know the likely specific problems (for instance, trees and vegetation are especially difficult in a landscape model) and ways of diverting attention from them (deliberately obscuring the lighting, for instance, by choosing a night-time or contre-jour setting).

The first major principle is that the model is built for the camera, and not as an independent object. Specifically, this means that some effort can be spared by building no more than is necessary – just what faces the

This model of the great pyramid was made for the photograph on page 218. The construction was simplified by first deciding the camera angle (only half of the model was built) and the lighting, which was intended to resemble floodlighting from below. Cork sheets were used; first cut to shape, they were stacked on top of each other, and finally worked on with a knife and drill. The final stages were performed in the intended lighting, to judge the precise effect.

camera and not the back – that perspective can be built into the model to enhance the impression of scale (this is known as forced perspective), and that the degree of the detail should be just sufficient for the resolution of the photograph (itself made up of the film, lens and scale of enlargement). The matter of sufficient detail is important, because in most models it is this rather than the basic structure that takes up time, yet finely-resolved detail is ultimately the most convincing quality of a model. All of this, naturally, benefits from advance planning.

In shooting, the photographic techniques must also help to compensate for the lack of scale. The depth of field, which is small at shorter distance, needs to be restored; this can be done partly by using a small aperture, partly by compressing the perspective of the model (see above), and partly by using a wide-angle lens. A view camera also has the possibility of movements, which can bring more of the subject into focus if carefully used. A wide-angle lens has the additional advantage of exaggerating the perspective, so enhancing the sense of scale.

The lighting also plays an important part, and for realism should be scaled accordingly. Direct sunlight is, to all intents, a point source of light, and can be mimicked in the studio only by a very small bulb or flash unit (out of doors, the sun itself is no different in effect on a smaller scale). Simulation of cloudy weather allows more diffusion, while night scenes have great flexibility and can make use of miniature modelling lamps (long exposures will be necessary).

Photographed with a 4 × 5 inch view camera, this ship model was treated to camera movements (see pages 50-51) and a small aperture (f64), both to ensure maximum sharpness. Shallow focus gives the game away in model photography that attempts realism.

This model of the NASA space telescope was photographed for later inclusion in another picture. The distracting background was partially eliminated by the simple method of hanging black velvet behind. One undraped corner was later retouched out.

Tricks with gravity

One popular kind of special effect in still-life photography is to show objects appearing to defy gravity or caught in mid-air. The chances of dropping an item onto the set and catching it on film before it strikes are extremely small without special lighting and triggering equipment (and this limits the quality of the lighting); there are, however, a number of solutions which allow everything in the set to be held securely in place.

One of the most obvious methods is to suspend objects with very thin line, but the difficulty is to conceal it, particularly as any viewer will be looking for just such a simple trick as this. Monofilament fishing line is very thin and supple, but even so, against a plain, pale background may still be obvious. A patterned or dark background will disguise the line; alternatively, coloured thread can be used that matches the hue and tone of the background. If the shot is taken on large-format film, such as 8 × 10 inches, the line can be retouched out, even on a transparency (in this case, it helps if the line is slightly higher in tone than the background).

Another technique is back suspension, in which a rigid pole is fixed more or less horizontally, pointing directly towards the camera. The object intended for free-fall is then attached to the end of the pole, which is concealed from view partly by the object and partly by a background sheet into which a hole is cut. This done, the only clue that might give away the illusion is a shadow cast by the horizontal pole. There are a number of things which can be done to avoid this: one is to use a diffused light, another is to position the light so that any shadow is not cast on a nearby surface (slightly behind the subject pointing forwards, for example) and to mask the lighting with barn doors or flags so that little light actually spills onto the pole. In any case, to some extent the shadow of the suspended object will obscure that

Back-suspension is the most common method used to make still-life objects appear to float. With a double-exposure image of an eye added later, this reflecting sphere is, in fact, a half-silvered electric bulb, suspended from a horizontal pole, as shown below. Diffuse lighting ensured that no recognizable shadow of the pole was cast.

This 'exploded' view of a bicycle lamp was constructed from two images, double-exposed on the same negative. The batteries were simply photographed resting on black velvet, but two of the other parts were suspended by thin black cotton. This merged with the dark upper background, and the print needed no retouching.

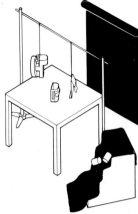

Back-suspension, as shown on the opposite page, was the basic technique used here for photographing models of space – craft. The horizontal pole was pushed through a hole in a large backdrop of black cloth.

cast by the pole.

As a back-suspension pole must be thinner than the object it supports, there may be too much strain for it to work successfully. In such a case, an alternative is to photograph vertically – either upwards, with the object hanging from the ceiling, or downwards, with the object perched on top of a stand or placed on a back-lit sheet of glass or plastic. The set and the lighting must then be adjusted with care to appear more or less horizontal (for example, the lighting to appear as if it comes from the top of the picture).

More deliberate trickery can be played by tilting both the set and the camera, so that through the view finder everything appears to be level and normal; then, anything naturally influenced by gravity, such as a liquid, will appear to behave oddly. Some effort is involved in building a tilted set, using clamps and adhesives to hold objects at an angle, but the more illusory the clues to levelness, the more effective the trick.

Streak and step photography

There are two conventions for showing movement in a still-life shot, both of them approximating quite closely to our impression of seeing it. One is streak photography, in which a time-explosion shows the blur of a moving object tracing the direction of travel; the other is step photography, in which a sequence of short exposures taken as the object moves also traces its path. Both need careful planning and the adjustment of light and camera settings so that the trace appears satisfactorily, and, for a conventional treatment, a

well-lit, sharp image of the object also needs to appear at the head of the trace.

For streak photography, a continuous light source is essential, and as the exposure time usually measures seconds, tungsten film which suffers little from reciprocity is the more useful emulsion. Streaking appears more distinctly against a dark background than against light, as the latter washes out the passing image. Exposure time, light level and rate of movement all control the length and intensity of the streak, and

In both of these special-effects science pictures , streak photography was used with moving lights. In the photograph of the orbiting light (right), representing an atom, a tiny battery-powered lamp was attached to the end of a rotor arm and photographed for several seconds as it rotated. During this time exposure, made with the apparatus shown above right, the background was draped in black cloth and the room lights switched off.

Step photography can be performed with precision by copying existing images on a rotating or sliding mount that is accurately graduated. In this way, the intervals can be exact.

stroboscopic flash, highly effective against a dark background but limited in lighting quality.

Although these techniques can be used to show the movement of a regular object, they can also be used more imaginatively, to create shapes and patterns. Curved shapes of all kinds, for example, are quite easy to produce with geometric perfection by photographing circular movement (an object or light revolving on a turntable, for instance) at different angles and with different focal lengths of lens.

After the initial exposure of microscope and culture, the dish was photographed separately (on the same sheet of film) against a dark background, moved sideways and backwards between each exposure.

experiment is usually necessary. Opening the lens slowly at the start while the object is already moving produces a graduated 'tail'. Another, more controlled way of doing this is to place a black card mask close to the lens so that its edge is soft; as the moving object appears behind it, the trace is revealed gradually.

To include a full, sharp image at the head of the trace, either a timed flash exposure (filtered with an orange gel to match the tungsten lighting) must be added to the sequence, or a separate exposure on the same sheet must be made (see pages 216-217), or else the movement can be reversed, starting with a static time exposure.

In many situations, it may be easier and more controllable to move the camera rather than the object, provided that the background is plain so that it shows no evidence of streaking (black, for instance). The alternatives are panning on the tripod head; tracking, which involves moving the camera on some kind of rail; or, with a view camera, winding the shift knob. Smooth movement is easier when panning than when using the other two methods; graduated scales on the tripod head, rail or camera shift make stepping easy.

Stepping sequences are most easily done slowly, under control, making, in effect, a series of multiple exposures (see pages 216-217). Graduating the exposure of each step, or the distance between them, helps the sense of movement. Precision is important. An alternative is to photograph real-time movement with

Special effects/projection

Combining images is an instrinsic part of still-life special-effects photography, and this in turn has become increasingly popular as a standard studio technique – a means of creating unusual images. Here and on the next few pages are the basic studio methods of juxtaposing two separate pictures. The simplest and most direct is projection. We have already seen on pages 146-147, how a front-projection system can add previously photographed backgrounds to a studio portrait. The same system can, of course, be used for still-life subjects, but in addition, projection can be used for more fanciful images, in which one image is projected onto the surface of a solid object rather than a screen.

One necessary precaution is to tone down the set lighting, or at least make sure that it is weak on the parts of the subject that will carry the projected image. Alternatively, the projected picture can be of high

One method of back-projection makes the simplest use of high-contrast line film for producing convincing atmospheric settings. In this case, what was needed was a misty power station in a certain location. As these conditions were impossible to guarantee in the time available, the image was prepared as artwork and photographed onto a sheet of line film. This was suspended *behind* a diffusing sheet of perspex (Plexiglas) for a misty appearance, and an orange gel held at an angle behind it to give a naturalistic, graduated effect.

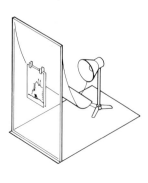

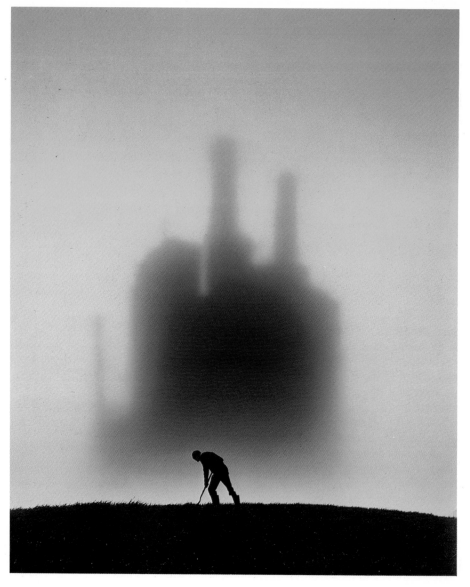

Even photographs themselves can be back-lit as backgrounds. The problem here was to have small and large fish in the same shot. To avoid unpleasant scenes of aggression in the tank, and in order to have at least one of the fish in a fixed position, a 4 × 5 inch transparency was first made at magnification, and then this was suspended, in the water, as a transparent backdrop. The final shot as used (above) was cropped to remove the tell-tale surroundings.

contrast (a pattern photographed on line film will register the most strongly of all). In either case, the set lighting and the projection will compete. The most straightforward equipment is a regular slide projector, which is, after all, purpose-built for the task, and bright. As it operates on tungsten lighting, it imposes some limitations on the choice of film and with moving subjects (exposures are likely to be a substantial fraction of a second), and if accurate colour balance is impor-tant, a filtration test will have to be run. Another possible disadvantage is the lack of an aperture diaphragm: there is no way of improving the depth of field, and if the object being projected onto is rounded or deep, some of the image will be out of focus.

To overcome the depth of field problem, use either an enlarger placed on its side, or a view camera adapted so that a lamp behind shines through a slide positioned in place of the ground-glass screen. The view camera

Special effects/projection

adaptation also makes it possible to use electronic flash, an advantage if the set lighting is also flash and if there is movement.

With all these methods, the projection must be placed close to the camera if an undistorted projection is wanted, and to avoid projection 'shadows'. In any other case, care must still be taken in positioning, while masking by means of a cut-out card in front of the projector can localize the image and shape it.

Most smooth surfaces will take a reflection to some degree, but the best for a three-dimensional object, if there is the opportunity to paint it, is matt white. An interesting alternative is 3M Scotchlite, the material used for front-projection screens. Although this can only be applied to flat or small areas, when used with a front-projection system it can give extremely bright images; if the set lighting is adjusted appropriately the Scotchlite image can even be made to glow.

A porcelain phrenology head, first sprayed matt white to reflect the projected image as clearly as possible, provided the basic surface. Broad back-lighting was used so that the side facing the projector would remain dark. Then, a sandwich of two transparencies – a sunrise and a lake scene – was projected, the edges of the image being vignetted through a hole in a piece of black card. The projection was made with an enlarger rather than a slide projector, in order to take advantage of the lens aperture – stopping it down to give good depth of field on the three-dimensional surface of the head.

Back-projection with filters and diffusers can be used to simulate a variety of skies. In this case, a collection of drawing instruments are assembled in silhouette to mimic the appearance of skyscrapers against twilight. The arrangement was made on a horizontal sheet of diffusing perspex (Plexiglas) from a light-box, with a diffused flash underneath. Coloured gels were suspended at varying distances to give a graduated effect from one colour to another.

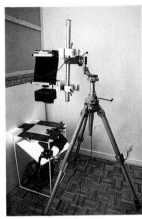

Special effects/multiple exposure

As a combination technique, projection has some obvious limitations. The main-stay special-effects system that can still be performed during shooting is multiple exposure. The principle is, of course, completely straightforward – separate exposures on the same frame of film – but there are a number of techniques that need to be mastered in order to combine images successfully.

Once the first image has been recorded on the film, subsequent exposures, if they are to be recorded normally, and fully, need to be made against dark, featureless areas. This in itself is something of a limitation, but if a black background is aesthetically acceptable, a number of separate exposures can be made that combine perfectly. The two requirements are accurate register and consistent lighting. Register is easiest with a large-format camera, and the most sensible method is to draw on the ground-glass screen, in ink or with a marker, the outline of each object as it is photographed. With some smaller cameras the prism

In this photograph (right), a magazine cover illustration, the brass safe handle was added as the second exposure, on a 4 × 5 inch sheet of transparency film (disparity of size made it impossible to shoot the can and handle together in a straight-forward manner). The black background of the painted sardine can gave an unexposed area of film for this second image. As a positioning guide, the first image was sketched on the camera's viewing screen.

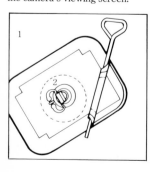

head may not be removable, in which case an alternative is to copy the outlines on a sheet of paper drawn to the proportions of the screen.

If the tolerance of the positioning is very close, it will help the register if the sheet of film (for view cameras) is taped at one edge inside the holder, so that it does not shift between exposures. Lighting consistency is principally a matter of accurate metering, and making allowance for any significant differences in the bellows' extension (if some of the shots are in close-up, different magnifications will need different exposure settings).

Such a combination, essentially realistic and non-overlapping, is most easily performed on a pure black background, the most efficient of which is good-quality black cotton velvet. Mounting objects a short distance above the background on vertical stands and masking the spill of light beneath them, is an extra precaution.

This, however, is only one limited way of using multiple exposure. Still working with full-contrast images, any dark area left in one image, however small, is a suitable background for a subsequent exposure. This can even be provided artificially, in the form of matching soft masks in front of the camera. For instance, if the lower-half of one exposure is blocked off

In a more complex multiple-exposure, four separate images were shot on the same sheet of 4 × 5 inch film, also because the sizes of the objects were different. For precise positioning, the film was located securely in its holder with a small piece of adhesive tape at one edge, to prevent any slight movement when the slide was removed and replaced each time.

by a black card a few inches in front of the lens, and then the upper-half of a second exposure is blocked off by a card in a corresponding position, the two images will appear to merge.

Overlapping multiple exposure produces quite a different type of imagery, and is less a matter of accuracy than being able to visualize the ways in which different exposures can blend. Overlapping creates a kind of ghosting effect, but soft masking, as just described, can be used to shade one image off at the side where it merges with another. Exposure settings are largely a matter of trial and error, and Polaroids are a useful intermediate testing procedure.

Photo-composition

Using the principle of multiple exposure – exposing fresh images onto un-exposed areas of the film – the logical extension is a system that actually provides the black areas, the silhouettes, for any image that has to be dropped into another. Such artificial masking, which can be performed with any type of image and needs no special conditions such as black backgrounds, is known principally as photo-composition. It is, naturally, a post-production technique, requiring the services of special copying and duplicating methods, and it needs to be extremely precise to work effectively. In advertising photography it is usually performed, for a fee, by specialist laboratories, but can, with training, be undertaken by photographers themselves.

The principle is to isolate, graphically, a single element, and to produce from it two masks on high-contrast line film: one is a solid black silhouette on clear film, the other is the reverse, a completely black area with the same outline against a solid black background. These two corresponding pieces of film make it possible to drop this image into any other photograph. Because of this extreme versatility, photo-composition is mainly used with transparencies, which are otherwise difficult to work with.

Technically, the normal method of producing these

To produce the surrealistic composite picture above, for a paperback cover, several production stages were involved. First the basic street scene was photographed, as was the model pyramid (shown under construction on page 206). In 1 and 2, the positioning is determined by means of trace overlays. Step 3 involves taping the two transparencies in this position, to punched sheets of discarded film. They can now be registered on the pin bar shown.

1.

2.

3.

4.

two line masks, as they are known, is to copy the transparency onto a sheet of line film in the darkroom, processing it in high-contrast fine-line developer. This line negative, if the original subject was light against a dark background, will be a silhouette (it may need some retouching with photo-opaque). This is then copied again onto another sheet of line film to produce its reverse image, a line positive. Retouching is performed by blocking in clear gaps with photo opaque, a proprietary paint, and can be repeated simply by making another contact copy (the fine hard edges of line copies mean that there is virtually no loss of image quality through repeated copying). The ultimate objective is a line-positive and line-negative pair.

In use the silhouette mask is sandwiched with the background transparency, and the outline mask is sandwiched with the transparency from which it was derived. Each of these pairs complements the other, and if both are copied, in exact register, onto a single piece of film, the combination will be complete. Two useful tips for blending the images without matte lines around the edge are first, to make the line film copies very slightly smaller, and second, to slip a thin sheet of frosted acetate under the transparencies so that the line silhouette underneath is softened.

Registering exactly, even with these precautions, is no easy matter, and needs the use of a matching register punch-and-pin-bar system.

A much cleaner, more precise, but more expensive method is to cut and paste images on a computer. This is normal practice commercially, and at a much simpler level can be achieved with off-the-shelf software.

Copying the final assembly onto a sheet of 4 × 5 inch transparency film calls for a rigid set-up and a duplicating machine (basically a flash unit housed to provide backlighting).

5.

6.

In 4, a line film positive, itself derived from a contact-printed line negative, is retouched and spotted; in 5, the same is done for the pyramid. Steps 6 through 8 show the final assembly, performed on a duplicating machine: in 6, the street is re-photographed in combination with its line negative; in 7, the sky is added to the duplicate with a line positive from the street *and* the pyramid; and in 8, the pyramid is added with *its* line negative.

7.

8.

Photo-composition

For this apparently high-speed shot of a bullet shattering a globe of the earth, eight separate transparencies were composited (the original was in colour). The revolver, muzzle flash, fragments, powder bursts, globe, crack lines, and bullet were each photographed separately.

The transparencies of the crack lines (a white-painted light bulb partly shattered) and the globe were then sandwiched together. Finally, using the pin registration method described on pages 218-219, the different transparencies were copied in sequence on one sheet of film, using a 4 × 5 inch camera and a slide duplicating machine.

In the photograph opposite, part of a sequence illustrating the creation of sub-atomic particles, 15 separate transparencies were combined. In this case, many were overlaid without masking, but the broken sphere in the foreground needed a line film positive mask to obscure the white grid lines.

SPECIAL SUBJECTS

Although portraits and still-life between them make up the major use of studios, there are a number of subjects that do not fit exactly into either category, yet are either important fields in their own right or else useful adjuncts.

Some, like room sets or vehicles, that bear some resemblance to still-life photography, are logistically specialized, by virtue of sheer size and technical difficulties. There are of course, any number of specific set problems, but interiors and vehicles are significant because they fulfil an important commercial role, and so are quite widely photographed.

A different kind of specialization, because it invokes some specific optical and lighting techniques, is close-up photography, merging at one end of the scale of magnification with photomacrography – that is, photographing at greater than life-size reproduction – and at the other end with normal still-life methods. With any close-range work, its techniques are a valuable addition.

Both as a means of recording flat artwork and as an essential step in post-production work, copying is very much a studio activity. While it is certainly more technical and less imaginative then the photography of regular three-dimensional sets, it is the basis for a large amount of special-effects work also.

Finally, technical and scientific subjects, particularly those that involve various kinds of light emission, such as video monitors and lasers, require some very specific methods. Again, as these are all subjects that need a high degree of control they are, principally, the province of studio photography.

Room sets

The largest of all indoor sets are rooms themselves, and the lighting principles, as might be expected, are different from those for smaller discrete sets. As the view point is, for once, within the subject, the lighting arrangement is multiple, and consequently complex in setting up. An extra consideration is that viewer expectations are fairly specific and there are certain lighting conventions that generally have to be met – in other words, rooms in photographs are expected to look the way they do in people's experience, or else need a good reason for looking different.

Although the natural starting point for interior photography may seem to be an existing room, there are often better reasons for treating the problem as a studio project and constructing a room set to order. Just as a still-life set can be treated with more control in studio surroundings, so a room can be assembled and lit in ways that suit the camera. Moreover, the structure of an interior is much easier to simulate than might be thought; what is being photographed is the surface on walls, floor and ceiling, not the underlying fabric, and with thin board, struts and ready-made window and door fittings, a typical room set can be created by, say, a couple of carpenters in about two days. And, as the object of this preparation is generally a single shot, little more than half the actual room, and often less, needs to be built. Anything outside the field of view is irrelevant.

Nevertheless, set construction is a speciality that demands, above all, space, as the studio plan on page 19 illustrates. Some room is always needed surrounding the set, for stuctural support and for lighting.

Both set construction and the rental of the large interior space necessary can be costly. To save time and money, thorough planning is important. Most large set studios for hire can supply plans on which the set designer or photographer can calculate the dimensions of their particular set and lay it out.

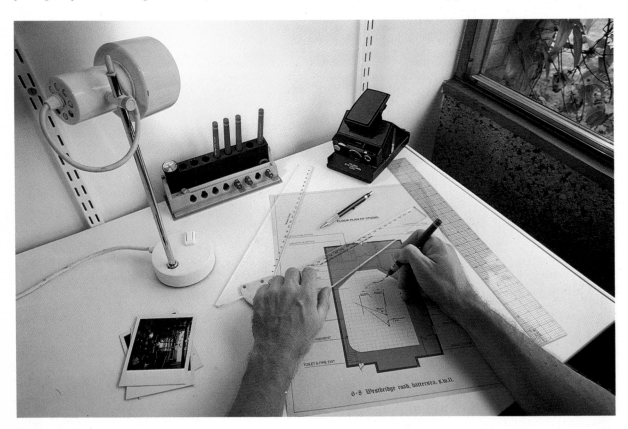

In this reconstruction of an old newspaper office, three walls have been included for a corner shot. The illumination is provided by four kilowatt tungsten lamps placed to the left of the window and diffused through cloudy plastic. The exposure was f45 and three minutes on 4 × 5 inch film, through a 90mm wide-angle lens.

Using flare through the facing windows to simulate bright daylight outside (from two kilowatt tungsten lamps aimed towards the camera through large translucent sheets of corrugated plastic) this photograph of a reconstructed Italian-American living room of 1925 is lit for a natural effect, with fairly high contrast. A third lamp, also diffused, provided fill from slightly forward of left. The exposure was f37 and two and a half minutes, with the front of the 4 × 5 inch view camera tilted a little forward to keep foreground and background in sharp focus.

Room sets

More often than not a window appears in shot, and then there is usually some need to show something through it, either a simulated view or just light. Of these two alternatives, a view sets the greater challenge, because it needs to look realistic. One method is to use a painted backdrop, separated from the window by at least a couple of feet to allow separate lighting; needless to say, this calls for a high order of set-painting skill, and the risk of it failing to convince, and so spoiling an expensive set, must always be a consideration. An alternative is a projected slide, which at least overcomes the problem of realism within the view, but poses fresh problems of matching the lighting and perspective to the set. Trial and error, and live testing is the only reliable method.

Full back-lighting is an easy alternative to the treatment of windows and open doors. A flood of light, possibly even flared a little deliberately, is both an acceptable convention and a means of adding extra lighting interest. The standard technique is to cover the outside of the window with an even translucent material, such as tracing paper or scrim, and then to direct light through it from outside. The actual balance of this simulated daylight and the interior lights must be worked out by trial and error; there are no formulae for what looks right. Generally, for more atmosphere and less detail, the balance can favour the light through the windows.

With large sets such as these, studio time, construction time and labour, all of which are generally hired except by the very few photographers who specialize exclusively in this field, all cost a considerable amount. This places a premium on efficient planning, so that no

Considerably more space is needed around any set being photographed than the actual picture area, both for lighting and the movement and construction of props. This room-set studio, for which the plan is shown in the photograph on page 224, is converted from an old Methodist chapel. Set construction, as can be seen here, is generally an untidy business.

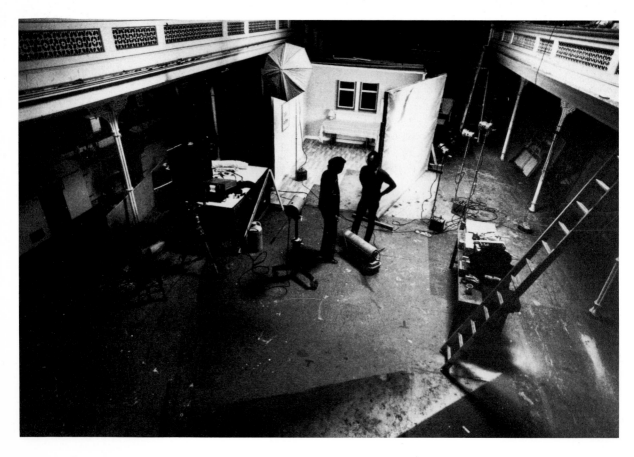

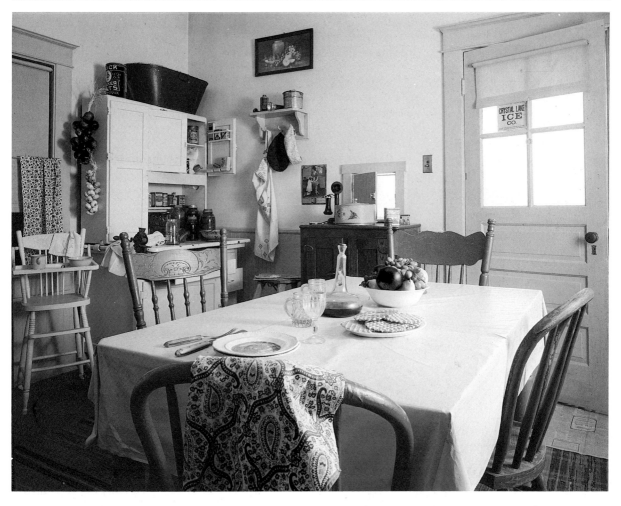

more of the set is built than necessary and so that the entire shoot can be completed as soon as possible. It is, as a result, normal to start with an art director's approximate sketch and progress to detailed plans that take into account the perspective, camera position and field of view of the lens. Alterations, such as changing the focal length of the lens or moving the camera back are likely to be unnecessarily costly. Freedom to experiment on set tends, therefore, to be restricted, and it is usually more important to be able to visualize results at the planning stage. Props supply is on a larger scale than discussed on pages 144-145, but the same principles apply.

For practical reasons, lighting for room sets tend to be tungsten rather than flash. Multiple lighting on a large scale calls for several thousands of joules, which is

In the same sequence of photographs as that on page 225, this set of a 1920 s kitchen uses a similar lighting style (slight flare from strongly backlit windows, and diffused fill from one side). Prop selection in period reconstructions such as this is a skilled matter, as to appear authentic the objects must be neither too special nor obviously aged. Using contemporary magazines for reference, it may be necessary to make certain of the objects from scratch, or adapt modern items (fabrics and paper labels in particular).

costly, and there is often little available in the way of spare power to cope with reduced apertures. Tungsten, on the other hand, is relatively expensive, and extra light to the film is simple enough to provide – by increasing the time exposure.

Studio car photography

Although massively inconvenient as a studio subject, cars are more often photographed in these controlled conditions than on location for two main reasons: most cars have highly reflective paintwork which picks up all kinds of unwanted detail from natural surroundings, and the client often needs to keep the appearance of a new model secret before its launch (most car photography is for advertising, and most of this has to be prepared well before the car is on the market).

As a technical problem a car is a shiny object in a full three dimensions, and large. In particular, the bonnet and roof can collect reflections from an extremely broad overhead area, and as top-lighting is the most natural and expected, these parts of the car tend to attract attention out of proportion to their area. Cloudless twilight is a near perfect condition – and the one most used in location shooting – but there are very few places where this can be guaranteed, and guarantee is important in a commercial shoot.

The alternative is an extraordinarily elaborate and expensive studio set, in which the necessary envelop-ing light is provided by a specially-constructed reflective surface. Sometimes called a cyclorama, this is an enlarged scoop that extends in smooth curves from the floor to the back wall, and ideally to the ceiling, as in the design on page 18. The sides of such a car studio do not need to be built up into curves, as they do not usually come into view.

This type of photograph is basically a scaled-up still-life of great precision, and the scale brings some problems of evenness and texture in the surroundings and the lighting. Generally, blemishes and roughness disappear with increasing scale, but for the floor, which is prominent, in focus, and subject to wear and tear, this is often not so. Marks can be painted over (and a fresh coat all over is usually a necessary prelude to a session), but an even floor surface is difficult to achieve in any variety. One method is to use floor tiling in a regular pattern. Another, which is painstaking but very successful is to flood a bordered area with water – if clean and fresh, this gives a mirror-like surface. Only an inch or two of depth is necessary, and for a typical car

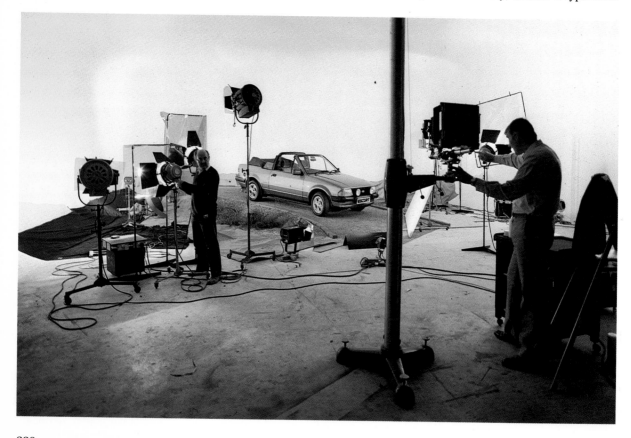

set about 1540 gallons (7000 litres) is sufficient.

Lighting is the major consideration. Special cyclorama lights that have curved reflectors can be used to give even lighting over the curves when suspended over the set.

A great quantity of lighting is usually necessary – 60,000 watts of tungsten light is not unusual – because all the lighting in a shot such as the one opposite is reflected, and from a broad area. Some car studios use direct ceiling lights aimed through a false ceiling of diffusing material, but this is less even and controllable than reflected light. In any case, most of the light reflected from the bonnet and roof in a typical shot comes from the back wall.

An alternative method of lighting the back wall that allows a great control over the gradation of tones favoured by many car photographers is to build a false black horizon, and to install a ground row of lamps behind. With a highly reflective surface, such as water, the black reflection and black screen blend together. In this and all other lighting systems, side reflectors and

small frontal arrays are often needed to pick out specific details and to fill shadows.

Background colours can be controlled either by spraying, which commits the shot at an early stage, or by fitting coloured gels over the lights. The gels are particularly controllable because of the number of lamps used . In all this lengthy process of setting up, which can take a couple of days or more, the car must be positioned at the start in order to plan the field of view and the lighting. The best method may be to leave it in position, wrapped carefully to prevent damage until the time of shooting.

The brief for this photograph called for a low setting sun on a mountain road. To give the effect of height, the 'road' was built on block boards on joists. The 'mountains' on the right-hand side of the shot were made out of crumpled grey Colorama, while those in the background were painted with a spray gun.
The lighting used was tungsten 26,000 watts and it was shot on a 8 x 10 inch Sinar with a 360mm lens on 8 x 10 inch Ektachrome.

Close-up techniques

Magnified images involve different optical principles from photography at regular scales, and also, because of the close working distances and small size of the subjects, make some special demands on manipulating the set, camera and lighting. Most close-up photography in the studio is essentially that of a miniature still-life, and there is no clear dividing line between the two.

The special technical considerations of close-up photography are in exposure adjustment, depth of field, image quality and stable, vibration-free mountings. All of these are progressive, in that they become more of an issue with increasing magnification. Practically, they begin at the point where some adjustment needs to be made to the exposure setting – the least that is worth while is one-third of a stop – while the upper limit is the point at which the optics of regular camera lenses can no longer give an adequate image quality, and the only way continuing to magnify is with a microscope. This is the range of close-up photography, extending from images that are about one-seventh of the actual size of the subject to those that are about twenty times larger. By convention, there is a further sub-division: photography in which the images are larger than life-size is known as photomacrography.

The equipment needed for achieving these magnifications depends on the type of camera. For rigid-body designs – principally 35mm and most rollfilm models – small magnifications can be made by fitting a supplementary lens, while for significant magnifications (more than about 0.25) the lens is extended from the body by means of either a rigid tube or a flexible, adjustable bellows. The greater the extension, the greater, in proportion, the magnification.

Monorail view cameras are different in that their in-built versatility fits them to close-up photography without any substantial alterations. View-camera focusing is, in any situation, performed by sliding the front and rear standards along the rail. Focusing at close range simply involves extending these further. For great magnifications, an extra bellows and supporting standard are fitted, as shown in the diagram. Close-up photography with a view camera, therefore, is merely an extension of normal operation.

Because the calculations and adjustments depend on the size of the image compared with the size of the real subject, there is a certain amount of special terminology involved. Two interchangeable measurements are magnification and reproduction ratio. Magnification is self-

Using a modified form of darkfield lighting, this bright proof coin was placed above a dark background, and lit from one side. With the lamp so low that it illuminated only the raised areas of metal. A white card was placed with a reflector opposite.

explanatory, and calculated by dividing the size of the image by that of the subject. A head-and-shoulders portrait on 35mm film, for example, has an insignificant magnification – about $\frac{1}{70}$ × or, decimally, 0.014 ×. A match head, on the other hand, measures about 3mm compared with about 30mm as it would appear on a full frame of 35mm film; this magnification is $\frac{1}{10}$ ×, or 0.1 ×. Reproduction ratio is just another way of expressing the same thing; a magnification of 0.014 × is a ratio of 1:70, that of 0.1 is 1:10.

The exposure settings need adjustment because, in order to magnify, the standard method is to move the film further away from the lens; as the light inside the camera has to travel further, it is weaker when it reaches the film – in inverse proportion to the *square* of the distance. Normal exposure measurements are made for when the focus is set at infinity, at which point the film-to-lens distance is the same as the focal length of the lens. So, for example, a 150mm lens is 150mm in front of the film when photographing a distant scene,

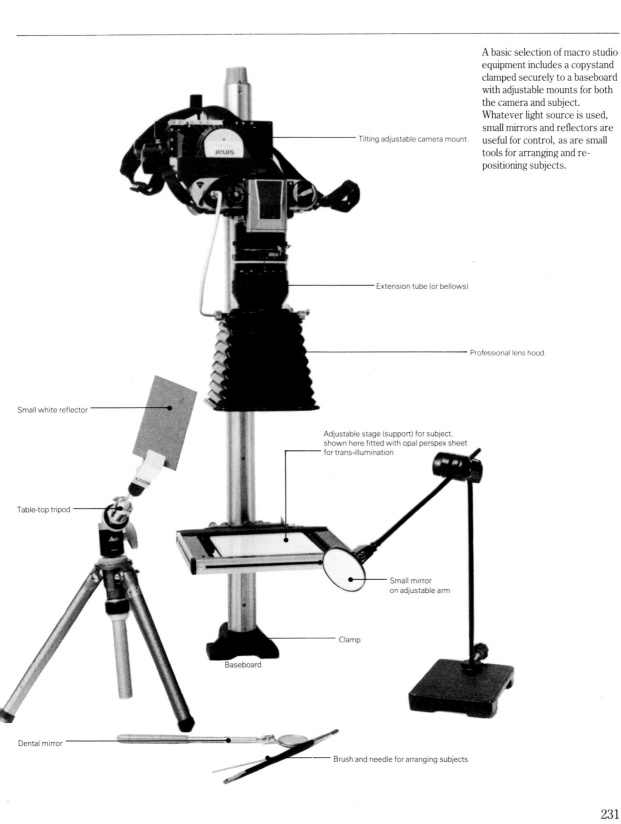

A basic selection of macro studio equipment includes a copystand clamped securely to a baseboard with adjustable mounts for both the camera and subject. Whatever light source is used, small mirrors and reflectors are useful for control, as are small tools for arranging and re-positioning subjects.

Tilting adjustable camera mount

Extension tube (or bellows)

Professional lens hood.

Small white reflector

Adjustable stage (support) for subject, shown here fitted with opal perspex sheet for trans-illumination

Table-top tripod

Small mirror on adjustable arm

Clamp

Baseboard

Dental mirror

Brush and needle for arranging subjects

Close-up techniques

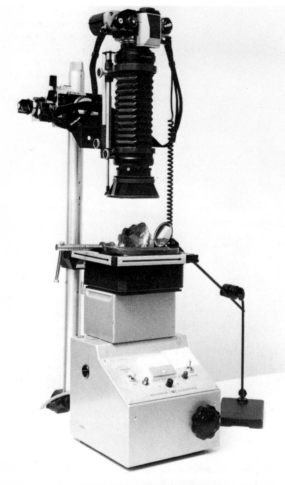

not very much more when the subject is several feet away, but considerably further when it is focused on something just a few inches in front of the camera. If the head of a small flower is photographed from a distance of 90mm from the lens (the exact distance depends upon which point you measure it from and that in turn depends on the design), a 50mm lens would have to be extended 75mm in front of the film, and then the image would be exactly 1.5 × life-size. The image-forming light inside the camera then has twice as far to travel, but is weaker when it reaches the film by the square of this – that is, by four times. The adjustment, or exposure factor as it is sometimes called, is, as a result, also four times.

Exposure calculation tables are all based on the assumption that the settings have been worked out for normal scales, with no significant magnification. They show, as do those below, the alteration that needs to be made. In the case of the life-size picture just mentioned, the photograph needs four times as much light as it would without the magnification. A half life-size magnification (0.5 ×), with the lens extended half as far from the film as normal, would need 2⅓ × (that is an increase of 1⅓ stops) as much light and, as the table shows, so on. None of this, however, matters if the camera has through-the-lens metering, which reads the level directly off the film plane, but for full control this requires a continuous light source, which in the studio means tungsten (through-the-lens metering is an automatic procedure that happens at the time of exposure, and so prevents advance planning of depth of field).

There are three ways of increasing the light that reaches the film. One is to adjust the exposure settings on the camera – the aperture or the shutter speed – another is to increase the output of the lighting, and the third is to move the light source closer to the subject. Which is best depends on the facilities available, on the type of film being used, and on the nature of the subject. For instance, with a static subject and tungsten-balanced film with tungsten lighting a simple increase in the exposure time is easy, whereas a

A small section of a fluorite crystal is here photographed with trans-illumination. The crystal is clamped in position on an open frame stage, and the light provided by a slide duplicator with an enlarged diffusing attachment. A bellows below the stage masks off stray light to minimize flare, and a small mirror adds controlled reflections.

Photomacrography can often reveal unexpected scenes. The scale-less view (left) could be an aerial photograph of drainage patterns, but is actually an enlargement of a crushed area of a Polaroid SX-70 print.

A 5× magnification of a butterfly wing (left), reproduced on this page at 3½×, glows irridescently in the light of a ring flash.

Close-up techniques

flash exposure of a moving subject has a distinct limit. Similarly, a heavy-flash tube allows extra power packs to be linked to it in series whereas, say, a 1000-joule capacity tube is rather limited. The table opposite shows how these different alternatives are determined.

Depth of field is directly affected by magnification. The closer the working distance, the less there is, and with fairly deep subjects there are distinct problems in keeping large parts of the image in sharp focus. A complicating factor is that depth of field is more of a subjective measurement than an objective one. It is the depth of area in the picture that *looks* sharp, and so always the best way of judging it is by appearance. This can be something of a problem at magnification, as the image on the viewing screen with the lens stopped down is dim, particularly with a view camera. Depth of field scales and tables are useful, but are based on the judgement of the camera or lens manufacturer, which may not correspond exactly with that of the photographer. These tables can be used either by direct measurement on the set, or by focusing at full aperture at both the close and far distances and then working out what exposure will be needed to cover this range. In cases of extreme difficulty, a Polaroid or live test is the best check. Whereas at normal scales of photography the focused distance is roughly one-third of the way into the depth of field, at close range it is nearer the middle.

Deep subjects are impossible to render sharply overall; for instance, with a 200mm lens on a 35mm

Magnified views of even mundane objects, such as a sliced cabbage, often emphasize abstract patterns.

Lens: 55mm, extended 40mm. Magnification: 0.7x, reproduction here at 1.6x.

camera focused to a magnification of half life-size, the maximum depth of field, even at an aperture of f32 is only 1cm/0.25 inch. This is not, of course, necessarily a problem, and the very shallowness of the focus can even be a help, in making one subject stand out against another and in offering a choice of tones and colours in a soft background. When, however, it is important for a particular area of the picture to be sharp, the alternatives with a regular camera are a weaker magnification and re-positioning the subject so that it appears shallower (only a spherical object is the same depth from any angle). With a view camera, and certain makes of bellows extensions, a more useful solution is to use camera movements to line up the plane of sharp focus with the axis of the subject (see diagram).

All lenses suffer to some degree from aberrations, and one method of minimizing these is to design lenses for specific uses, making sure that the relevant ones are corrected. Normal, multiple-purpose lenses are designed to perform best at distances between a foot or so and infinity, and so are not necessarily the best choice for close-up photography. In particular, they are designed for use when the lens is further from the subject than the film. At magnifications greater than 1 ×, however, this situation is reversed, and the subject is closer to the lens than is the film. At these magnifications, the loss of image quality is partly restored by reversing the lens so that its front element points towards the film. With small-format cameras this can be done with a special reversing ring, but with view cameras the entire shutter and lens combination can simply be unscrewed and turned round in its panel, or the front and rear lens elements can be exchanged in the shutter mount.

A few manufacturers produce photomacrographic lenses; unlike the general-purpose macro lenses commonly available for 35mm cameras, these do not have their own focusing mounts but are intended for use only at the front of a bellows extension. A close alternative, at no extra cost if the photographer already has a dark room, is an enlarging lens, reversed to point back towards the film. Used like this, it performs a similar function to its intended use – projecting an image from a close subject onto a large flat area. Such lenses are, of course, very suitable for use in large-format view cameras: at large extensions their picture coverage is wide.

Although the minimal depth of field in close-up photography encourages the use of the smallest

apertures, most lenses perform best when closed down by only about two stops, and other aberrations increase at the smallest settings. This usually means a compromise with the photographer having to decide which is the greater priority, the degree or the amount of sharpness in the picture.

High magnifications create a real risk of vibration affecting the image, particularly with a continuous light source or with multiple flash. Even a tiny amount of shake that may not be apparent at the time can cause a loss of sharpness. Likely problems are doors banged shut during an exposure, people walking over loose floorboards, passing traffic, slippage on a tripod head or

other mount, and internal equipment vibrations from the shutter or triggering mechanism. Depending on the building's construction, either the floor or a wall may be the more stable structure; identify which and attach the camera mount accordingly. Hard rubber blocks can make useful dampers, used either underneath a tripod or bench, or in screwing a stand to a wall.

Manipulating small subjects requires small and precise tools. The most useful, although expensive, is a macro-mechanical stage, in which a specimen is mounted. Two screws permit fine lateral adjustments on two axes. For moving things round by hand, tweezers, needles, probes and small brushes are useful.

Lens extension: reproduction ratios and magnification

Extension (mm)	50mm Lens Reproduction ratio	Magnification	100mm Lens Reproduction ratio	Magnification	200mm Lens Reproduction ratio	Magnification
5	1:10	0.1×	1:20	0.05×	1:40	0.025×
10	1:5	0.2×	1:10	0.1×	1:20	0.05×
15	1:3.3	0.3×	1:7	0.15×	1:13	0.075×
20	1:2.5	0.4×	1:5	0.2×	1:10	0.1×
25	1:2	0.5×	1:4	0.25×	1:8	0.125×
30	1:1.7	0.6×	1:3.3	0.3×	1:7	0.15×
35	1:1.4	0.7×	1:2.8	0.35×	1:6	0.175×
40	1:1.2	0.8×	1:2.5	0.4×	1:5	0.2×
45	1:1.1	0.9×	1:2.2	0.45×	1:4.4	0.225×
50	1:1	1×	1:2	0.5×	1:4	0.25×
55	1.1:1	1.1×	1:1.8	0.55×	1:3.6	0.275×
60	1.2:1	1.2×	1:1.7	0.6×	1:3.3	0.3×
70	1.4:1	1.4×	1:1.4	0.7×	1:2.8	0.35×
80	1.6:1	1.6×	1:1.2	0.8×	1:2.5	0.4×
90	1.8:1	1.8×	1:1.1	0.9×	1:2.2	0.45×
100	2:1	2×	1:1	1×	1:2	0.5×
110	2.2:1	2.2×	1.1:1	1.1×	1:1.8	0.55×
120	2.4:1	2.4×	1.2:1	1.2×	1:1.7	0.6×
130	2.6:1	2.6×	1.3:1	1.3×	1:1.5	0.65×
140	2.8:1	2.8×	1.4:1	1.4×	1:1.4	0.7×
150	3:1	3×	1.5:1	1.5×	1:1.3	0.75×

Supplementary close-up lenses (diopters)

Reproduction ratio (magnification), 50mm lens on 35mm format

Diopter	+½	+1	+2	+3	+4
lens focused on infinity	1:40 (0.025×)	1:20 (0.05×)	1:10 (0.1×)	1:6 (0.17×)	1:5 (0.2×)
lens focused on 1 metre	1:20 (0.05×)	1:10 (0.1×)	1:6 (0.17×)	1:5 (0.2×)	1:4 (0.25×)

New technology

Computer graphics

With the spread of relatively inexpensive graphics systems and software, digital images can be combined with straight photography for special effects. With the shading tools available from most software packages, quite realistic objects and backgrounds can be created, and these can be combined with other photographic images using the techniques outlined earlier – projection, multiple exposure or photo-composition. The most common graphics software packages are either bit-image or object-oriented. Bit-image software manipulates pixels – paintbox programs are this type. Object-oriented software creates objects such as spheres and boxes which can then be shaded, rotated

For direct copying from a colour video, the camera was tripod-mounted, and exposed for ¹⁄₁₅ second to avoid 'banding' (see text). The filtration was CC30 Red + CC20 Yellow.

Computer graphics were combined with straight studio photography to produce this composite image. The image of the brain was produced digitally and recorded onto film. This transparency was then double-exposed with a silhouette of a girl's head. The sparks were produced separately, by passing a charge of static electricity through unexposed film, and later photo-composited with the other images.

and otherwise manipulated. Each has particular advantages. The best way of creating photographs from these is to copy the results onto a floppy disk and give this to a film bureau which will record the image onto transparency film.

Alternatively, you can photograph the screen directly. This is quicker, but will record the screen lines. If you choose to do this, you will probably need to use a 30 Red filter, or similar, to correct the colour balance from most monitors. Test this first. Avoid reflections from the surface of the screen by darkening the room, or by draping black cloth around the screen and camera, and by masking bright parts of the camera and tripod that might cause reflections.

A magnified view of artificial fibres (left), was made by trans-illumination, photographing vertically downwards onto a back-lit sheet of opal perspex. Covering this, under the fibres, was a sheet of polarizing material. A polarizing filter over the lens was rotated to extinguish the appearance of the background.

New technology

Lasers

The colour of laser beams depends on the type, red helium-neon (He-Ne) being the most common and inexpensive. As the colour is due to the extremely narrow wavelength, any form of filtration is pointless. In order to show the *beam* in a photograph, it must pass through some medium containing particles that will reflect it, and probably the most direct method of doing this is to provide a smoky atmosphere. On a small set, cigarette smoke is one of the easiest to manage, with a time exposure and several puffs of smoke to ensure an even coverage of the beam. In a laboratory shot of a laser at work, if the equipment must also be lit separately, make two exposure on the same frame of film: one for the setting, with appropriate lighting but without smoke, and one with the smoke lit by the laser alone.

This array, used in the Apollo programme, was designed to reflect laser signals from the earth to the moon. To simulate this, it was first lit normally, by diffused electronic flash. Then, in darkness, a low-power helium-neon laser was trained on every reflector in turn, each for a few seconds.

Refraction and reflection from different surfaces, such as crystals, prisms, mirrors and liquids, can produce patterns and star-shaped highlights, but can be as dangerous to the eyes as looking directly into the beam. Use protective goggles and take great care when moving the laser beam. A speckled pattern is characteristic of many surfaces illuminated by a laser beam. If the laser is moved during the exposure, the effect on the image will be that of a number of lines – a form of streak photography (see pages 210-211). When a beam is passed through mirrors or prisms that are oscillated rapidly, the projected patterns can be complex.

Exposures depend on the wavelength and power, but a standard laboratory shot showing the beam of a 1 milliwatt He-Ne laser would need an exposure in the region of 1-2 minutes at f5.6 on ISO 64 film.

Stress Polarization

Certain transparent substances, notably plastics, contain complex stress patterns created during their manufacture. Through transmitted polarized light these can produce a vivid spectrum of colours. Place small subjects on a sheet of polarizing material that is back-lit by an area light, and fit a polarizing filter over the lens. Rotating the filter or moving the object will change the play of colours, while the colour of the background can be altered drastically by rotating just the filter. The background can be made to appear any tone from white to deep violet-blue.

A laser beam reflected in a bead of mercury has a star-like effect (above). In addition to a flash exposure, the laser image was exposed for f32 at 30 seconds.

A thermographic image of a man sitting with his hands on a table (below) is colour-coded by means of a set of filters built into the system. Each represents a particular, narrow temperature band.

Copying transparencies

Needing trans-illumination in the same way as negatives, colour transparencies can be duplicated by the same three methods: in-camera with a slide duplicating machine, in an enlarger, and by contact. Two factors favour the duplicating machine for general use: first, the flash source in most of these machines is easier to maintain at a consistent colour balance than tungsten lamps; second, rigorously preserving the resolution to the degree that is possible in an enlarger is not quite as necessary if the end product is a slide for projection. And, as 35mm slide duplication is a popular amateur process, the technology of these machines is well-developed and the prices reasonable.

Because a reversal emulsion is needed for copying, any regular slide film can be used – daylight-balanced for the majority of machines that use a flash tube, Type B for the fewer tungsten machines. However, the constant problem of duplicating – the increase in contrast – means that regular films must either be overexposed and underdeveloped (by between one-half and one stop), or else they must be 'flashed'. This technique involves fogging the film very slightly, and is performed in the machine by diverting a small proportion of the light directly onto the copying film. This lightens the shadows, so giving the general appearance of less contrast; however, as it produces an 'empty' lightening of the dark areas, the effect is unsatisfactory if deep shadows fill a large part of the picture area.

A more elaborate method of reducing the contrast is to make beforehand a weak monochrome negative mask by contact-copying; this is then sandwiched in perfect register with the original for copying.

A better alternative, particularly for high-contrast originals, is a specific duplicating film such as Ektachrome SO-366, designed for flash-source copying. This solves the contrast problem by having its own built-in masking. Indeed, with low-contrast originals it may even be better to underexpose and overdevelop by about one-half stop in order to *increase* the contrast slightly.

Intensifying colours
In this example, duplicating onto Kodachrome 25 (far right) has increased contrast and, importantly, made the colours of this scene richer.

Original Duplicate

Increasing contrast
Flare in the original (near right), due to large sunlit areas just outside the picture frame, has been treated by slight under-exposure and an increase in contrast.

Original Duplicate

Apart from matching the contrast range of the original, the main concern in slide duplication is colour fidelity. A colour emulsion does not react in the same way to the dyes in another transparency as it does to the original colours. As a result, it is normal to use a pack of filters over the light source, and for this pack to vary according to the film type of the original. For example, using Ektachrome Duplicating Film SO-366, Kodachrome originals are likely to need a filter pack that is bluer than that for Ektachrome originals by about CC 10 B.

What this clearly implies is that both the machine and the batch of copying film must be tested before use, and the manufacturers' recommendations can only be taken as a starting point. Select test transparencies that have been shot on different emulsions, such as Kodachrome, Fujichrome and Ektachrome, and that contain a normal range of tones and some recognizable colours that can be judged easily for accuracy (such as flesh tones and greys). The tests should cover a range of filter packs and half-stop variations in exposure. As each fresh batch of copy film will have slightly different characteristics, these tests will have to be made afresh each time, which argues for stocking up with a quantity of one batch, storing it in refrigerated conditions.

The alternative methods of slide duplication are enlarging and contact-copying, both normally performed with a colour enlarger and a tungsten-balanced film such as Ektachrome Duplicating Film 6121. Because the film is used outside the camera, being inserted into the baseboard easel or a contact printing frame, extra precautions are necessary against dust (see pages 242-243), and the darkroom must be completely light-tight. A voltage regulator is essential in order to keep a consistent colour balance from the enlarger head. Tests for filtration must be run in the same way as described above, although the enlarger head's built-in filters can be used.

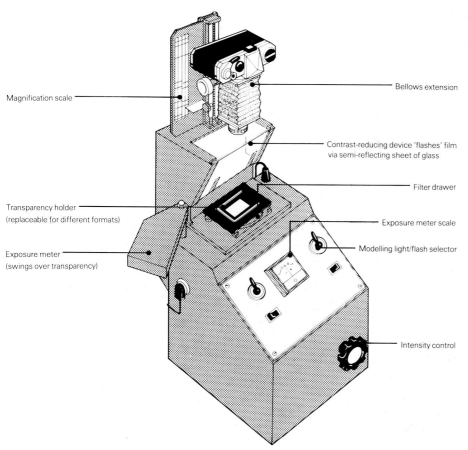

Magnification scale

Bellows extension

Contrast-reducing device 'flashes' film
via semi-reflecting sheet of glass

Filter drawer

Transparency holder
(replaceable for different formats)

Exposure meter scale

Modelling light/flash selector

Exposure meter
(swings over transparency)

Intensity control

One of several designs of similar equipment. This slide duplicator uses electronic flash as its light source. Rated at 5500K, this requires a daylight-balanced film, although the Tungsten modelling lamp, intended for focusing, can also be used as a light source with 3200K balanced film.

Copying negatives

In order to make a direct copy of a black-and-white negative, reversal film and processing is needed. Hence, the choice of copy film is restricted to specialist emulsions, such as Kodak Professional Direct Duplicating Film in sheets and Rapid Process Copy Film in 35mm. Copies can be made in the camera, using a slide duplicating machine, in an enlarger, projecting the image onto the baseboard as if making a print, or by contact, using any broad light source.

By mounting the camera onto a slide duplicating machine, following the same basic procedure as for copying transparencies (see pages 240-241, copies can be made without a darkroom and conveniently. Using 35mm copy film, this system is suitable for reducing different negative sizes to a common format, but fine shading controls are not easy to make. Copying 35mm negatives requires 1:1 magnification, making it important to use a high-quality macro or enlarging lens.

Using Direct Duplicating sheet film which is available in sizes up to 8 × 10 inches, has two considerable advantages. One is that, by enlarging the copy to the size that it will be printed, the subsequent printing can be performed by contact, and this helps to reduce loss of image quality. Ordinarily, each *optical* generation of copying loses some resolution, but a contact stage loses virtually nothing. The second advantage is that, by working on a large image with an exposure of several seconds, it is possible to exercise the same kind of controls that are normal when making a regular print. Even with these special duplicating films, an increase in contrast is possible, with loss of detail in the shadows and highlights. By shading and printing-in, using either special tools such as dodgers and cut-out cards or just a pair of hands, the image in an original negative can even be improved by copying. Because the copy film is positive, however, all the normal printing controls must be reversed. A shorter exposure produces a darker copy, as does short development; if the image of a face, for instance, is too dense in the original negative, resulting in a too pale image in a print, it would need *more* light when copying.

The third method, contact-copying, also has the advantage of losing virtually no sharpness, but it severely limits any of the above controls. An additional precaution is absolute cleanliness, as any specks of dust will be recorded as blemishes in the copy. Use compressed air and an antistatic gun, and keep the glass of the printing frame spotless.

Step 1: First load the negative that is to be copied in the negative carrier of the enlarger. In this sequence, a 35mm negative is being enlarged up to the full size of the final print, at the same time as being copied, in order to save one optical step — and so minimize loss of picture quality.

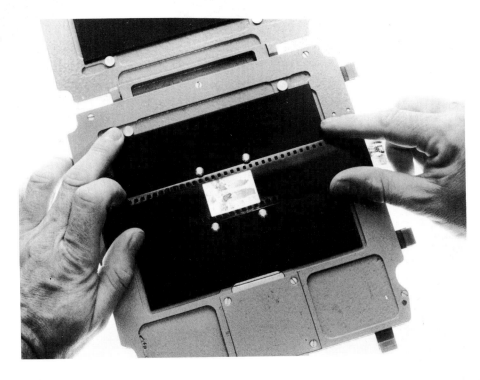

Step 2: In exactly the same manner as for making a regular print enlargement, adjust the frame of the easel to the desired shape and size (the film being used here measures 8 x 10 inches), and focus the image. With the enlarger lamp switched off.
The copying film can then be placed in the easel, emulsion side up. As the copying film is orthochromatic (sensitive to blue light only) a weak red darkroom safelight can be used throughout.

Time the enlargement according to experience, or else first make a test exposure of different times. In this example, the basic exposure was 30 seconds at f11, using a 50mm enlarging lens, and developing for two minutes in Kodak D-163.
Shading and printing-in can be performed by blocking the light to parts of the film, as shown here, but the effect is the *opposite* of what would happen with printing paper.

Copying flat artwork

Flat artwork includes any two-dimensional opaque image, such as a photographic print or a painting, and for practical purposes sub-divides into continuous tone, half-tone and line originals, with colour as an additional factor. Continuous tone artwork itself comprises anything that retains full tonal gradations at any magnification: photographic prints, watercolours, oil paintings, and so on. Half-tone originals are a product of photo-mechanical reproduction, in which pictures are given the *appearance* of having continuous tone while in fact being constructed from a pattern of small dots of solid ink, and are found in all normal printed matter. Line originals contain, even at normal viewing distances, just two tones: a solid colour, usually black, and white.

For continuous tone originals, a regular film is needed for the copying, but to preserve as much detail as possible, and to avoid overlaying a pattern of graininess, a slow, fine-grained film is best, such as Panatomic-X or a dye-image film in black-and-white, or Kodachrome 25 in colour. A large format also helps the detail. Matching the contrast of the original is important: in black-and-white, adjustments can be made at the stage of printing by selecting the paper grade, but in colour altering the processing (see page 124) may be necessary. Perfect colour fidelity is almost impossible, as film reacts imperfectly to certain dyes and pigments, but for most purposes is likely to be close enough, given some occasional mild corrective filtering. An aid to colour fidelity that is useful if a print is to be made or for photo-mechanical reproduction is a strip of standard colours, known as a separation guide, photographed alongside the original.

Staining on a black-and-white original can be removed from the copy image by photographing through a filter as the same colour as the stain. The yellowing of aged paper can be treated in the same way, with a yellow filter.

Half-tone originals at normal viewing distances can be treated as above, but in close-up it may be better to treat black-and-white half-tones as line originals. For

If the frame must be included in the photograph, and it is gilded or similarly reflective, diffuse the lights to give broad, even reflections in its edges rather than specular ones.

Gold blocking, such as here, on an illuminated manuscript, should be treated as a regular reflective surface (see page 96). Use a well-diffused area light, positioned at an angle that just catches some of the texture.

A copystand is basically a vertical column over a baseboard, one method of making sure that the original is absolutely perpendicular to the camera axis is to place a mirror on its surface (centre) and focus on the reflected image of the camera (far right); the image of the lens should be central.

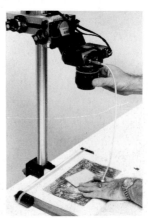

In colour copying, standard colour patches help to maintain accuracy in printing later. Include them, whenever possible, in the photograph in black and white copying. A grey scale is similarly useful.

these last, line film such as Kodak Ortho 2556 Type 3 is the standard emulsion, an ortho-chromatic film processed in a high contrast, fine-line developer. The procedure is straightforward, although because the film is insensitive to blue, the exposure will vary according to the colour of the lamps being used, and tests may have to be run first.

For accurate alignment, use a copystand or a tripod with the camera aimed vertically downwards or horizontally towards a wall. Use a spirit level for vertical shots and a clinometer for horizontal ones, to help keep the film plane parallel to the original. A grid viewing screen is another aid, but the most accurate method of aligning camera and original is to place a small mirror flat against the centre of the original and to focus the camera on the reflection of the lens; simply adjust until this image is centred.

For even lighting, at least two lamps are needed, equidistant from the original, at approximately 45° to the camera axis (any closer and flare is likely). Check evenness of lighting with a hand-held meter, and also by holding a pencil perpendicularly against the original – its shadows should be equal in length and strength. Shade the lens from any direct lighting. With a shiny original, such as a glossed oil painting, place polarizing sheets over the lamps and use a polarizing filter over the lens; also consider hiding the shiny parts of the camera with a black cloth or card to avoid reflections from a glass-fronted original.

With an original that does not have continuous tones, a high contrast line film gives the clearest image. This engraving, from the book being photographed (left), was recorded on Kodak Ortho 2556 Type 3, developed in Fine Line developer.

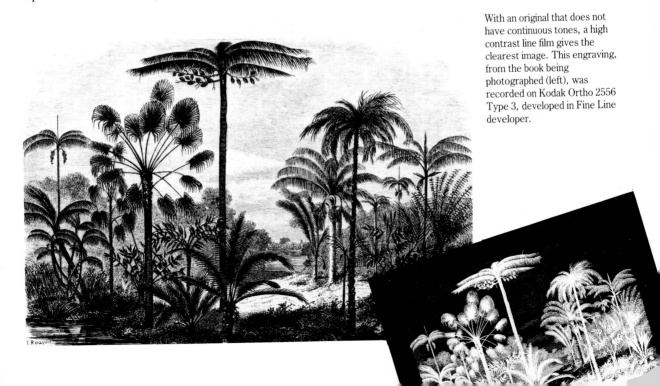

Glossary

A

Angle of view The widest angle of those light rays accepted by a lens that form an acceptably sharp image at the film plane. This angle is widest when the lens is focused at infinity.

Aperture An adjustable circular hole centred on the lens axis. It is part of the lens that admits light.

ASA Arithmetically progressive rating of the sensitivity of a film to light (American Standards Association). ASA 100 film, for example, has twice the sensitivity of film rated at ASA 50.

Axial lighting A method of illuminating a subject in which the light travels along the lens axis, thereby casting no visible shadows. The normal method is by using an angled half-silvered mirror, and is a part of front-projection systems.

B

Back-lighting Lighting from behind the subject directed towards the camera position.

Back projection Projection system in which the image on a transparency is projected onto a translucent screen from the side opposite the camera. It is one method of making a background from an existing photograph, although generally less efficient than front projection.

Background roll A standard type of studio background, in the form of heavy gauge coloured paper, most commonly available in 9-foot wide rolls.

Barn doors Adjustable flaps that fit at the front of a photographic lamp to prevent light from spilling at the sides. Consists of two or four hinged flaps on a frame.

Bellows Flexible black sleeve of concertina-like construction, that connects the camera back or body with the lens. Being continuously adjustable in length, bellows are used in close-up attachments for small-format cameras as an accessory, and as a standard fitting on large-format view cameras.

Boom Lighting support in the form of a metal arm that pivots on a vertical stand. It is generally counter-weighted and adjusts laterally. Useful for suspending lights high over a subject.

Bounced light A method of increasing the area of illumination and so softening the shadows, by aiming a lamp towards a large reflecting surface, such as a ceiling.

C

Camera movements Mechanical adjustments normal on large-format view cameras that permit the lens panel and/or film back to be shifted and pivoted. They allow valuable adjustments to the coverage and geometry of the image.

Capacitor Electrical device that allows a charge to be built up and stored. An integral part of electronic flash units.

Click stop The graduation of the aperture ring on a lens that allows the change between individual f stops to be felt and heard.

Clip test A short strip of film that is processed before the rest to determine whether any adjustment is needed in processing. Useful when the exposure conditions are uncertain.

Colour balance Adjustment made at any stage of photography, from film manufacture to post-production, to ensure that neutral greys in the subject appear neutral in the photograph.

Colour cast An overall bias in a photograph towards one particular colour.

Colour compensating (CC) filters Series of filters of different colours and strengths to change the overall colour balance. Useful to compensate for deficiencies in lighting systems and in film manufacture.

Colour contrast Subjective impression of the difference in intensity between two close or adjacent colours.

Colour conversion filters Series of filters used to convert the colour temperature of various light sources to the colour balance of the film in use.

Colour temperature The temperature to which an inert substance would have to be heated in order for it to glow a particular colour. The scale of colour temperature significant for photography ranges from the red of approximately 2000K (Kelvins) through standard white at 5400K to blues at above 6000K.

Complementary colours A pair of colours that when combined in equal proportions (by additive process), produce white light.

Compound lens Lens constructed of more than one element. This enables various optical corrections to be made.

Contact sheet A print of all the frames of a roll of film arranged on one sheet, same-size. Used for selecting frames for enlargement.

Contrast The subjective difference in brightness between adjacent areas of tone. In photographic emulsions, it is also the rate of increase in density measured against exposure.

Covering power The diameter of usable image produced at the focal plane by a lens when focused at a given distance. An important measurement to take into account when selecting lenses for view cameras, which have camera movements that depend for their usefulness on a wide covering power.

Coving A concave shape, generally moulded, that smoothes out the normally sharp edge between a studio wall and floor. It gives the effect of a continuous, 'horizon-less' background.

Cyan Blue-green, complementary to red. Also produces white in combination with magenta and yellow.

Cyclorama *See* **Coving**.

D

Darkcloth Black cloth used by view camera photographers to eliminate the distraction of ambient light when looking at the image through the ground-glass screen.

Darkfield lighting Lighting technique used in photomacrography and photomicrography, in which the subject is lit from all sides by a cone of light directed from beneath the subject; the visible background remains black.

Darkslide A lightproof sheet used to protect film from exposure until it is mounted in the camera. Used with sheet film and certain rollfilm systems.

Daylight film Colour film that is balanced for exposure with daylight or some other source with a colour temperature of 5400K, such as electronic flash.

Depth of field The distance through which the subject may extend and still form an acceptably sharp image, in front of and beyond the plane of critical focus. Depth of field can be increased by stopping the lens down to a smaller aperture.

Depth of focus The distance through which the film plane can be moved and still record an acceptably sharp image.

Diaphragm An adjustable opening that controls the amount of light passing through a lens.

Diffuser Material that scatters transmitted light, so increasing the area of illumination.

DIN Logarithmically progressive rating of the sensitivity of a film to light (Deutsche Industrie Norm). Its use is restricted largely to Germany.

Dolly A rolling trolley to support either a camera tripod or a light stand. The wheels can be locked for stability.

E

Electronic flash Artificial light source produced by passing an electrical charge across two electrodes enclosed in a gas. The colour balance in photographic systems is usually 5400K, the same as standard daylight.

Exposure In photography, the amount of light reaching an emulsion, being the product of intensity and time.

Exposure latitude For film, the increase in exposure that can be made from the minimum necessary to record shadow detail, while still presenting highlight detail.

Exposure value (EV) A notation of exposure settings for cameras that links aperture and shutter speed. A single EV number can, for example, represent $\frac{1}{60}$ second at f8 *and* $\frac{1}{250}$ second at f4.

Extension A fixed or adjustable tube between the lens and camera body, used to increase the magnification of the image.

F

f number Notation for relative aperture which is the ratio of the focal length to the diameter of the aperture. The light-gathering power of lenses is usually described by their widest (that is, lowest) f number. Lens aperture rings are calibrated in a standard series: f1, f1.4, f2, f2.8, f4, f5.6, f8, f11, f16, f22, f32, f45, f64.

Fibre optic Optical transmission system in which light is passed along flexible bundles of light-conducting strands. Within each fibre, the light is internally reflected with high efficiency, to ensure very little loss with distance.

Fill The illumination of shadow areas in a scene.

Film plane In a camera, the plane at the back in which the film lies and at which focus is judged.

Filter factor The number by which the exposure must be multiplied in order to compensate for the loss of light due to absorption by a filter.

Flag A matt black sheet held in position between a lamp and the camera lens to reduce flare.

Flare Non-image-forming light caused by scattering and reflection. It degrades the image quality.

Flash *See* **Electronic flash**

Flash bulb Transparent bulb containing a substance that ignites with a brilliant flash when a low-voltage charged is passed through it. Expendable.

Flash synchronization Camera system that ensures that the peak light output from a flash unit coincides with the time that the shutter is fully open.

Format The size and shape of film, which determines the size and shape of the camera viewing area.

Fresnel lens An almost flat lens made up of a stepped convex series of concentric rings. In combination with a viewing screen, it brightens the image, performing the same function as a condenser lens.

Front projection System of projecting the image from a transparency onto a background screen from the camera position, thus ensuring minimum loss of image quality (the chief problem with back projection). The system relies upon axial projection via a half-silvered mirror, and on a super-reflecting screen.

G

Gelatin filter Thin coloured filters made from dyed gelatin that have no significant effect on the optical quality of the image passed.

Graininess Subjective impression of granularity in a photograph, when viewed under normal conditions. The impression is created by clumps of grains seen, not of individual grains.

H

Heat filter Transparent screen used in front of a photographic lamp to absorb heat without reducing the light transmission.

High key Type of image made up of light tones only.

Highlight The brightest areas of a scene, and of the photographic image.

I

Incident reading Exposure measurement of the light source rather than the reflectance of the subject. The meter is covered with a compensating attachment and pointed at the light. The reading is independent of the subject.

ISO Film speed notation which is replacing the ASA and DIN systems. The initials stand for the International Standards Organisation. The figures used are identical, however, to those in the ASA system.

J

Joule Unit of output from an electronic flash, equal to one watt-second. This measurement permits the comparison of the power of different flash units.

K

Kelvin (K) The standard unit of thermodynamic temperature, calculated by adding 273 to degrees Celsius.

Key light The main light source.

Kilowatt Unit of electrical power, equivalent to 1000 watts.

Glossary

L

Latitude The variation in exposure that an emulsion can tolerate and still give an acceptable image.

LCD Liquid crystal diode, a solid-state display system used in viewfinder information displays particularly. Consumes less power than LEDs (light-emitting diodes).

Light tent Enclosing device made of translucent material positioned to surround the subject. The lighting is directed through the material to give an extremely diffused effect, useful with shiny-surfaced subjects to make the reflections less distracting.

Line film Extremely high-contrast film, which can be developed so that there are no intermediate tones, only black and clear.

Low key Type of image made up of dark tones only.

M

Macro Abbreviation for photomacrographic, applied to close-up photography of at least life-size reproduction.

Magenta Blue-red, complementary to green. Also produces white in combination with cyan and yellow.

Mask Derived image, often opaque and made on line film, that is registered with the full-tone transparency or negative to hold back a part of that image. Used extensively in photo-composition.

Mid-tone An average level of brightness, halfway between the brightest and darkest areas of a scene or image (that is, between the highlighted and shadowed areas).

Mired Abbreviation of Micro-reciprocal degrees, a notation for colour temperature that is sometimes used for calculating the appropriate colour-balancing filters needed with different light sources. The mired value of any light source is 1 million divided by the Kelvin value.

Modelling lamp The continuous-light lamp fitted next to the flash tube in studio flash units that is used to show what the lighting effect will be when the discharge is triggered. Modelling lamps are usually low-wattage and either tungsten or fluorescent, and do not interfere with the actual flash exposure.

Monorail The base support for the modern design of studio view cameras, in the form of an optical bench. Also used as an abbreviation for such a camera.

Multiple exposure Method of combining more than one image on a single frame of film by making successive exposures of different subjects. Provided that each exposure fits the image into a shadow area of the previous exposure, the resulting photograph can seem to be a realistic combination, without obvious overlapping.

Multiple flash The repeated triggering of a flash unit to increase exposure (with a static subject). Sometimes also called serial flash.

N

Neutral density Density of tone that is equal across all wavelengths, resulting in an absence of colour. Neutral density filters are used for reducing exposure by specific amounts, without altering the colour balance.

O

Opalescent The milky, or cloudy white translucent quality of certain materials, valuable in the even diffusion of a light source.

Orthochromatic Photographic materials that are insensitive to red. They can be worked with under a red safelight.

Outrig frame Open metal frame that fits in front of a lamp and can be used to carry filters, gels or diffusing material.

P

Panchromatic Photographic materials that are sensitive to all colours of the spectrum.

Pantograph In photography, a device constructed of interlocking, pivoted metal arms that allows the extension and retraction of lamps.

Photo-electric cell Light-sensitive cell used to measure exposure. Some cells produce electricity when exposed to light; others react by offering electrical resistance.

Photoflood Over-rated tungsten lamp used in photography. Being run at a higher voltage than normal, the light output is increased, and the colour temperature can be balanced at 3200K or 3400K, but the life of the lamp is correspondingly short.

Photographic lamp Any lamp specifically designed for photography – that is, having a consistent light output and at a recognized colour temperature (usually either 3200K or 3400K).

Photomacrography Close-up photography, specifically at magnifications greater than life-size but less than those for which a microscope must be used.

Photomicrography Photography through a microscope, using different optical principles from those in regular cameras.

Polarization Restriction of the direction of vibration of light. Normal light vibrates at right angles to its direction of travel in every plane; a plane-polarizing filter, which is the most common in photography, restricts this vibration to one plane only. The result is the elimination of reflections from non-metallic surfaces.

Pulling Giving film less development than normal, in order to compensate for over-exposure or to reduce contrast.

Pushing Giving film more development than normal, in order to compensate for under-exposure or to increase contrast.

R

Rebate The margin surrounding the image area on film; dark on a developed transparency, clear on a developed negative.

Reciprocity failure At very short and very long exposures, the reciprocity law (*see below*) ceases to hold true and extra exposure is needed. With colour film, the three dye layers usually suffer differently, causing colour cast.

Reciprocity law Exposure = intensity × time. Alternatively, the amount of light reaching the film is the product of the size of the aperture opening and the length of exposure.

Reflector Surface that reflects light aimed at it. The shine and texture of the surface, as well as the colour and tone, control the quality of the reflected light.

Register system System used in darkroom and assembly work in which separate pieces of film can be alligned exactly in position. The usual method is a punch and pin bar.

Reproduction ratio The relative proportions of the size of the subject and its image.

Ring flash Electronic flash in the shape of a ring, used in front of and surrounding the camera lens. The effect is virtually shadowless lighting.

Rollfilm Film rolled on a spool with a dark paper backing. The most common rollfilm format today is 120.

S

Scheimpflug principle Rules governing the relative angles of the lens panel, film plane, and plane of critical sharpness. Used in view camera photography, (and described fully on pages 50-51).

Scrim Mesh material placed in front of a lamp to reduce its intensity, and to some extent diffuse it. One thickness of standard scrim reduces output by the equivalent of about one f stop.

Shadow detail The darkest visible detail in a subject or in the positive image. Often sets the lower limit for exposure.

Sheet film Film used in the form of flat sheets rather than rolls or strips. The most common formats are 4×5 inch and 8×10 inch. They are normally loaded individually into film holders.

Shift Lateral camera movement; that is, of either the lens panel or film back. *See* **Camera movements**

Slave trigger A remotely operated device for triggering additional flash units without a cable connection. The normal method is a photo-cell that responds to the pulse of light from the main flash unit.

Snoot A tapered black cone that fits at the front of a lamp, to concentrate the light into a circle.

Soft focus Deliberate reduction of image quality, normally by means of a mixture of sharp and unsharp resolution, with additional flare and some diffusion.

Spotlight A lamp containing a focusing system that concentrates a narrow beam of light in a controllable way.

Spotmeter Hand-held exposure meter that measures reflected light from a very small area of the subject. The angle of acceptance is commonly only 1°.

Spreader Rigid flat frame that fits underneath an adjustable tripod to lock the three legs into position and increase stability.

Strobe Abbreviation for 'stroboscopic light'. A rapidly repeating flash unit that can be used, with multiple exposure and a moving subject or camera, to produce a distinctive type of multiple image.

Supplementary lens A simple lens fitted in front of the regular camera lens to alter the focal length. Used in close-up photography.

Swing Rotating camera movement of the lens panel or film back around a vertical axis. *See* **Camera movements**

T

Through-the-lens (TTL) meter Exposure meter built into the camera to read off the image formed inside the camera.

Tilt Rotating camera movement of the lens panel or film back around a horizontal axis. *See* **Camera movements**

Tungsten-balanced film Film manufactured for use with tungsten lighting without the need for balancing filters. Type A film is balanced for use with light sources that have a colour temperature of 3400K; the more common type B film is balanced for use with 3200K light sources.

Tungsten lamp Artificial lighting created by heating a filament of tungsten wire electrically to a temperature at which it glows.

Tungsten-halogen lamp Tungsten lamp of improved efficiency, in which the filament is enclosed in halogen gas, which causes the vapourized parts of the filament to be re-deposited on the filament itself rather than on the envelope (which would lower the light output and lower the colour temperature).

V

View camera Large-format camera in which the image is projected onto a ground-glass viewing screen. After viewing, the film is inserted in a holder into the same position as the viewing screen.

W

Watt Electrical unit of power. The wattage of tungsten lamps indicates their relative light output.

Watt-second Unit of energy, equal to one joule.

Index

Index

Index

Bibliography

The Techniques of Photography, Time-Life Books 1976
The Studio, from The Life Library of Photography,
Time-Life Books 1971
View Camera Technique, Leslie Stroebel, 1970 Focal
Press
Worlds in a Small Room, Irving Penn, 1974 Secker &
Warburg
Fashion: Theory, Ed. Carol di Grappa, 1980 Lustrum
Press
Design and Art Direction annuals (various years), The
Design and Art Directors Association of London
Motion Picture Camera and Lighting Equipment,
David W. Samuelson 1977 Focal Press
Collins Photography Workshop series: Image,
Cameras & Lenses, Light, Film. Michael Freeman, 1990
Collins.
Retouching, O. R. Croy, 1964 Focal Press

Acknowledgements

All photographs in this book were taken by Michael
Freeman with the exception of the following: APA,
Singapore: 15. Michael Busselle: 143 (bottom); 154; 155;
156; 157 (bottom); 159 (both); 164 (bottom); 165.
Colorific: 132 (Annie Leibowitz). Peter Hampshire
FRIIP: 228, 229. Keith Johnson Limited: 30; 35; 143
(top)/Julian Bajert; 146; 147; 157 (top)/Julian Bajert;
158/S. Conroy-Hargrave. Rose Jones: 8-9; 21; 44; 45
(bottom); 134 (top); 136; 137; 138; 139; 140; 141; 142; 148;
149; 150; 151; 152; 153; 162; 163; 164 (top); 178; 179.
Francis Lumley : 60-1. Sinar, Geneva: 45 (top).
Courtesy of Sotheby's, London: 133 (Cecil Beaton).

The author and publishers also gratefully acknowledge
the assistance of the following: Gossen; Keith Johnson
Limited/Multiblitz; Minolta; Pentax; Sinar.